Cover: Giambattista Tiepolo, No. 74

Copyright © 1981 by The Metropolitan Museum of Art
ISBN 0-87099-269-4

Published by The Metropolitan Museum of Art
Bradford D. Kelleher, Publisher
John P. O'Neill, Editor in Chief
Polly Cone, Editor

EIGHTEENTH CENTURY ITALIAN DRAWINGS

From the Robert Lehman Collection

CATALOGUE BY
GEORGE SZABO

The Metropolitan Museum of Art
New York
1981

INTRODUCTION

This exhibition of eighteenth-century Italian drawings is the most extensive in the series intended to show all the drawings in the Robert Lehman Collection. Robert Lehman was especially interested in the works of the Venetian artists. He began collecting Venetian drawings in the 1920s and continued it steadily through forty years. Thus, his acquisition of the Paul Wallraf collection in the 1960s only rounded out a splendid assembly.

The drawings of the Guardis, Canaletto, and the two Tiepolos constitute the main body of the exhibition. These artists' development and techniques can be studied almost fully from the sheets seen here. The subjects include landscapes and *vedute*, religious and everyday scenes, and caricatures. The famous series of the Tiepolos, such as the lives of Christ and of the Virgin, the story of St. Anthony, and the designs for the frescoes in the family villa in Zianigo, are all represented here with outstanding examples. Nine drawings from Giovanni Domenico's famous Punchinello series, *Divertimento per li regazzi*, also are included, as are some other sheets that are related to this lighthearted but very touching satire of Venetian life at the end of the eighteenth century.

The virtuoso techniques, brilliant observations, and complete command of the medium are also evident in many drawings that are not related to any known works of these artists, but were evidently done simply for the sake and pleasure of drawing. These sheets, too, are rich sources for the study of contemporary life, manners, and work.

Canaletto's *Meeting at "Liston"* summarizes the social changes in progress at the turn of the century. Novelli's design for the sign of a mirror maker throws an interesting light on the glass industry of Venice. The drawings of Carlevaris or Zucchi represent the various social classes, their aspirations and everyday lives.

Most of these drawings are widely known and have been exhibited and published extensively; therefore, the present catalogue entries and bibliography are brief. Further information may be found in the works listed at the end of the catalogue.

The exhibition is accompanied by many eighteenth-century Venetian frames and other contemporary decorative objects, all from the Robert Lehman Collection.

The staff of the Robert Lehman Collection assisted in the preparation of the exhibition and catalogue. The graphic design for the exhibition—especially that for the catalogue and poster—was the work of the Design Department.

George Szabo
Curator
Robert Lehman Collection

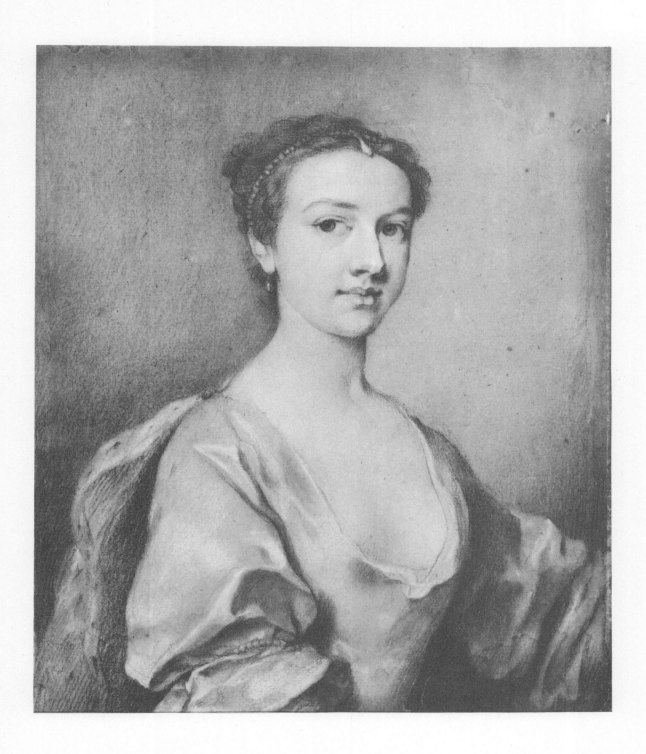

JACOPO AMIGONI, Venice, Munich, London, Paris, Madrid, 1675–1752

1. *Portrait of a Young Woman*

Chalk and pastel on paper, 29.5 x 24.8 cm.

Unpublished.

The drawing is not signed or dated, but the style and the costume of the young woman both indicate that it is from the 1740s. Since one of the artist's daughters was an accomplished portrait painter in chalk and pastel, the drawing may be attributable to her.

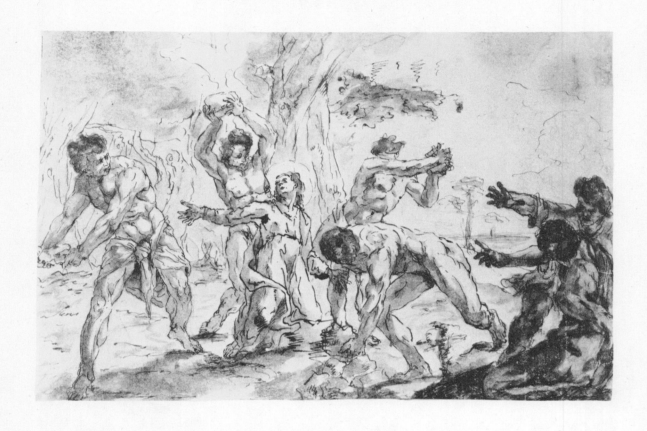

NICOLO BAMBINI, Venice, Rome, Udine, 1651–1736

2a. *The Stoning of St. Stephen*

Pen and ink with brown wash and traces of red chalk on paper, 20.3 x 31.4 cm. On the verso: No. 2b.
Unpublished.

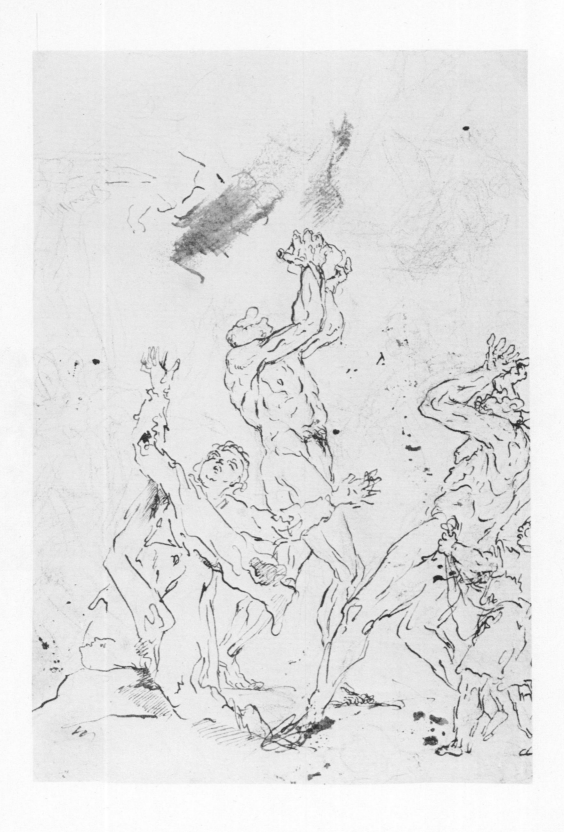

NICOLO BAMBINI, Venice, Rome, Udine, 1651–1736

2b. *The Stoning of St. Stephen*

Pen and ink with traces of red chalk on paper, 31.4 x 20.3 cm. Verso of No. 2a.
Unpublished.

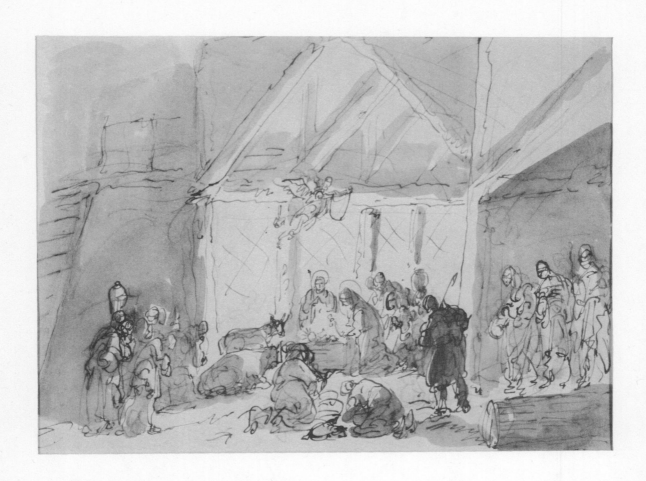

GIUSEPPE BERNARDINO BISON, Palmanova, Venice, Milan, 1762–1844

3. *The Adoration of the Magi*

Pen and ink with wash and traces of red chalk on paper, 17.5 x 24 cm. Signed at lower right: *Bison*.

BIBLIOGRAPHY: Morassi, no. 1.

Morassi dates this drawing to the last years of the eighteenth century and points out its affinities to the Venetian art of that time.

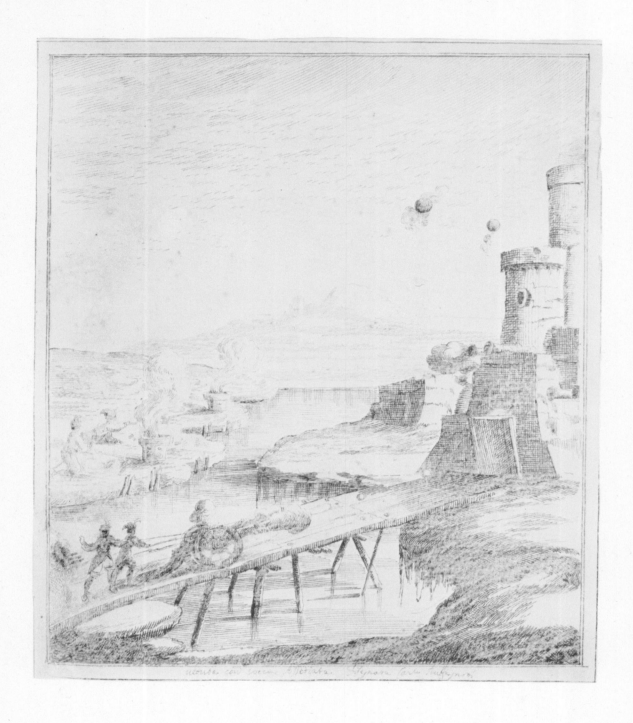

CARLO ANTONIO BUFFAGNOTTI, Bologna, Ferrara, Genoa, b. ca. 1660; still active 1710

4. *Siege of a Fortification*

Pen and ink on paper, 23.2 x 19.4 cm. Inscribed on the old mat at lower center: *veduta con zocca Assediata. Disegnova Carlo Buffagnotti.*

Unpublished.

This prolific painter and engraver, a collaborator of Ferdinando Galli Bibiena in Torino, was also a designer of stage sets and theatrical scenery. The fantastic costumes of the figures and the unusual proportions of this drawing may be indications that it is one of his stage designs—possibly a preliminary drawing for an engraved work.

ANTONIO CANAL, called IL CANALETTO, Venice, London, 1697–1768

5a. *Architectural Study*

Pen and ink on paper, 20 x 14 cm. Numbered, probably in an eighteenth-century hand, at upper right: *21*. On the verso: No. 5b.

BIBLIOGRAPHY: Morassi, no. 2.

This drawing, after nature or possibly from memory, is of existing buildings, although their original identities are not known. Morassi points out that it is in the manner of the *veduta ideata* and that some elements of it can be found in certain paintings by the artist.

ANTONIO CANAL, called IL CANALETTO, Venice, London, 1697–1768

5b. *View of the Rialto Bridge*

Pen and ink on paper, 14 x 20 cm. Verso of No. 5a.

BIBLIOGRAPHY: Morassi, no. 2.

This quick, nervous sketch was rendered from nature and probably on the site without a preliminary pencil drawing. It is closely related to a drawing of the same subject in the Ashmolean Museum, Oxford (K. T. Parker, *Disegni Veneti di Oxford*, exhibition catalogue, San Giorgio Maggiore, Venice, 1956, no. 82).

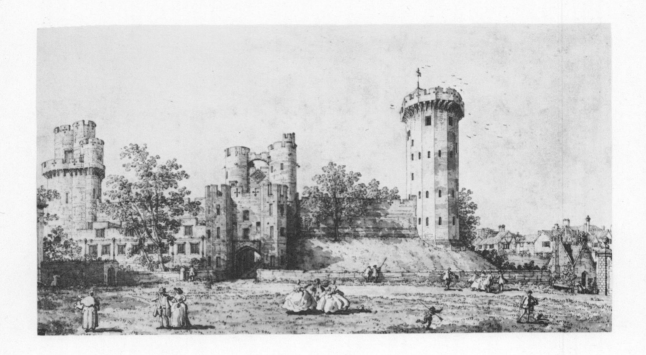

ANTONIO CANAL, called IL CANALETTO, Venice, London, 1697–1768

6. *The East Front of Warwick Castle*

Pen and brown ink with gray wash on paper, 31.6 x 56.2 cm.

BIBLIOGRAPHY: H. F. Finberg, "Canaletto in England," *The Walpole Society* 9 (1920–21), p. 68; Paris, no. 89; Cincinnati, no. 228; W. G. Constable, *Canaletto*, Oxford, 1962, no. 759; Bean-Stampfle, no. 157.

It has been suggested that "this particularly brilliant drawn veduta" is from Canaletto's early stay in England, probably from 1749 (Bean-Stampfle, no. 157). It is generally accepted that the drawing is also the basis for the artist's famous painting of the same subject (see W. G. Constable, *Canaletto*, no. 446).

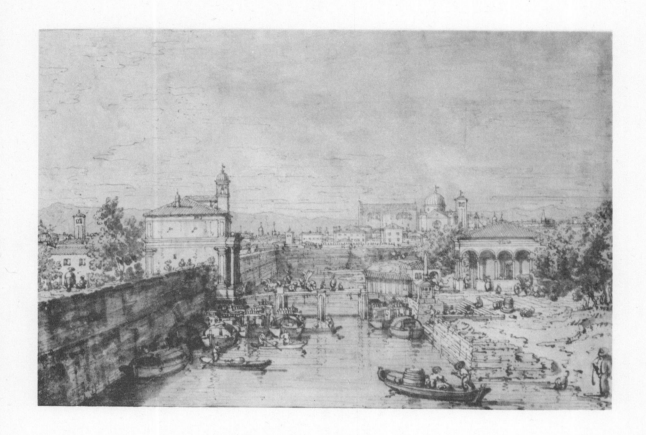

ANTONIO CANAL, called IL CANALETTO, Venice, London, 1697–1768

7. *View of the Brenta Canal and the Porta Portello in Padua*

Pen and ink with brown and gray wash on paper, 17.8 x 26 cm.

BIBLIOGRAPHY: Cincinnati, no. 227; Yale University Art Gallery, *Paintings, Drawings and Sculpture Collected by Yale Alumni,* exhibition catalogue, New Haven, 1960, no. 162.

Similar views of Padua by the artist are in the collections of Windsor Castle and the Albertina, Vienna (See W. G. Constable, *Canaletto,* Oxford, 1962, nos. 675, 676). This drawing may be one of several versions mentioned by Constable as formerly in the Mariette and F. F. Madan collections.

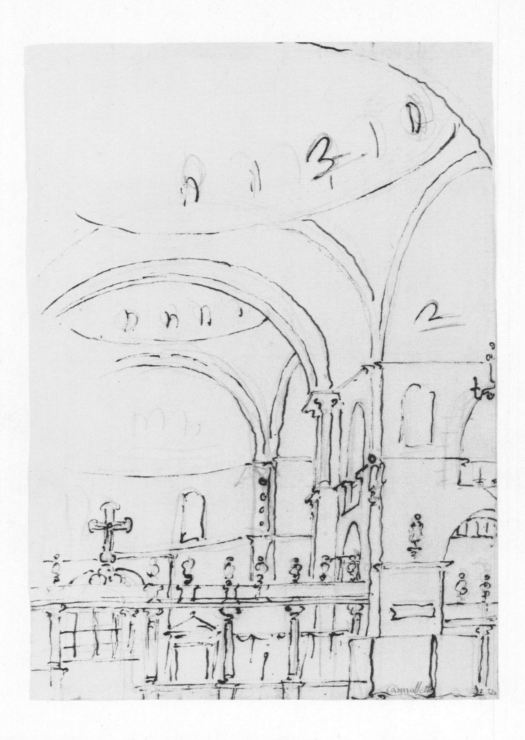

ANTONIO CANAL, called IL CANALETTO, Venice, London, 1697–1768

8. *Interior of the Basilica of San Marco*

Pen and brown ink over thick black chalk on paper, 28 x 19 cm. Inscribed at lower right in a nine-teenth-century hand: *Cannalletto*.

BIBLIOGRAPHY: Morassi, no. 8; Szabo, *Venetian Drawings*, no. 2.

This rapid study is in the so-called *maniera cifrata* that the artist used in his later years. He frequently drew the interior of San Marco and on a similar sketch, now at the Kunsthalle in Hamburg, he proudly noted: "de Anni 68 cenza Ochiali L'anno 1766" (Morassi, p. 12). This and other drawings of the same style and provenance might have been pages in one of Canaletto's sketchbooks (M. Muraro, *Venetian Drawings from the Collection of Janos Scholz*, Venice, 1957, no. 79).

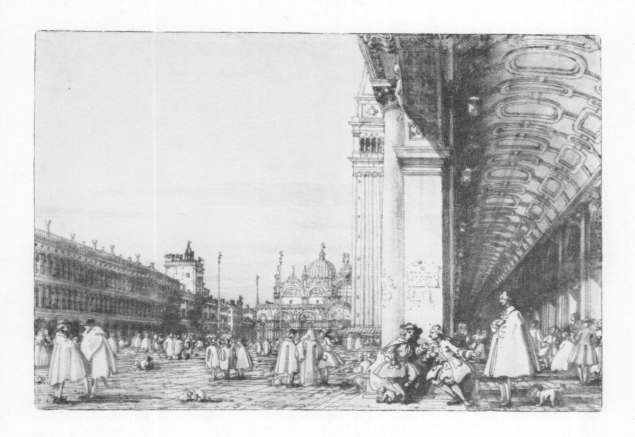

ANTONIO CANAL, called IL CANALETTO, Venice, London, 1697–1768

9. *The Piazza di San Marco Seen from the Arcades of the Procuratie Nuove*

Pen and brown ink with gray wash on paper, 22.2 x 33 cm.

BIBLIOGRAPHY: D. von Hadeln, *Drawings of Antonio Canal*, London, 1929, p. 14; K. T. Parker, *Canaletto Drawings at Windsor Castle*, London, 1948, no. 57, p. 40; Morassi, no. 120; Szabo, *Venetian Drawings*, no. 3.

In this important and beautiful sheet from the later years of Canaletto's life, the lively and colorful scene on the Piazza is masterfully depicted with rapid strokes and a deft use of washes. The animated drawing, with its rhythmic grouping of people, dogs, and buildings, exudes the essence of the famous center of Venice. Another version of this composition is in Windsor Castle, but it is probably a workshop drawing (Morassi, p. 81).

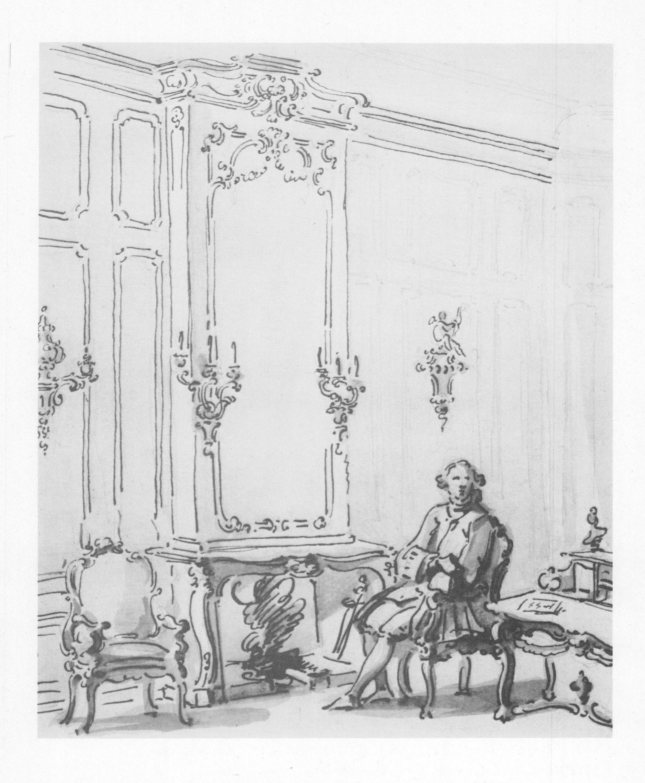

ANTONIO CANAL, called IL CANALETTO, Venice, London, 1697–1768

10. *Young Gentleman Sitting at a Fireplace*

Pen and brown ink with bister wash over preliminary pencil drawing on paper, 21 x 17 cm.

BIBLIOGRAPHY: Morassi, no. 4; Szabo, *Venetian Drawings*, no. 4.

Representations of figures in domestic interiors are rare in the oeuvre of Canaletto. Therefore, the attribution of this drawing to him is still uncertain. Morassi remarks that a somewhat similar drawing by Canaletto is in the Sir Robert Witt Bequest at the Courtauld Institute in London and is dated around 1755 (Morassi, p. 13).

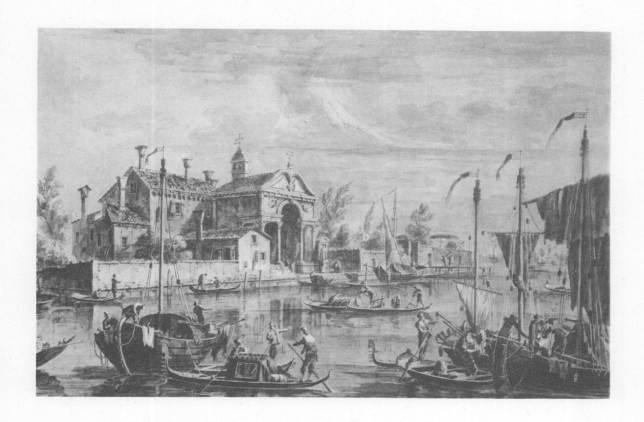

ANTONIO CANAL, called IL CANALETTO, Venice, London, 1697–1768

11. *The Island of San Giacomo*

Pen and ink with gray wash and white highlights on paper, 27.5 x 41.5 cm. Inscribed in a nineteenth-century hand on a small label attached to the verso: *San Giacomo*.

BIBLIOGRAPHY: *Ritter J. C. von Klinkosch Katalog...Sammlung von Alten Handzeichnungen, etc.*, Vienna, 1889, vol. IV, no. 274; Szabo, *Venetian Drawings*, no. 1.

Support for the attribution to Canaletto is mixed. However, the drawing is definitely from Canaletto's circle.

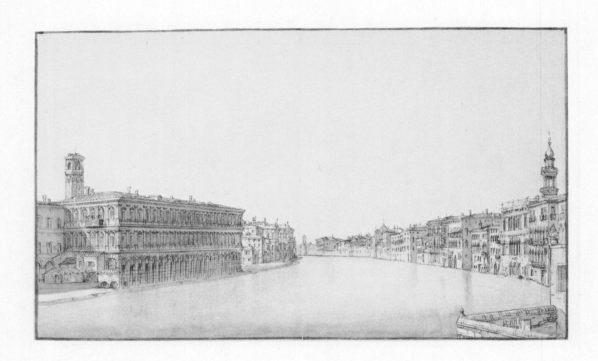

VENETIAN ARTIST, SCHOOL OF CANALETTO

12. *The Grand Canal with the Fabbriche Nuove on the Left*

Pen and ink with sepia and gray washes on paper, 25.5 x 43 cm.

BIBLIOGRAPHY: Morassi, no. 5; Szabo, *Venetian Drawings*, no. 5.

This and the following twelve drawings are all related to Canaletto's oeuvre, but they are not from his hand. These views lack the human figures that so enliven Canaletto's similar *vedute* and are drawn in a somewhat dry and mechanical manner. Most of the sheets are dependent upon Canaletto's series of engravings published in 1742 under the title *Urbis Venetiarum Prospectus*. The artists suggested as authors for these drawings include Canaletto's nephew Bernardo Belotto and Visentini, another member of Canaletto's school (Morassi, p. 14).

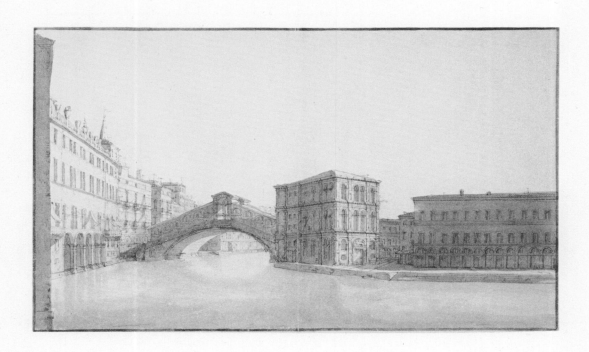

VENETIAN ARTIST, SCHOOL OF CANALETTO

13. *The Grand Canal with the Rialto Bridge and the Palazzo dei Camerlenghi*

Pen and brown ink with sepia and gray washes on paper, 25.5 x 43 cm.

BIBLIOGRAPHY: Morassi, no. 6; Szabo, *Venetian Drawings*, no. 7.

This lifeless drawing offers an interesting comparison with No. 5b, a view of the Rialto Bridge from Canaletto's own hand.

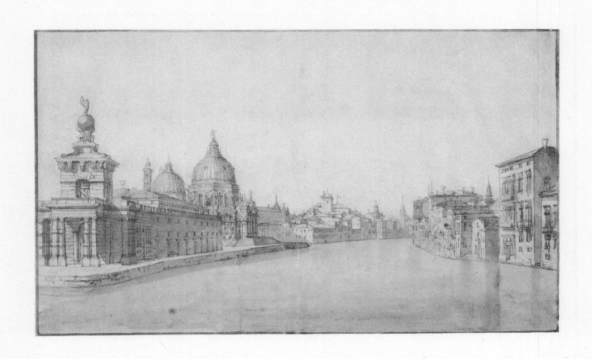

VENETIAN ARTIST, SCHOOL OF CANALETTO
14. *View of the Grand Canal with the Punta della Dogana and the Church of Santa Maria della Salute*
Pen and ink with sepia and gray washes on paper, 25 x 43 cm.
BIBLIOGRAPHY: Morassi, no. 8; Szabo, *Venetian Drawings*, no. 6.

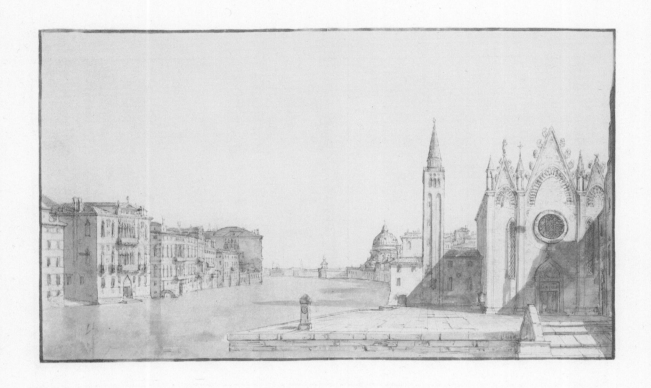

VENETIAN ARTIST, SCHOOL OF CANALETTO

15. *The Grand Canal with the Church of the Carità*

Pen and ink with sepia and gray washes on paper, 25.2 x 43 cm.

BIBLIOGRAPHY: Morassi, no. 7.

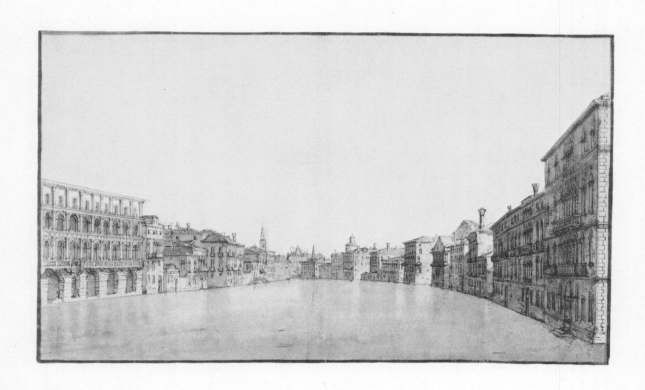

VENETIAN ARTIST, SCHOOL OF CANALETTO
16. *View of the Grand Canal with the Palazzo Moro-Lin*
Pen and ink with sepia and gray washes on paper, 24.2 x 42 cm.
BIBLIOGRAPHY: Morassi, no. 9.

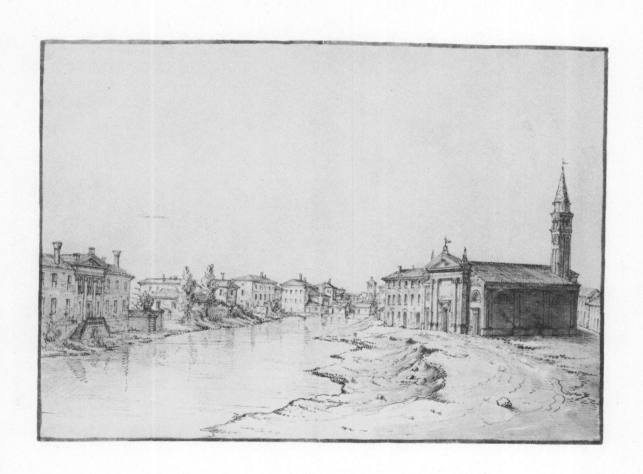

VENETIAN ARTIST, SCHOOL OF CANALETTO

17. *The Brenta at Dolo*

Pen and ink with gray wash on paper, 29 x 41 cm.

BIBLIOGRAPHY: Morassi, no. 11.

VENETIAN ARTIST, SCHOOL OF CANALETTO

18. *On the Shores of the Brenta*

Pen and ink with gray wash on paper, 28.7 x 43.9 cm.

BIBLIOGRAPHY: Morassi, no. 12.

VENETIAN ARTIST, SCHOOL OF CANALETTO

19. *Fantastic View of Padua from the Fortifications*

Pen and ink with gray wash on paper, 29 x 40.5 cm.

BIBLIOGRAPHY: Morassi, no. 16.

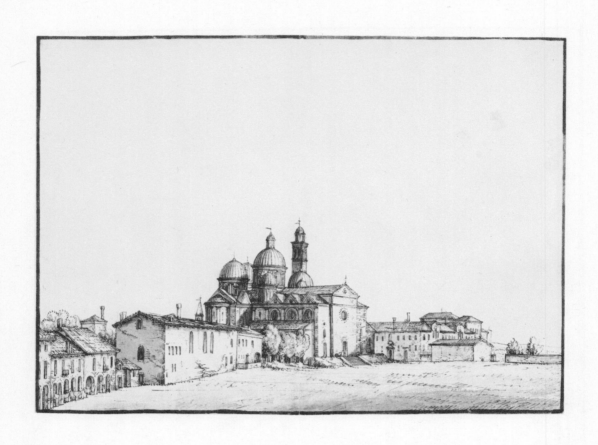

VENETIAN ARTIST, SCHOOL OF CANALETTO

20. The Church of Santa Giustina in Padua

Pen and ink with gray wash on paper, 29 x 40 cm.

BIBLIOGRAPHY: Morassi, no. 14.

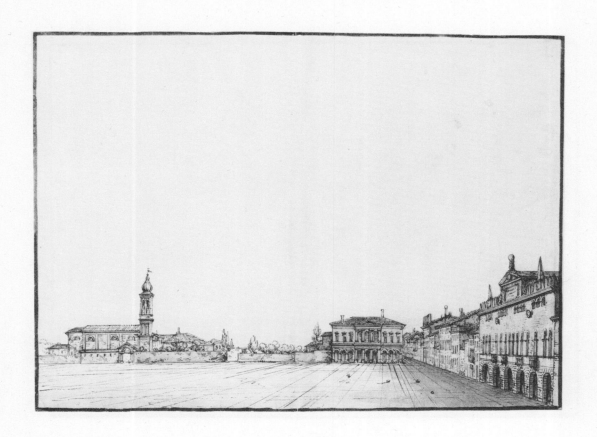

VENETIAN ARTIST, SCHOOL OF CANALETTO

21. *View of the Pra' della Valle in Padua*

Pen and ink with gray wash on paper, 29 x 40 cm.

BIBLIOGRAPHY: Morassi, no. 15.

This view of the large square is copied from an engraving by Canaletto, which is in turn dependent on his large drawing representing an even wider panorama and now in Windsor Castle (K. T. Parker, *Canaletto Drawings at Windsor Castle*, London, 1948, figs. 453, 454).

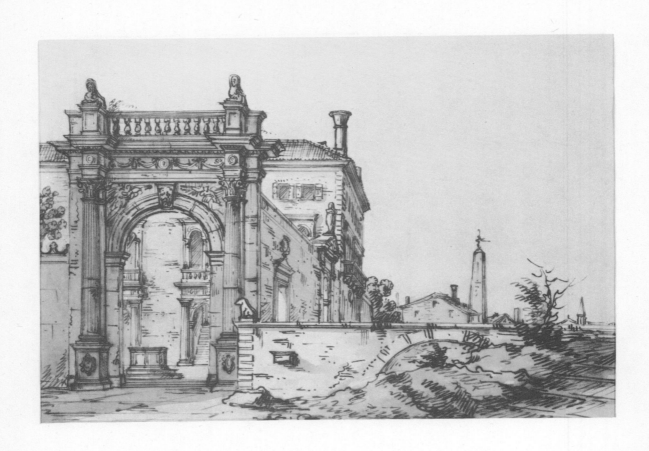

VENETIAN ARTIST, SCHOOL OF CANALETTO

22. Fantastic Veduta

Pen and ink with gray wash on paper, 19.3 x 27.5 cm.
BIBLIOGRAPHY: Morassi, no. 17.

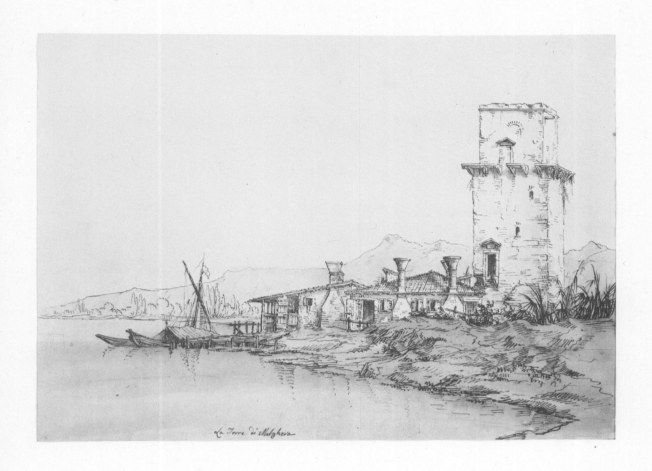

La Torre di Malghera

VENETIAN ARTIST, SCHOOL OF CANALETTO

23. *The Tower of Marghera*

Pen and ink with gray wash on paper, 29.5 x 40.5 cm. Inscribed at lower center: *La Torre di Malghera*.

BIBLIOGRAPHY: Morassi, no. 13.

The Tower of Marghera was a favorite subject of Canaletto and his contemporary Francesco Guardi. A small panel painting of the tower by Guardi is also in the Robert Lehman Collection.

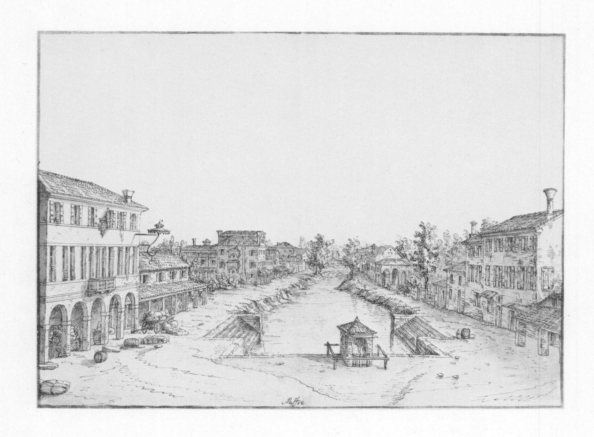

VENETIAN ARTIST, SCHOOL OF CANALETTO

24. *View of Mestre*

Pen and brown ink with gray wash on paper, 29.5 x 40.5 cm. Inscribed at lower center: *Mestre*.

BIBLIOGRAPHY: Morassi, no. 10; Szabo, *Venetian Drawings*, no. 8.

This and the following drawings belong to another series copied from Canaletto's works representing mostly views of the terra firma (see R. Palluchini and D. Guarnati, *Le acquaforti del Canaletto*, Venice, 1945, pl. 5).

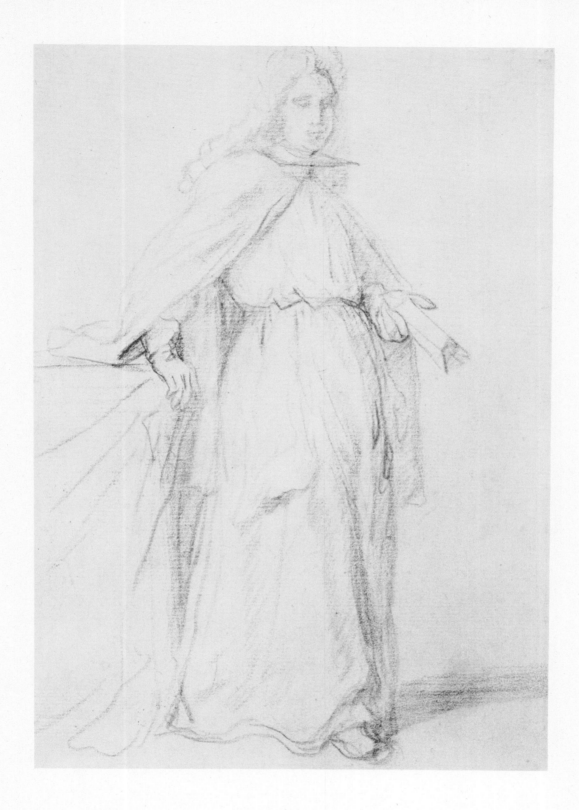

LUCA CARLEVARIS, Udine, Venice, 1665–1731

25. *Portrait of a Dignitary*

Red chalk on paper, 25 x 17 cm.

BIBLIOGRAPHY: Morassi, no. 18; Pignatti, no. 98; Szabo, *Venetian Drawings*, no. 9.

Pignatti remarks that "drawings by Carlevaris are very rare in American collections." This draw-ing, probably the portrait of a senator, is even more unique, since it represents a full-length fig-ure. It is generally dated to around 1730.

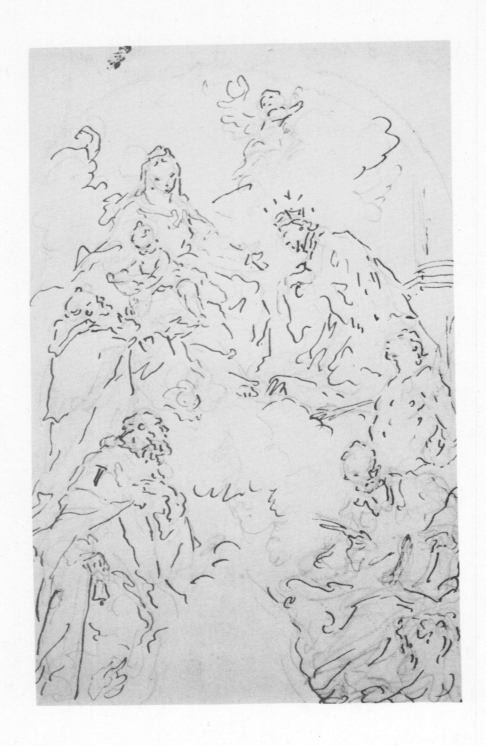

GIUSEPPE DIZIANI, Venice, active first half of eighteenth century

26. *Enthroned Madonna Surrounded by Saints*

Pen and black ink over pencil drawing on paper, 24 x 15 cm.

BIBLIOGRAPHY: Morassi, no. 19.

Very little is known of this artist, the son of the painter Gaspare Diziani (1689–1767). He was probably a student of his father and Antonio Guardi, and most of his works reflect their influence. This drawing is a study for an altarpiece very reminiscent of one by Guardi in the Church of Belvedere in Aquileja (see Morassi, no. 19).

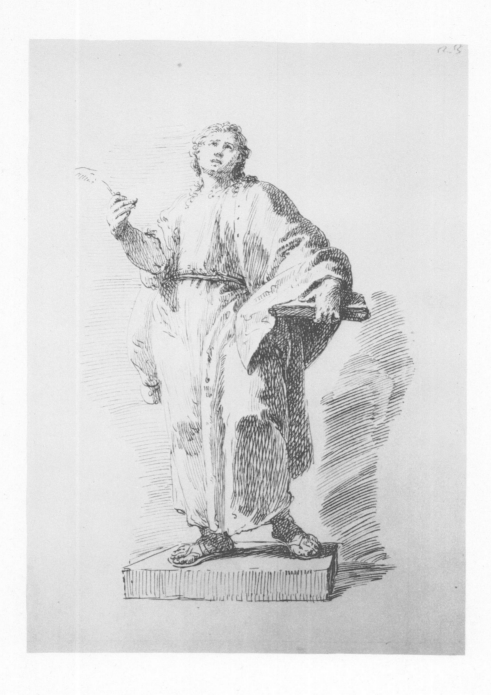

FRANCESCO SALVATOR FONTEBASSO, Venice, 1709–1768/69

27. *St. John the Evangelist*

Pen and ink on paper, 38.1 x 26 cm. Numbered in pen and ink in upper right corner: *23*. Vertical ruled lines on the top and two sides.

Unpublished.

This sheet is from an album that was broken up probably before 1924. Other pages, all showing the same vertical lines, are in various public and private collections (see J. Bean, *Italian Drawings in the Art Museum of Princeton University,* Princeton, 1966, nos. 98, 99). A sheet in the Metropolitan Museum, depicting two standing male figures and a seated woman, bears the number *41,* thus, the album must have had many pages (Bean-Stampfle, no. 181). The attribution of the drawings from this album to Fontebasso is not accepted by several scholars and connoisseurs (see J. Scholz, "Italian Drawings in the Art Museum of Princeton University," *Burlington Magazine* 109 [1967], p. 296).

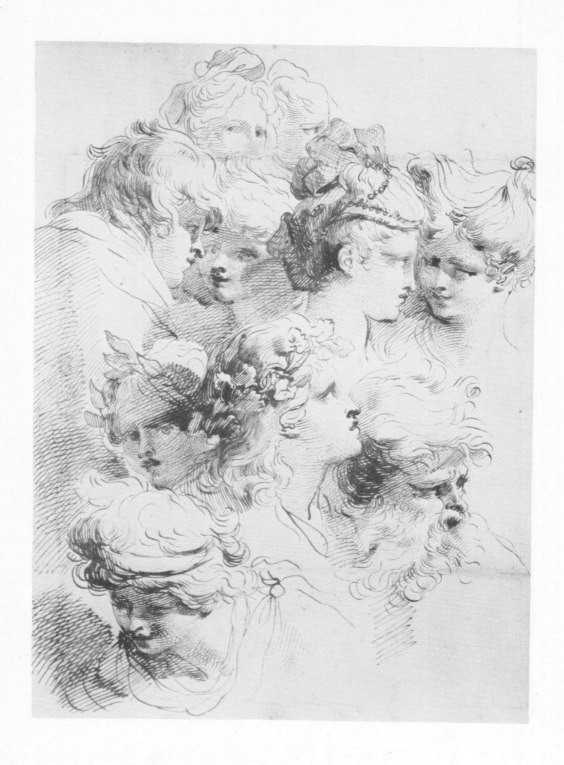

GAETANO GANDOLFI, Matteo della Decima (near Bologna), Venice, Bologna, 1734–1802

28. *Studies of Classical Heads*

Pen and ink on paper, 28.6 x 20 cm.

BIBLIOGRAPHY: Szabo, *Venetian Drawings*, no. 10.

This prolific Bolognese artist produced a large body of drawings and graphic works, among them anatomical and compositional studies and studies of the human head. This sheet is one of the latter, which, during Gandolfi's lifetime, were reproduced in engravings by Tadolini and by the artist himself.

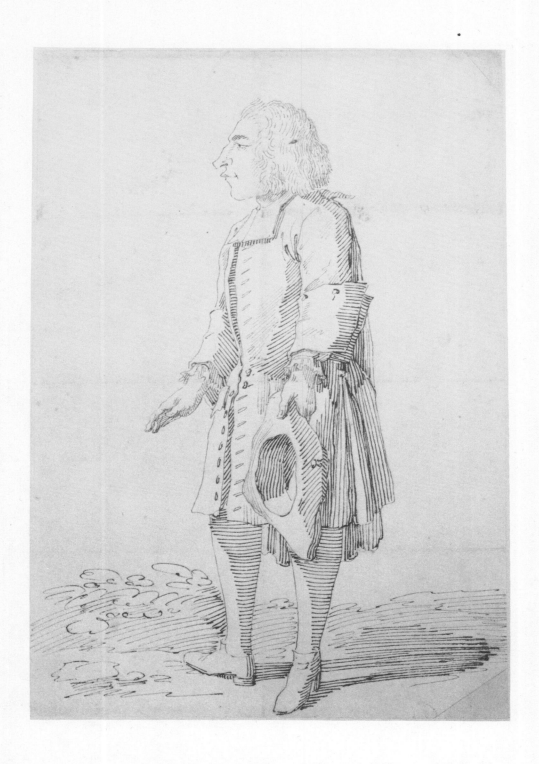

PIER LEONE GHEZZI, Rome, 1674–1755

29. *The Polish Count Onajchi*

Pen and ink on paper, 31.4 x 21.3 cm. Contemporary inscription on the verso: *C.e Onajchi Polacco.*
Unpublished.

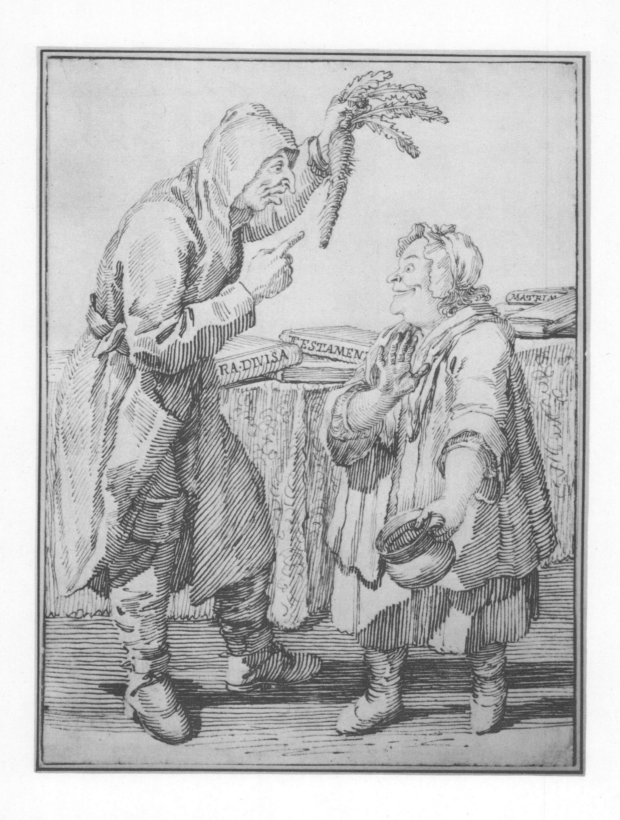

PIER LEONE GHEZZI, Rome, 1674–1755

30. *Allegorical Scene*

Pen and ink on paper, 28.1 x 20.3 cm.

Unpublished.

The key to this satirical drawing may be the inscriptions on the books strewn about on the table: ... *RA • DIVISA, TESTAMENT, MATRIM.*

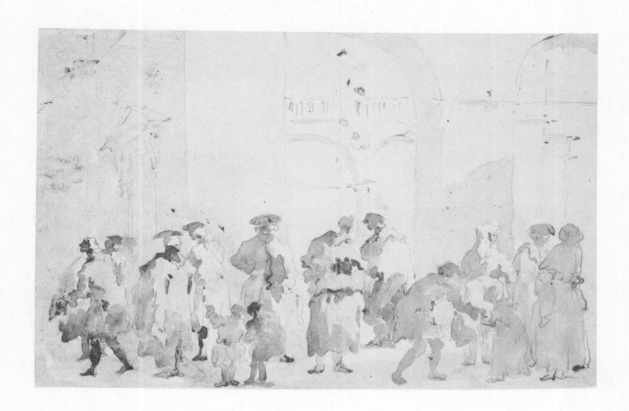

FRANCESCO GUARDI, Venice, 1712–1793

31a. *Sketches of Macchiette*

Pen and brown ink with gray wash on paper, 16.7 x 26 cm. On the verso: No. 31b.

BIBLIOGRAPHY: Morassi, no. 21; A. Morassi, *Guardi, Tutti i Disegni*, Venice, 1975, cat. 564; Szabo, *Venetian Drawings*, no. 12.

Macchiette are small representations of human figures formed from various tones of wash. Here noblemen, women, and children are shown under the arcades of a public building or a large house. They may be onlookers at a ceremonial procession such as the crowning of Doge Alvise Mocenigo, which took place in 1763. Other Venetian artists depicted this occasion; it is quite possible that Guardi made this and other sketches at the time.

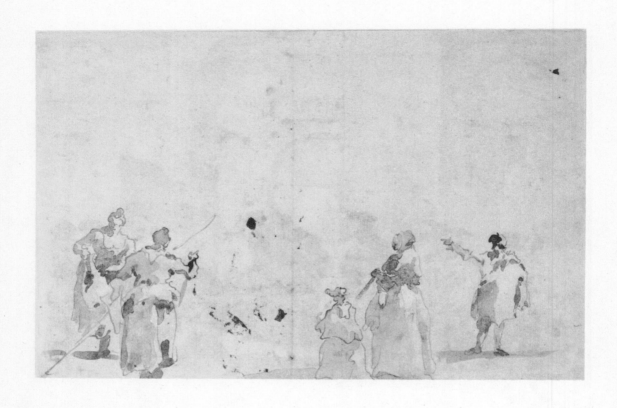

FRANCESCO GUARDI, Venice, 1712–1793

31b. *Five Figures of Macchiette*

Pen and ink with gray wash on paper, 16.7 x 26 cm. Verso of No. 31a.

BIBLIOGRAPHY: Morassi, no. 21; A. Morassi, *Guardi, Tutti i Disegni*, Venice, 1975, p. 176; Szabo, *Venetian Drawings*, no. 12.

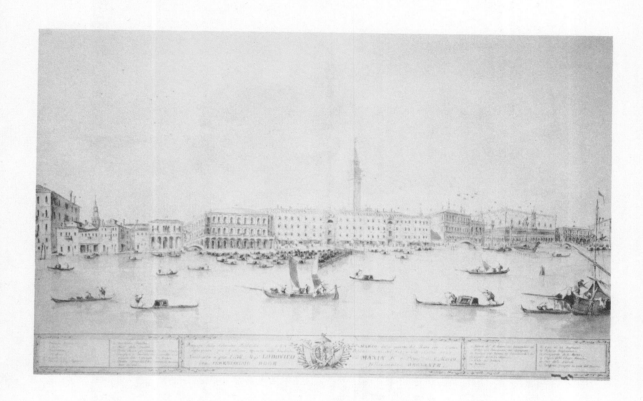

FRANCESCO GUARDI, Venice, 1712–1793

32. *View of the Grand Canal and the Buildings of San Marco as Seen from the Sea*

Pen and ink with gray wash and gouache on paper, 47.5 x 88.5 cm. In a cartouche along the lower edge, a coat of arms and the inscription: *Prospeto delle Fabriche Publiche di San Marco dalla parte del Mare con il Teatro disegnato per l'ultimo Quarto delli Fondachi Publici detti del Sal. e. nell. Anno 1787. Viniliato a sua Eccell: Missr. LODOVICO Co: MANIN K. e. Proccr: di S. Marco ora SERENISSIMO DOGE felicemente REGNANTE.* Flanking this inscription is a list of buildings with numbers corresponding to those in the drawing. Inscribed in lower right corner: *F. G. Pinxit;* inscribed in lower left corner: *P. B. A. A. C. Inv. Teat.*

BIBLIOGRAPHY: G. Fiocco, "Francesco Guardi pittore di teatro," *Dedalo* 13 (1933), pp. 360–67; Cincinnati, no. 231; A. Morassi, *Guardi, Tutti i Disegni*, Venice, 1975, p. 151, fig. 633; Szabo, *Venetian Drawings*, no. 13.

This late drawing was acclaimed by Fiocco as "rich with a magisterial vitality and freshness... one of the most significant by the sensitive painter" (Fiocco, "Francesco Guardi pittore di teatro," p. 364). Its abundant details, the elaborate inscriptions, and the list of buildings are all indications that it was intended for an etching or engraving. It may be related to the building of a proposed new theater, marked here with the number 10. It is known from other drawings and documents that Guardi was involved in the planning of this building, which was never erected.

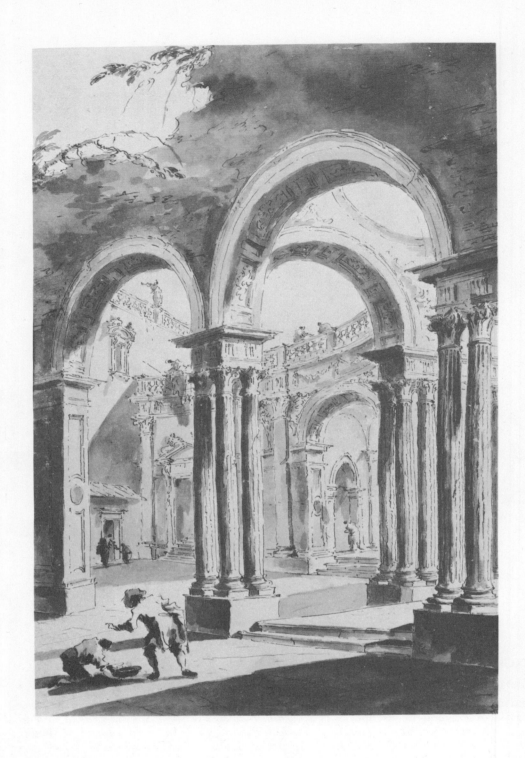

FRANCESCO GUARDI, Venice, 1712–1793

33. *Figures in a Fantastic Colonnade*

Pen and brown ink with brown and gray washes on paper, 45.3 x 30 cm.

BIBLIOGRAPHY: Springfield Museum of Fine Arts, *Francesco Guardi*, exhibition catalogue, Springfield, Mass., 1937, no. 46; A. Morassi, *Guardi, Tutti i Disegni*, Venice, 1975, pp. 173, 453; Szabo, *Venetian Drawings*, no. 11.

This is an architectural *capriccio* in the fine manner for which Guardi is greatly appreciated. The light, free lines, the varied washes, and the similarity to other drawings by the artist indicate a late date, between 1780 and 1790 (see J. Byam Shaw, *The Drawings of Francesco Guardi*, London, 1951, pl. 62).

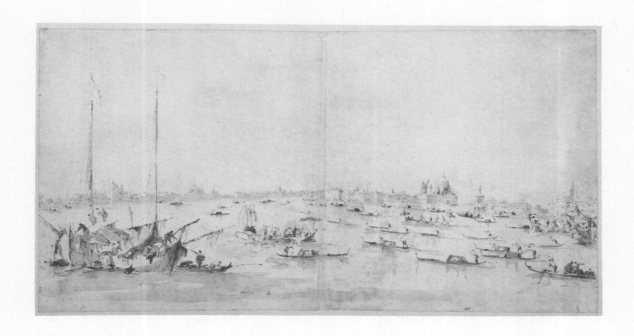

FRANCESCO GUARDI, Venice, 1712–1793

34. *Panorama from the Bacino di San Marco*

Pen and bister wash on paper, 34.9 x 67.6 cm.

BIBLIOGRAPHY: J. Byam Shaw, *The Drawings of Francesco Guardi*, London, 1951, no. 27; Orangerie, no. 104; Cincinnati, no. 230; Bean-Stampfle, no. 193; A. Morassi, *Guardi, Tutti i Disegni*, Venice, 1975, cat. 294; R. Kultzen, "Ein Spätwerk von Francesco Guardi in der Alten Pinakothek," *Pantheon* 34 (1976), pp. 219–20.

A preparatory drawing for a painting representing the Regatta on the Giudecca Canal reappeared only recently and was acquired by the Alte Pinakothek in Munich (R. Kultzen, "Ein Spätwerk von Francesco Guardi," p. 219). The painting and several drawn studies for it, including this one, are dated between 1784 and 1789. Byam Shaw remarks that the present sheet "is among the most beautiful and ambitious drawings in Guardi's developed style" (Byam Shaw, *The Drawings of Francesco Guardi*, p. 27). Especially ambitious and extraordinary is the panoramic view, which is "certainly wider than the eye could include in a single focus" (Byam Shaw, *The Drawings of Francesco Guardi*, p. 64). Therefore, it must have been composed from three separate drawings and several different views, probably taken from a boat positioned in front of San Giorgio.

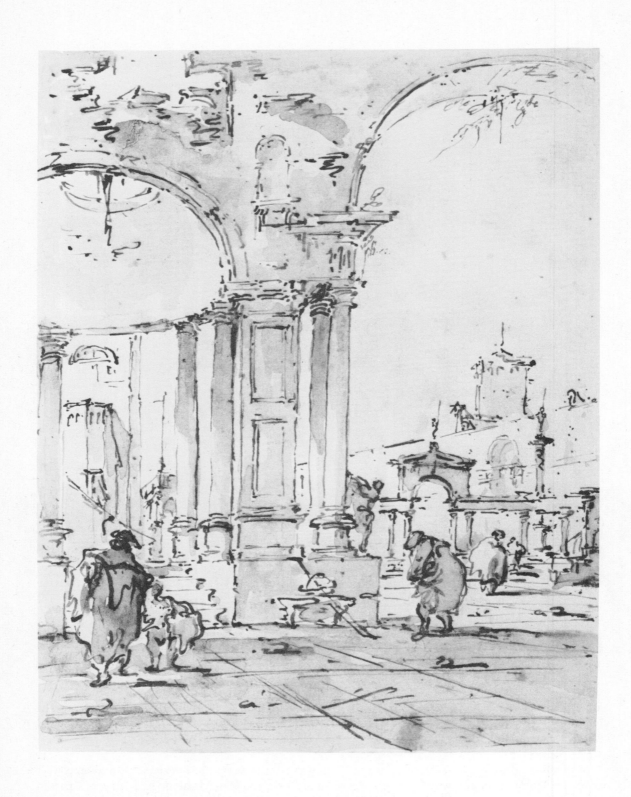

FRANCESCO GUARDI, Venice, 1712–1793

35. *Fantastic Architecture with Small Figures*

Pen and ink with brown wash on paper, 25.3 x 19.5 cm.

BIBLIOGRAPHY: J. Byam Shaw, *Drawings of Francesco Guardi*, London, 1951, no. 62; Morassi, no. 23; A. Morassi, *Guardi, Tutti i Disegni*, Venice, 1975, cat. 512.

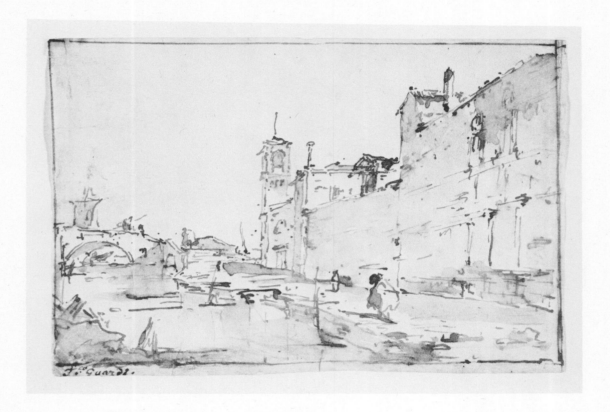

FRANCESCO GUARDI, Venice, 1712–1793

36. *Fantastic Architecture with a Canal*

Pen and brown ink with brown wash on paper, 12.7 x 18 cm. Inscribed in an eighteenth-century hand at lower left: *F. co Guardi*.

BIBLIOGRAPHY: Rijksmuseum, *Catalogus van de Tentoonstelling van Oude Kunst*, exhibition catalogue, Amsterdam, 1936, no. 185; Morassi, no. 22; A. Morassi, *Guardi, Tutti i Disegni*, Venice, 1975, cat. 602.

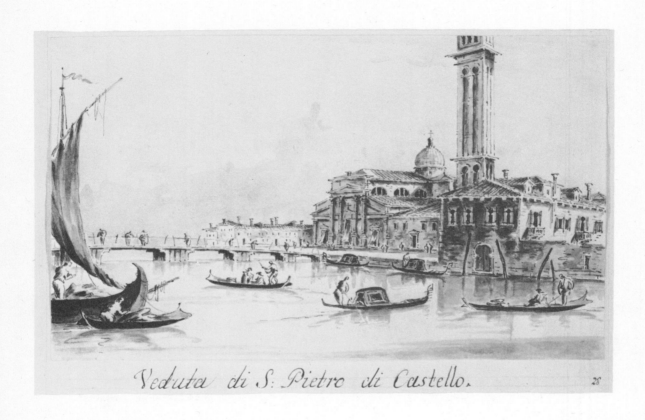

Veduta di S: Pietro di Castello. 28

GIACOMO GUARDI, Venice, 1764–1835

37. *View of San Pietro di Castello*

Pen and ink with gray wash on paper, 12.5 x 21 cm. Inscribed and numbered below by the artist: *Veduta di S: Pietro di Castello. 28.*

BIBLIOGRAPHY: Morassi, no. 25.

This drawing and the following twenty-one others by Giacomo Guardi, son and successor of Francesco, belonged to an album that originally contained thirty-six similar views of Venice and its environs. The album was put together between 1800 and 1804 and was in a private collection in Ireland before 1828. In contrast to his father's work, Giacomo's drawings are lifeless, but they constitute an interesting pictorial record of Venice before the period of mid-nineteenth-century industrialization and large-scale destruction of historic buildings.

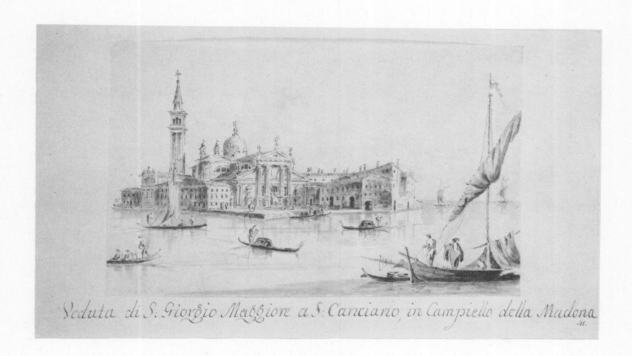

GIACOMO GUARDI, Venice, 1764–1835

38. *San Giorgio Maggiore*

Pen and ink with gray wash on paper, 11 x 18 cm. Inscribed and numbered below by the artist: *Veduta di S: Giorgio Maggiore a S: Canciano, in Campiello della Madona 41.*

BIBLIOGRAPHY: Morassi, no. 26.

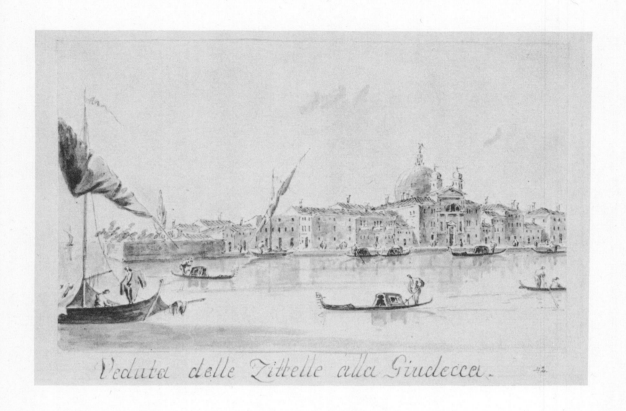

Veduta delle Zittelle alla Giudecca. 42.

GIACOMO GUARDI, Venice, 1764–1835

39. *View of the Zitelle on the Giudecca*

Pen and ink with gray wash on paper, 11.5 x 18.5 cm. Inscribed and numbered below by the artist:
Veduta delle Zittelle alla Giudecca. 42.

BIBLIOGRAPHY: Morassi, no. 27; Szabo, *Venetian Drawings*, no. 16.

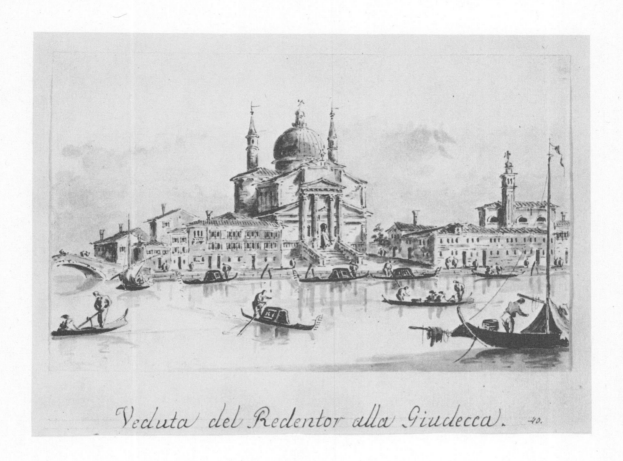

Veduta del Redentor alla Giudecca. 40.

GIACOMO GUARDI, Venice, 1764–1835

40. *View of the Church of Il Redentore on the Giudecca*

Pen and ink with gray wash on paper, 11.5 x 18.7 cm. Inscribed and numbered below by the artist:
Veduta del Redentor alla Giudecca. 40.

BIBLIOGRAPHY: Morassi, no. 28.

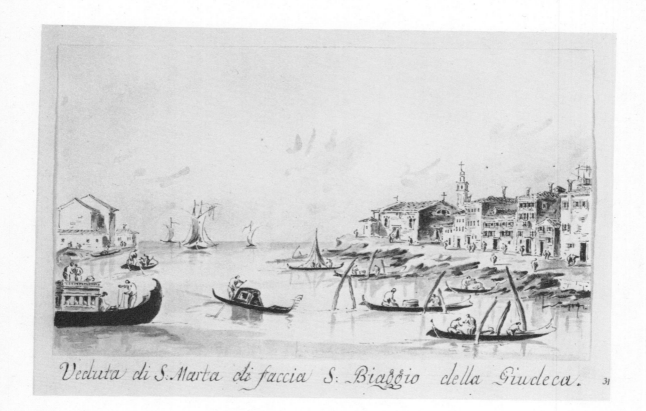

Veduta di S: Marta di faccia S: Biaggio della Giudeca. 31

GIACOMO GUARDI, Venice, 1764–1835

41. *View of Santa Marta Island as Seen from the Church of San Biaggio on the Giudecca*

Pen and ink with gray wash on paper, 12.5 x 21.1 cm. Inscribed and numbered below by the artist: *Veduta di S: Marta di faccia S: Biaggio della Giudeca. 31.*

BIBLIOGRAPHY: Morassi, no. 29.

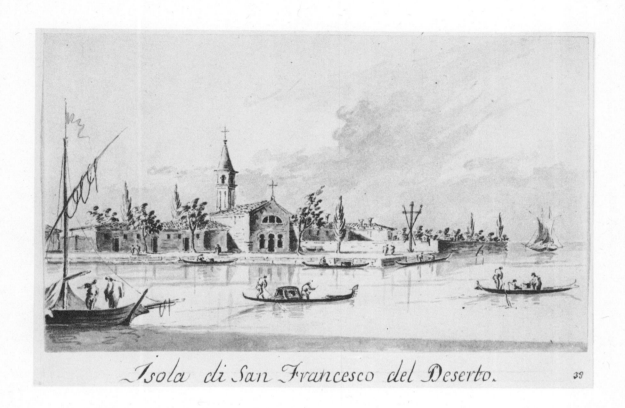

Isola di San Francesco del Deserto. 38

GIACOMO GUARDI, Venice, 1764–1835

42. *View of the Island of San Francesco del Deserto*

Pen and ink with gray wash on paper, 12.5 x 21 cm. Inscribed and numbered below by the artist: *Isola di San Francesco del Deserto. 38.*

BIBLIOGRAPHY: Morassi, no. 37.

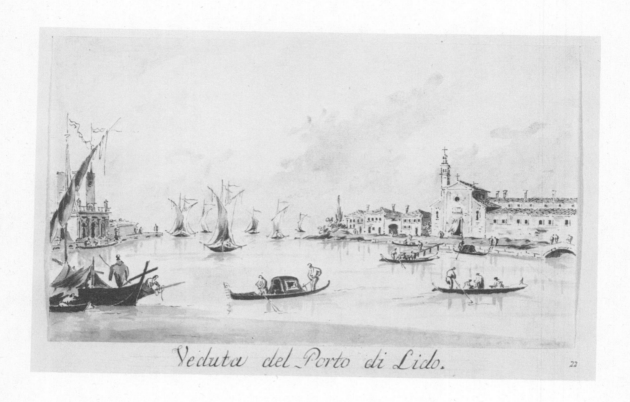

Veduta del Porto di Lido.

22

GIACOMO GUARDI, Venice, 1764–1835

43. *View of the Port of the Lido*

Pen and ink with gray wash on paper, 12.5 x 21 cm. Inscribed and numbered below by the artist:
Veduta del Porto di Lido. 22.

BIBLIOGRAPHY: Morassi, no. 33

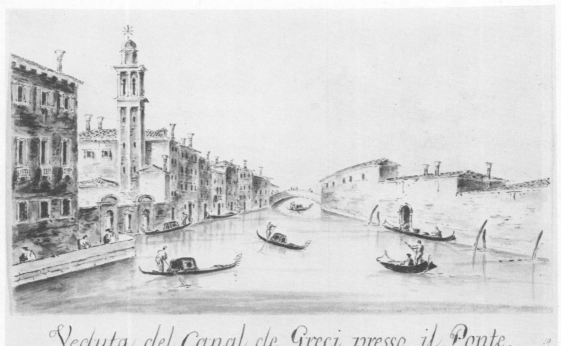

Veduta del Canal de Greci presso il Ponte.

GIACOMO GUARDI, Venice, 1764–1835

44. *View of the Canale dei Greci near the Bridge*

Pen and ink with gray wash on paper, 12 x 21.1 cm. Inscribed and numbered below by the artist: *Veduta del Canal de Greci presso il Ponte. 19.*

BIBLIOGRAPHY: Morassi, no. 30.

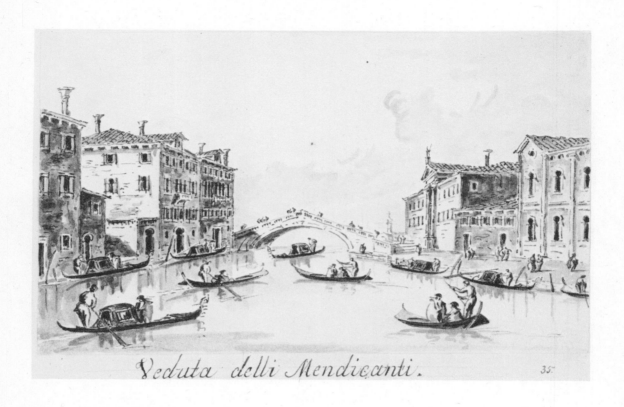

Veduta delli Mendicanti. 35.

GIACOMO GUARDI, Venice, 1764–1835

45. *View of the Rio dei Mendicanti*

Pen and ink with gray wash on paper, 12.5 x 20.9 cm. Inscribed and numbered below by the artist:
Veduta delli Mendicanti. 35.

BIBLIOGRAPHY: Morassi, no. 31.

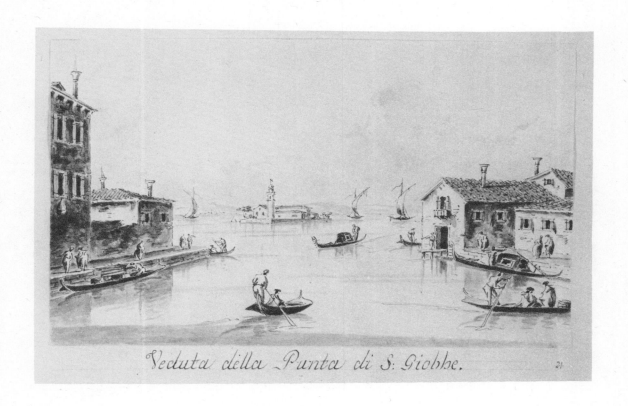

Veduta della Punta di S: Giobbe.

GIACOMO GUARDI, Venice, 1764–1835

46. *View of the Punta di San Giobbe*

Pen and ink with gray wash on paper, 12.5 x 19 cm. Inscribed and numbered below by the artist:
Veduta della Punta di S: Giobbe. 24.

BIBLIOGRAPHY: Morassi, no. 32.

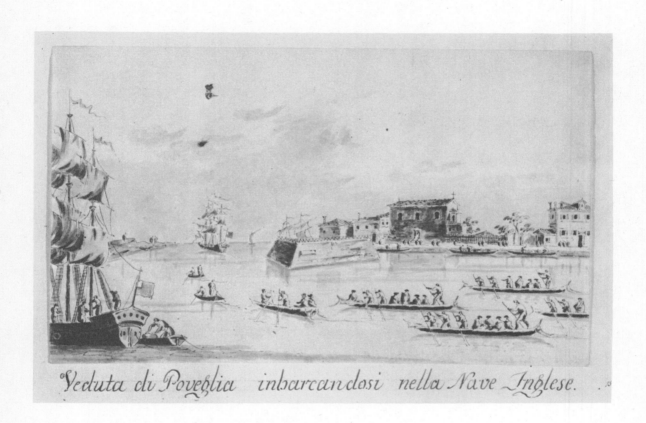

Veduta di Poveglia inbarcandosi nella Nave Inglese.

GIACOMO GUARDI, Venice, 1764–1835

47. *View of the Poveglia with English Ships*

Pen and ink with gray wash on paper, 12.5 x 21 cm. Inscribed and numbered below by the artist:
Veduta di Poveglia inbarcandosi nella Nave Inglese. 13.

BIBLIOGRAPHY: Morassi, no. 34.

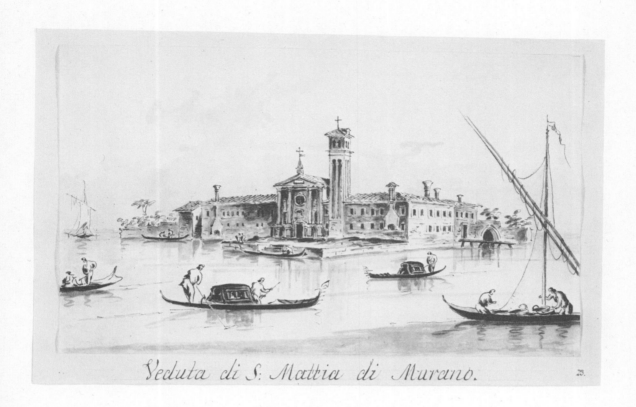

Veduta di S: Mattia di Murano.

GIACOMO GUARDI, Venice, 1764–1835

48. *View of San Mattia in Murano*

Pen and ink with gray wash on paper, 12.5 x 21 cm. Inscribed and numbered below by the artist:
Veduta di S: Mattia di Murano. 23.

BIBLIOGRAPHY: Morassi, no. 35.

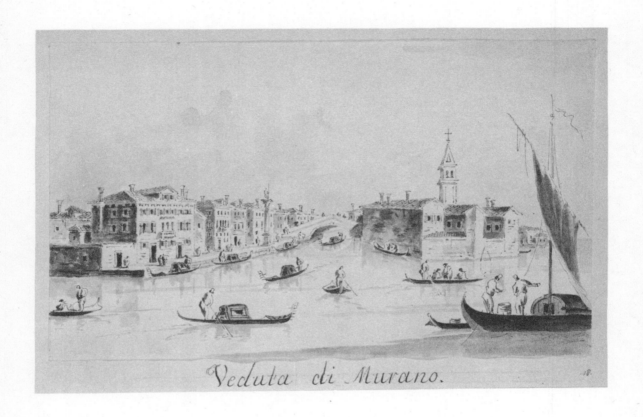

Veduta di Murano.

GIACOMO GUARDI, Venice, 1764–1835

49. *View of Murano*

Pen and ink with gray wash on paper, 12.5 x 21 cm. Inscribed and numbered below by the artist:
Veduta di Murano. 48.

BIBLIOGRAPHY: Morassi, no. 36; Szabo, *Venetian Drawings*, no. 17.

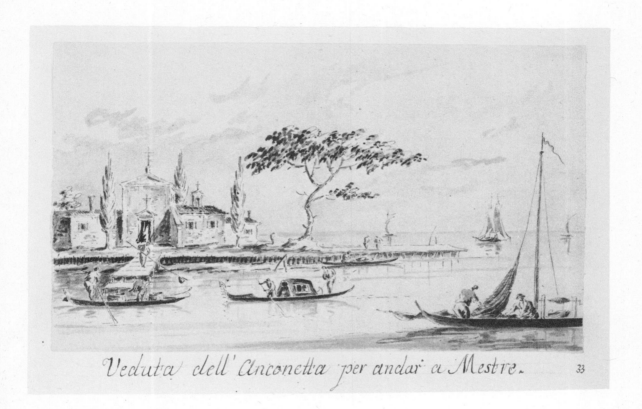

Veduta dell' Anconetta per andar a Mestre. 33

GIACOMO GUARDI, Venice, 1764–1835

50. *View of the Pier at Mestre*

Pen and ink with gray wash on paper, 12.4 x 21.1 cm. Inscribed and numbered below by the artist:
Veduta dell'Anconetta per andar a Mestre. 33.

BIBLIOGRAPHY: Morassi, no. 38.

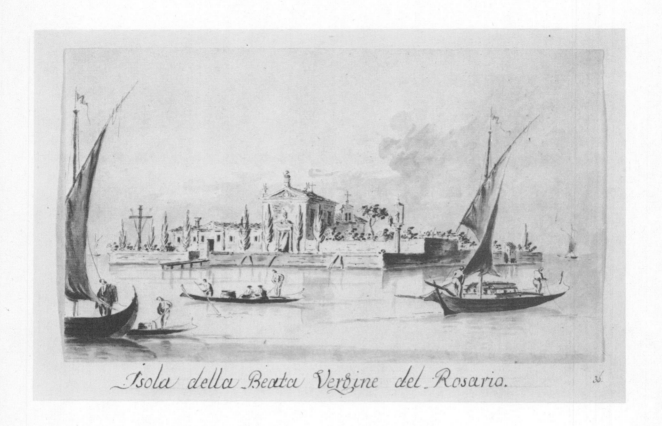

Isola della Beata Vergine del Rosario. 36

GIACOMO GUARDI, Venice, 1764–1835

51. *View of the Island of Beata Vergine del Rosario*

Pen and ink with gray wash on paper, 13.5 x 21.3 cm. Inscribed and numbered below by the artist:
Isola della Beata Vergine del Rosario. 36.

BIBLIOGRAPHY: Morassi, no. 39.

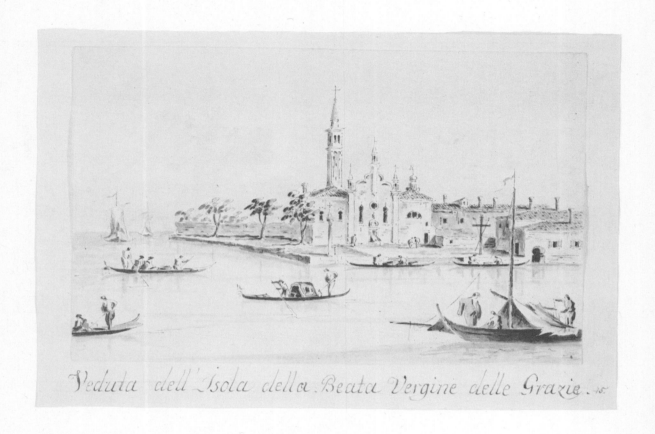

Veduta dell'Isola della Beata Vergine delle Grazie. 45.

GIACOMO GUARDI, Venice, 1764–1835

52. *View of the Island of Beata Vergine delle Grazie*

Pen and ink with gray wash on paper, 11.4 x 18.4 cm. Inscribed and numbered below by the artist:
Veduta dell'Isola della Beata Vergine delle Grazie. 45.

BIBLIOGRAPHY: Morassi, no. 40.

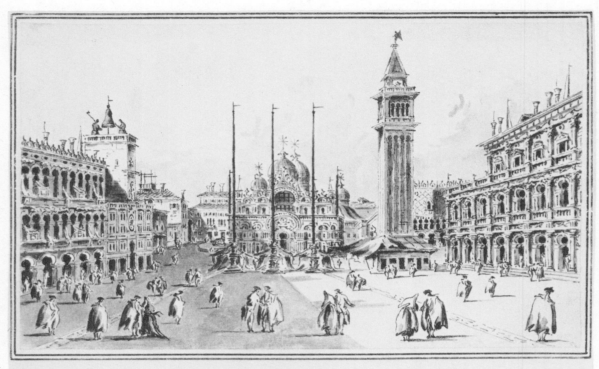

Piazza di S: Marco. no. 1

GIACOMO GUARDI, Venice, 1764–1835

53. *View of the Piazza di San Marco*

Pen and ink with brownish gray wash on paper, 12.7 x 22.5 cm. Inscribed and numbered below by the artist: *Piazza di S: Marco. No. 1.*

BIBLIOGRAPHY: Morassi, no. 121.

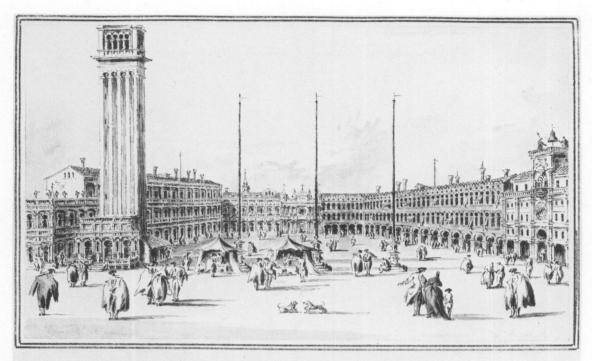

Veduta di S. Giminiano.

No. 2

GIACOMO GUARDI, Venice, 1764–1835

54. *View of San Gimignano on the Piazza di San Marco*

Pen and ink with brownish gray wash on paper, 12.7 x 22 cm. Inscribed and numbered below by the artist: *Veduta di S: Giminiano. No. 2.*

BIBLIOGRAPHY: Morassi, no. 122.

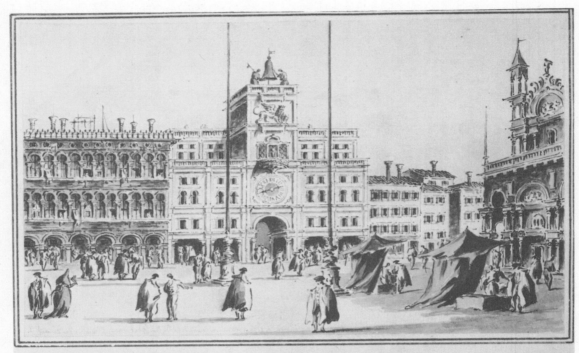

Veduta dell' Orologio.

3

GIACOMO GUARDI, Venice, 1764–1835

55. *View of the Torre dell' Orologio*

Pen and ink with brownish gray wash on paper, 12.7 x 21.5 cm. Inscribed and numbered below by the artist: *Veduta dell' Orologio. 3.*

BIBLIOGRAPHY: Morassi, no. 123.

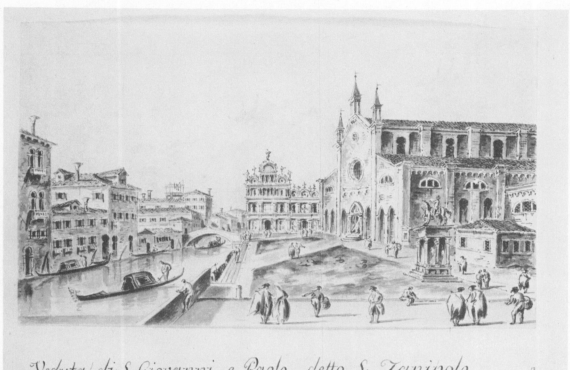

Veduta di S. Giovanni e Paolo, detto S. Zanipolo.

GIACOMO GUARDI, Venice, 1764–1835

56. *View of the Church of San Giovanni e Paolo, called San Zanipolo*

Pen and ink with brownish gray wash on paper, 12.3 x 21.5 cm. Inscribed and numbered below by the artist: *Veduta di S: Giovanni e Paolo, detto S: Zanipolo. 13.*

BIBLIOGRAPHY: Morassi, no. 124; Szabo, *Venetian Drawings*, no. 14.

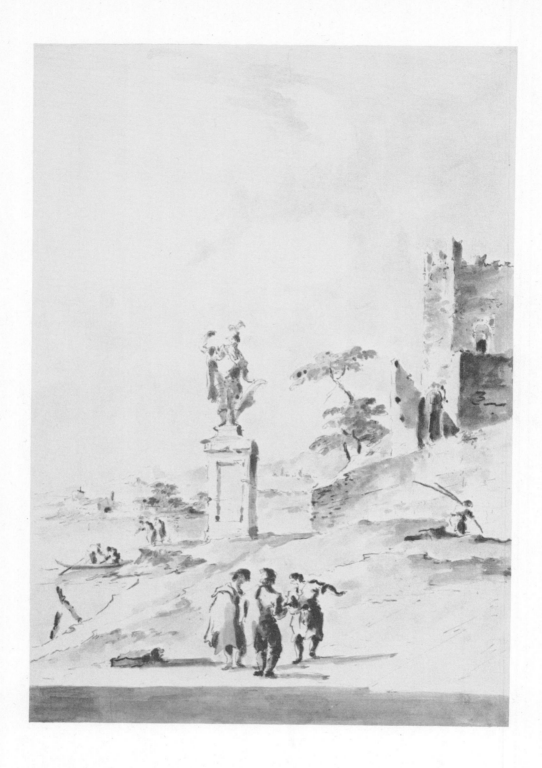

GIACOMO GUARDI, Venice, 1764–1835

57. *Sketch with a Castle Ruin and Macchiette Figures*

Pen and ink with gray wash on paper, 45.5 x 30.5 cm.

BIBLIOGRAPHY: J. Byam Shaw, *Drawings of Francesco Guardi*, London, 1951, p. 51; Morassi, no. 41.

This drawing shows the influence of Francesco Guardi, but the *macchiette* figures are heavier and the wash is not as refined. Morassi dates the work to the last decade of the eighteenth century.

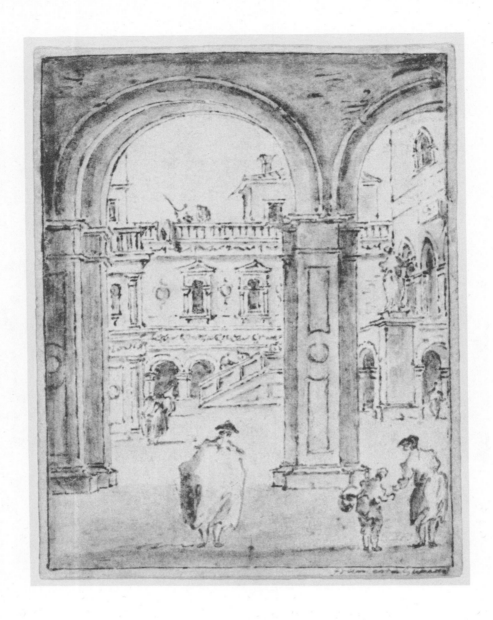

GIACOMO GUARDI, Venice, 1764–1835

58. *The Courtyard of the Palazzo Ducale*

Pen and ink with brown wash on paper, 14 x 10.2 cm. Inscribed in Giacomo's hand in lower right corner: *Francesco Guardi*.

BIBLIOGRAPHY: Morassi, no. 42.

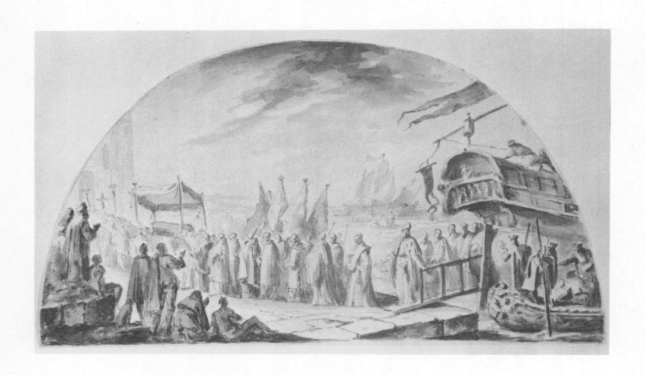

JACOPO MARIESCHI, Venice, 1711–1794

59. *The Transfer of the Relics of St. John to Venice*

Pen and ink with gray wash on paper, 22.7 x 41.5 cm.

BIBLIOGRAPHY: Morassi, no. 43.

This drawing is a study for a fresco painted into a lunette in a chapel of the Church of San Giovanni in Bragora, Venice. As the fresco is dated 1743, the drawing must have been made shortly before that date.

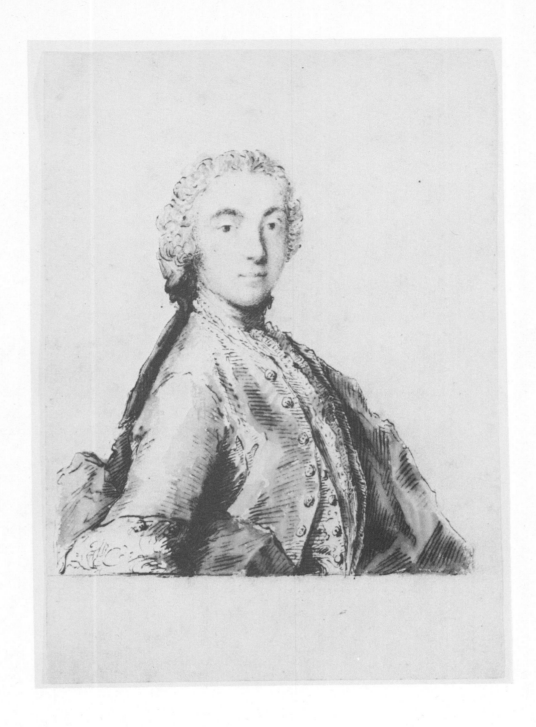

PIETRO ANTONIO NOVELLI, Venice, 1729–1804

60. *Portrait of a Young Nobleman*

Pen and brown ink with sepia and gray washes on paper, 16.7 x 11.7 cm.

BIBLIOGRAPHY: Morassi, no. 49; Szabo, *Venetian Drawings*, no. 19.

This sensitive drawing is probably a preliminary study for a portrait, but it is not known whether the intended work was a miniature painting or an engraving. However, the delicate stippling on the face and the fact that no portrait miniatures by Novelli are known would seem to favor the latter. The style of the costume indicates a date around 1780.

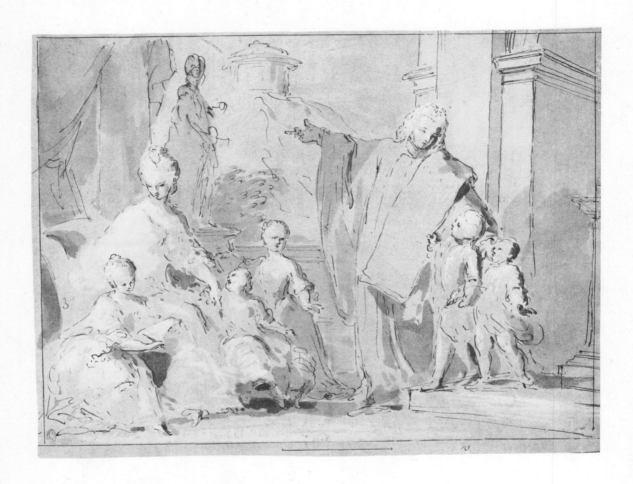

PIETRO ANTONIO NOVELLI, Venice, 1729–1804

61. *Study for a Family Portrait*

Pen and brown ink with sepia wash and white highlights on brown paper, 29.7 x 37.5 cm. Inscribed in an early-nineteenth-century hand: *10*.

BIBLIOGRAPHY: Morassi, no. 46; Szabo, *Venetian Drawings*, no. 18.

Morassi remarks that this study is in the manner of the eighteenth-century English conversation pieces. The father, possibly a Venetian senator, explains to his two sons the beauty and goodness of the classical heritage, personified by the statue of Minerva and the round tempietto in the background. At the left, the mother listens to her eldest daughter reading. It is not known whether Novelli used this study for a painting. From the style of the costume it may be dated to the 1780s.

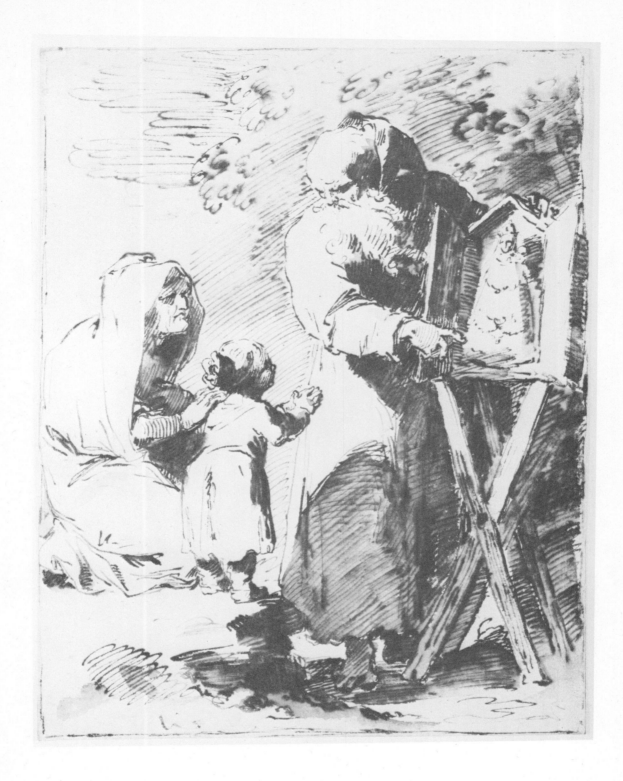

PIETRO ANTONIO NOVELLI, Venice, 1729–1804

62. *A Monk Displaying a Madonna Shrine to a Praying Old Woman and Child*

Pen and brown ink with sepia wash on paper, 26.6 x 20 cm.

BIBLIOGRAPHY: Morassi, no. 47; Szabo, *Venetian Drawings*, no. 21.

This inventive and dramatic drawing is also an interesting document of Venetian religious life and piety. Little tabernacles like the one represented here can still be seen affixed to houses in Venice.

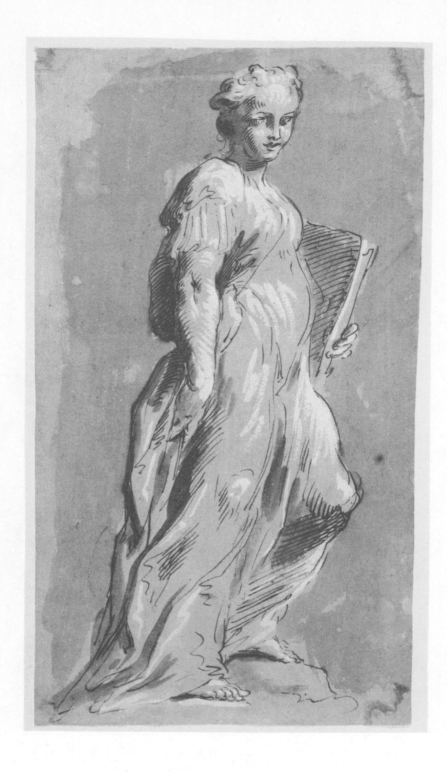

PIETRO ANTONIO NOVELLI, Venice, 1729–1804

63. *Draped Female Figure with Book*

Pen and ink with sepia wash and white highlights on yellowish paper, 33 x 18 cm.

BIBLIOGRAPHY: Morassi, no. 45.

Morassi remarks that this animated drawing is in the manner of Parmigianino, who became popular in the eighteenth century, and is related to certain sheets by that artist. Novelli reached back to the tradition of earlier masters in other cases as well, and is credited with arousing interest in the art of Rembrandt, whose etchings he studied.

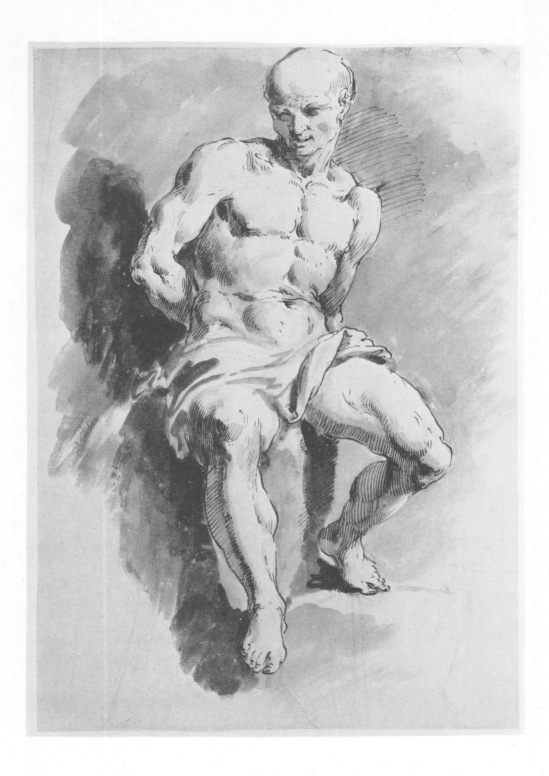

PIETRO ANTONIO NOVELLI, Venice, 1729–1804

64. *Study of a Seated Slave*

Pen and ink with sepia wash and white highlights on brown paper, 46 x 31 cm.

Unpublished.

This is a study after a figure on Pietro Tacca's monument of 1624 in Livorno, honoring Ferdinand I. It is possible that Novelli made the drawing from a small bronze version or a plaster cast.

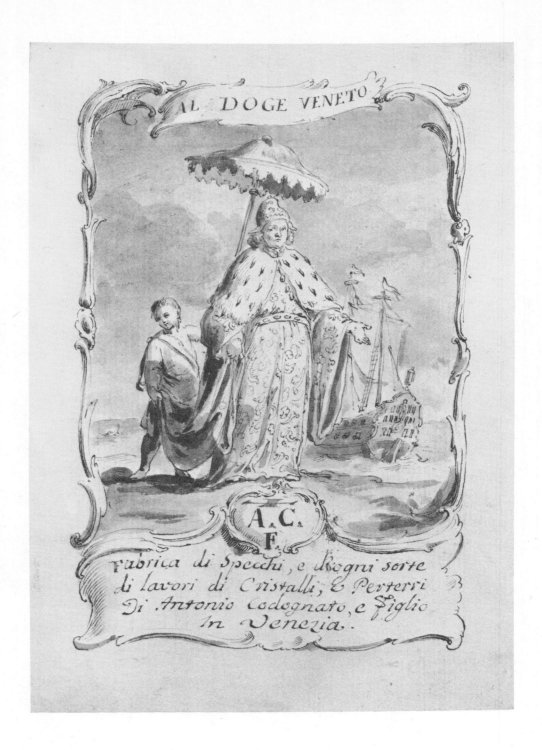

PIETRO ANTONIO NOVELLI, Venice, 1729–1804

65. *Study for the Sign of a Venetian Mirror Factory*

Pen and ink with sepia wash on paper, 22.5 x 15.5 cm. Inscribed within the drawing above: *AL DOGE VENETO*. Also inscribed below: *A. C. F. Fabrica di Specchi, e d'ogni sorte di Lavori di Cristalli, e Perterri Di Antonio Codognato, e Figlio in Venezia.*

BIBLIOGRAPHY: Morassi, no. 48; Szabo, *Venetian Drawings*, no. 20.

This study is a rare document of Venetian art and industry and of the cooperation between the artists and artisans of the city. The design was probably transferred onto a large sign made of wood or metal. The firm of Antonio Codognato and Son produced the mirrors and other works made of crystal for which the city had been justly famous since the Middle Ages.

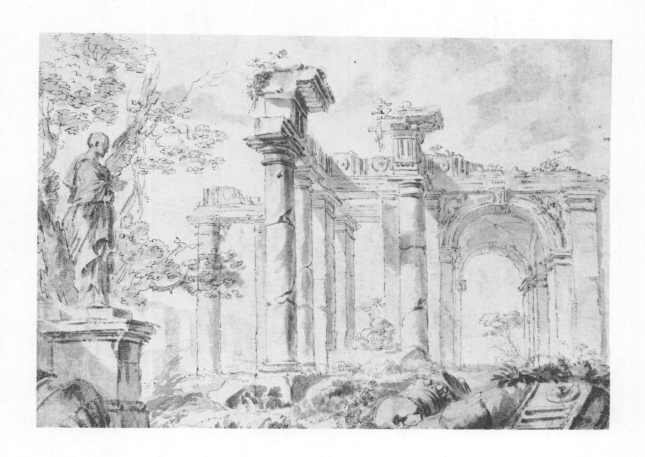

GIOVANNI PAOLO PANNINI, Piacenza, Rome, 1691–1765

66a. *Landscape with Statue and Ruins*

Pen and brush with tinted ink washes on paper, 18.4 x 26.2 cm. On the verso: No. 66b.
Unpublished.

This prolific painter produced many similar pictures of elaborate landscapes with ruins and
sculptures. However, none of the paintings can be connected with this drawing or with the one
on the verso.

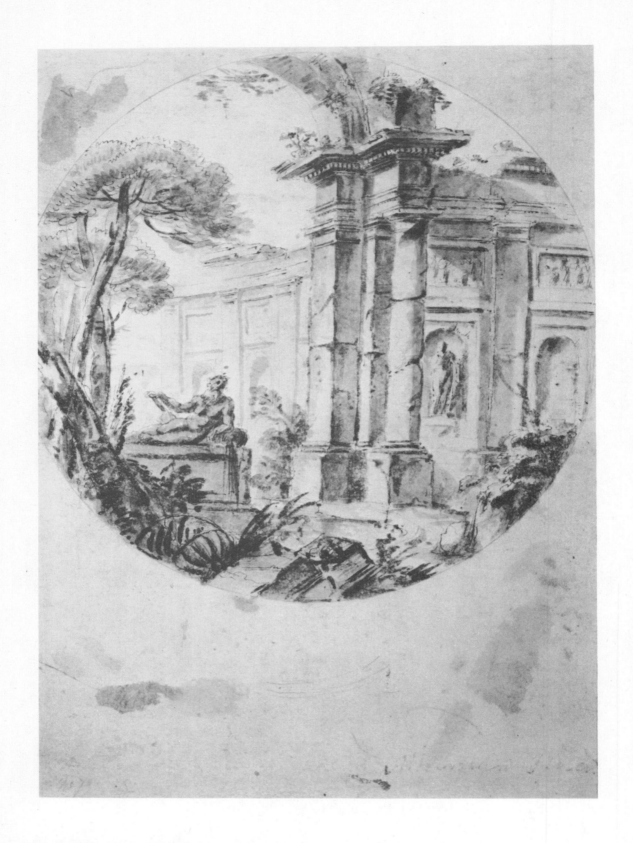

GIOVANNI PAOLO PANNINI, Piacenza, Rome, 1691–1765

66b. *Ruins with a Statue*

Pen and brush with tinted washes in tondo form on paper, 26.2 x 18.4 cm. The faint inscription in lower right corner is illegible. Verso of No. 66a.

Unpublished.

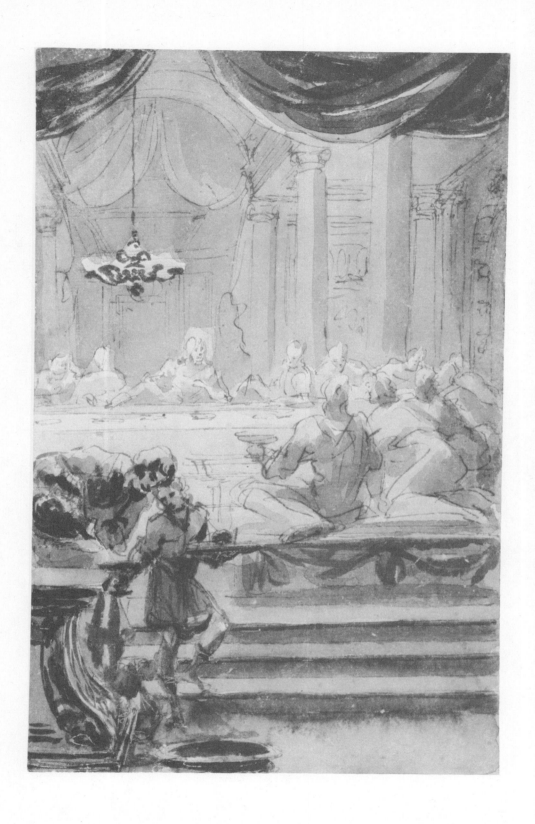

GIOVANNI ANTONIO PELLEGRINI, Venice, 1675–1741

67. *Study for a Last Supper*

Pen and ink with sepia and bister washes on paper, 27.1 x 16.9 cm.

BIBLIOGRAPHY: Morassi, no. 50.

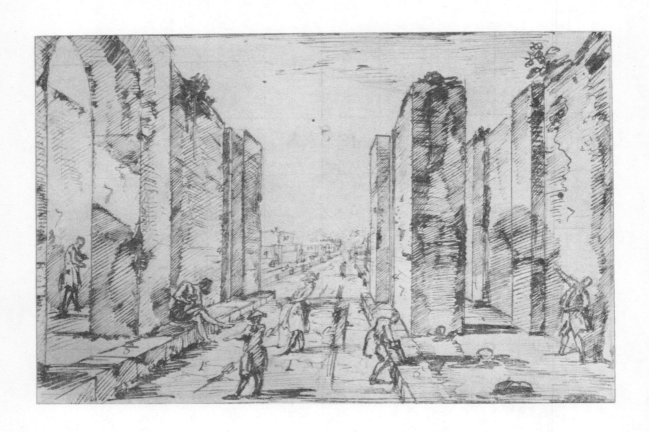

GIOVANNI BATTISTA PIRANESI, Mogliano (near Mestre), Venice, Rome, 1720–1778

68. *View of Pompeii*

Pen and ink on paper, 27.6 x 41.9 cm. Inscribed with numbers on various parts of the drawing.
Unpublished.

This drawing is from one of the many trips Piranesi made to Pompeii between 1770 and 1778.

MARCO RICCI, Belluno, Venice, 1676–1730

69. *The House of Marco Ricci*

Pen and ink with sepia wash on paper, 37 x 49.6 cm. On the verso, an inscription from 1726 (see below).

BIBLIOGRAPHY: Morassi, no. 51; Szabó, *Venetian Drawings*, no. 22.

The inscription on the verso states that this is "the house of Sign.r Marco Ricci in the Bellunese among the mountains: with a view of an adjacent monastery. Taken by Sig.r Marco Ricci and given on the spot to Humphrey Mildmay, Esq.r. An. 1726." Apparently, the drawing was made by the artist on the spot and given to Mildmay. It is not clear, however, whether the house is the artist's birthplace or rather one he owned in 1726.

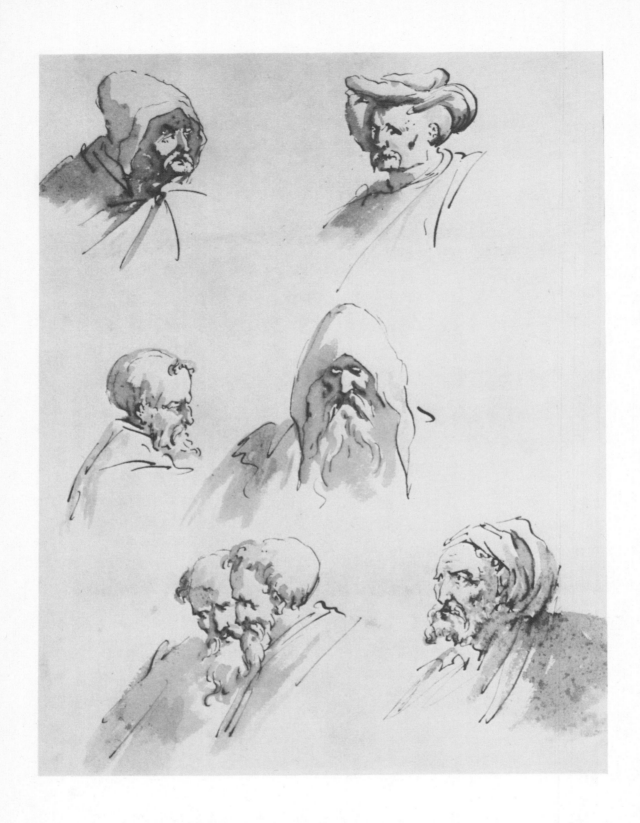

SEBASTIANO RICCI, Belluno, Venice, 1659–1734

70. *Studies of Seven Male Heads*

Pen and ink with wash on paper, 23.5 x 17.6 cm.

Unpublished.

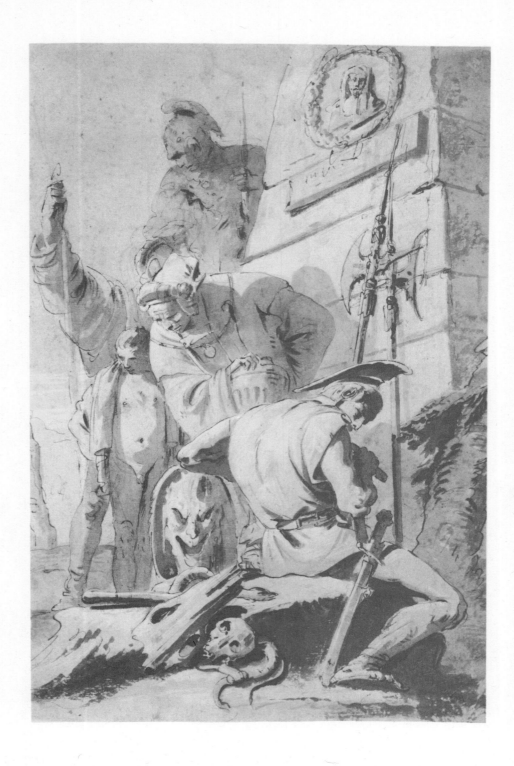

GIAMBATTISTA TIEPOLO, Venice, Madrid, 1696–1770

71. *Allegory with Figures Around a Pyramid*

Pen and ink with brown wash heightened with white over black chalk on paper, 42.1 x 27.5 cm.

BIBLIOGRAPHY: Morassi, no. 52; Bean-Stampfle, no. 59; *The Tiepolos*, no. 30.

Morassi regards this dramatic drawing as an early work by Giambattista and dates it around 1725. The pyramid is often represented in Tiepolo's later works. Sometimes it signifies Africa, but here it is probably connected with the symbolism of rulers and power (see M. Santifaller, "Die Gruppe mit der Pyramide in Giambattista Tiepolos Treppenhausfresko der Residenz zu Würzburg," *Münchner Jahrbuch der Bildenden Kunst* 26 [1975], pp. 193–207).

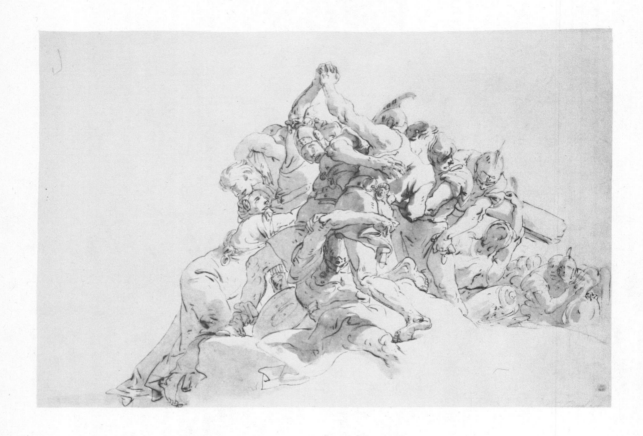

GIAMBATTISTA TIEPOLO, Venice, Madrid, 1696–1770

72. *Group of Fighting Warriors*

Pen and ink with brown wash over black chalk on paper, 35.7 x 53 cm. Inscribed in black chalk in lower right corner: *Tiepolo f.*

BIBLIOGRAPHY: Morassi, no. 53; Bean-Stampfle, no. 60.

This vigorous and dense drawing is probably related to ten scenes of Roman history that Tiepolo painted for the Ca'Dolfin in Venice in the mid-1720s (three are now in The Metropolitan Museum of Art). It has been remarked that "in this important early drawing Giambattista's contour line has an almost brutal incisiveness" (Bean-Stampfle, p. 41).

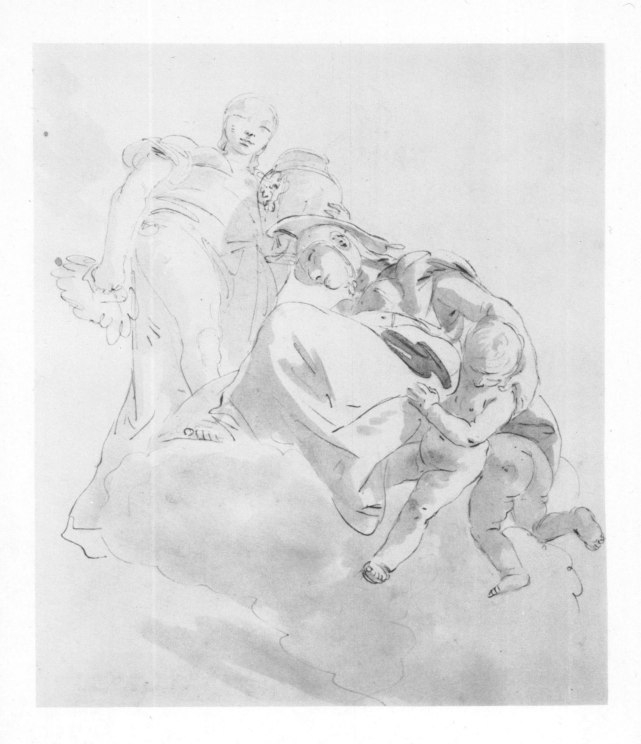

GIAMBATTISTA TIEPOLO, Venice, Madrid, 1696–1770

73. *Allegory with Minerva, Fame, and a Putto*

Pen and ink with sepia wash over pencil on paper, 30.5 x 25.5 cm.

BIBLIOGRAPHY: Morassi, no. 54.

This is probably a first sketch for a ceiling fresco, apparently never executed. Morassi compares it to the now destroyed frescoes of the Palazzo Archinto in Milan, which were painted around 1731.

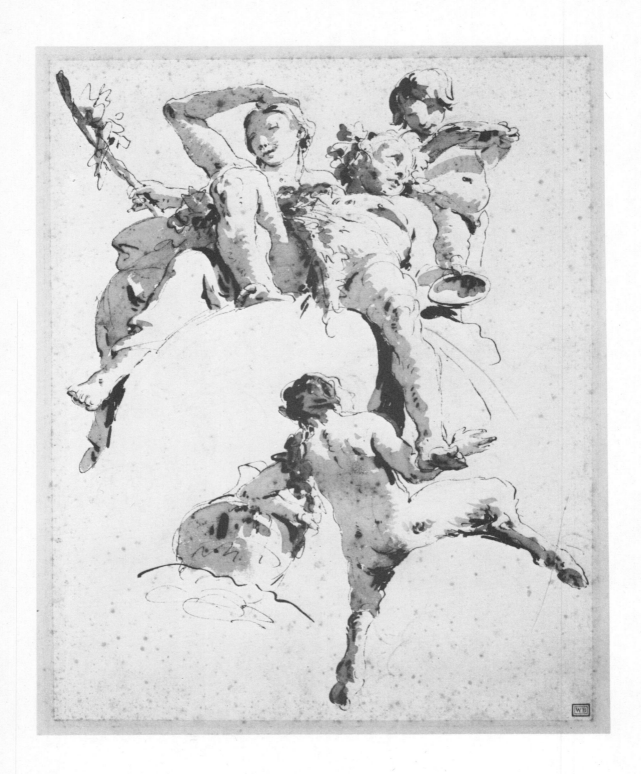

GIAMBATTISTA TIEPOLO, Venice, Madrid, 1696–1770

74. *Bacchus and Ariadne*

Pen and ink with brown wash over black chalk on paper, 31.1 x 24.1 cm.

BIBLIOGRAPHY: Paris, no. 128; Cincinnati, no. 226; Bean-Stampfle, no. 112.

"This justly celebrated drawing" is associated with various frescoes by the artist dated between 1740 and 1744. The style of the wash suggests the earlier date and a closer affinity to the artist's work in the Palazzo Clerici in Milan.

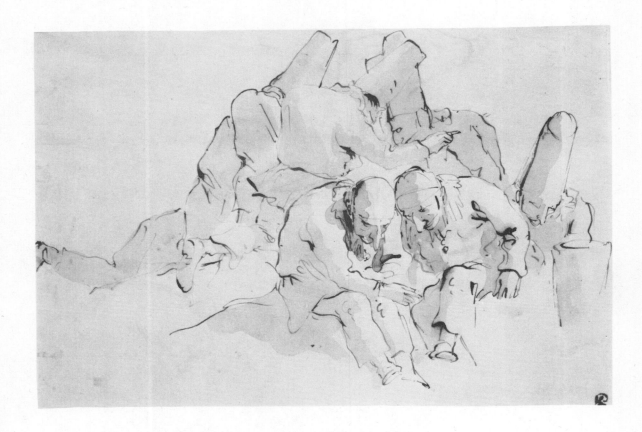

GIAMBATTISTA TIEPOLO, Venice, Madrid, 1696–1770

75. *Group of Seated Punchinelli*

Pen and ink with sepia wash over pencil on paper, 19.4 x 28.5 cm.

BIBLIOGRAPHY: Morassi, no. 71; *The Tiepolos*, no. 64; *Punchinello Drawings*, fig. 4.

This and other Punchinello drawings by Giambattista are usually dated between 1735 and 1740. They have the satirical manner of his caricatures of the same time. Many of these studies were used by his son Giandomenico for his famous series *Divertimento per li regazzi*, nine of which are also in this exhibition (Nos. 130–138).

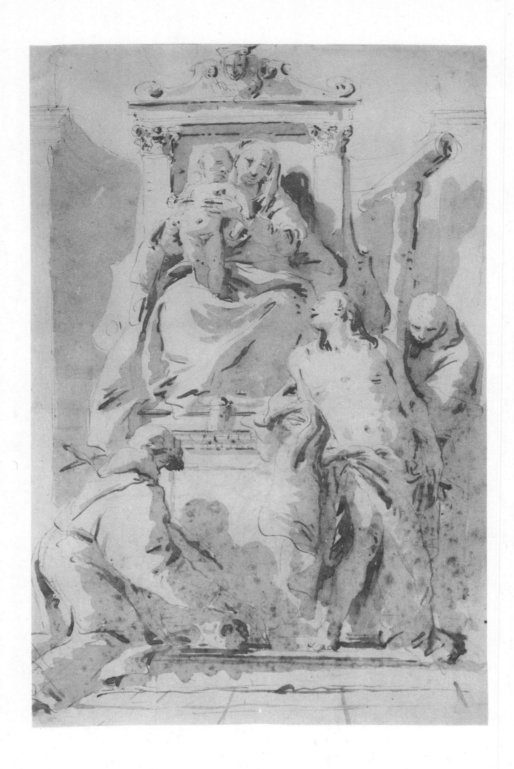

GIAMBATTISTA TIEPOLO, Venice, Madrid, 1696–1770

76. *Enthroned Virgin and Child Attended by St. Sebastian, St. Francis, and St. Anthony*

Pen and ink with brown wash over black chalk on paper, 45.6 x 30 cm.

BIBLIOGRAPHY: D. von Hadeln, *The Drawings of G. B. Tiepolo*, vol. 1, Paris, 1928, no. 43; Morassi, no. 56; G. Knox, "The Orloff Album of Tiepolo Drawings," *Burlington Magazine* 103 (1961), pp. 273–74, no. 10; Bean-Stampfle, no. 70; *The Tiepolos*, no. 44.

This is another fine drawing of rich texture and virtuoso draftsmanship without any relationship to known paintings by the artist. It is dated between 1735 and 1740 with other similar compositions representing the Virgin and Child or the Holy Family (see Morassi, pp. 43–44).

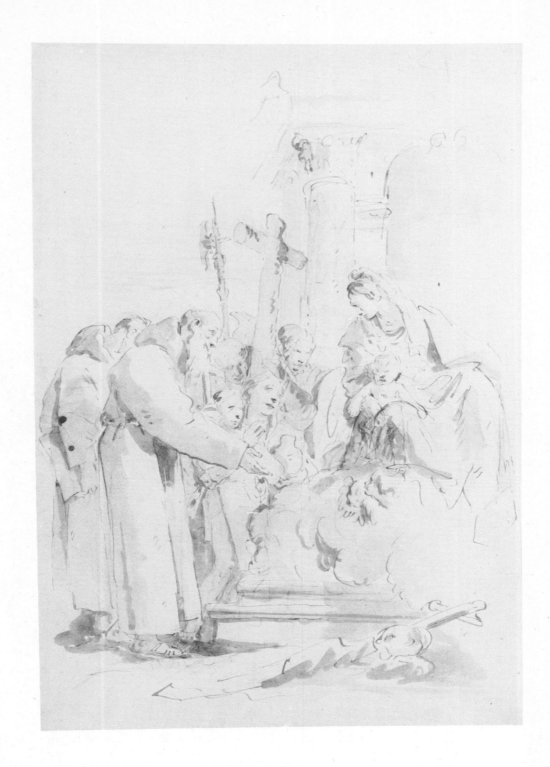

GIAMBATTISTA TIEPOLO, Venice, Madrid, 1696–1770

77. *Enthroned Madonna and Child with a Group of Worshipers*

Pen and ink with brown wash over black chalk, 41.6 x 28.6 cm. Partly erased number at upper right: *98*.

BIBLIOGRAPHY: Morassi, no. 55; G. Knox, "The Orloff Album of Tiepolo Drawings," *Burlington Magazine* 103 (1961), pp. 273–74, no. 14; Bean-Stampfle, no. 72.

This large-scale drawing is apparently not related to any known work by Tiepolo. Morassi dates it between 1730 and 1735, which is early, according to authors of more recent publications.

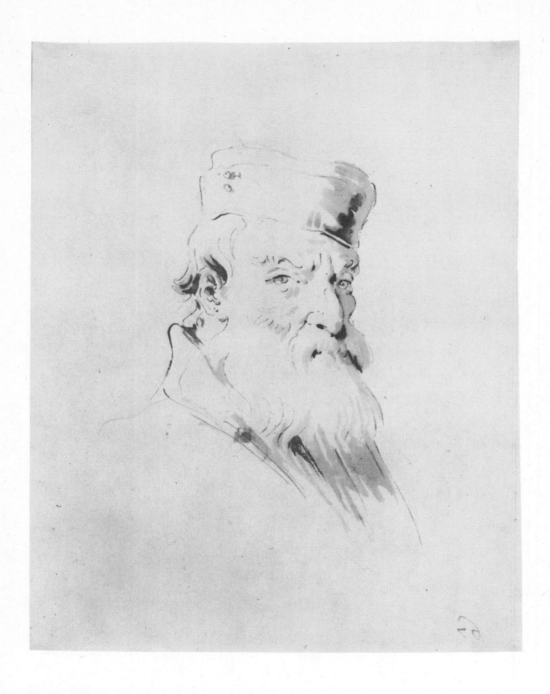

GIAMBATTISTA TIEPOLO, Venice, Madrid, 1696–1770

78. *Head of a Bearded Old Man*

Pen and ink with sepia wash over preliminary pencil drawing on paper, 29.2 x 20.5 cm. Inscribed in an eighteenth-century hand at lower left: *67.*

BIBLIOGRAPHY: Morassi, no. 58; Szabo, *Venetian Drawings*, no. 23.

This drawing was part of an album Tiepolo gathered and later presented to his son Giuseppe Maria Tiepolo, a priest. The history of the album is described in a note by an English collector, Edward Cheney, who acquired it in 1842 in Venice: "This collection was made by G. B. Tiepolo himself and given by him to his son for the Library of the Somasco (sic) Convent S. Maria della Salute at Venice in which he was professed. At the suppression of the Convents the volumes fell into the hands of Cicognara by whom they were given in an exchange to Canova from whom they passed after his death to Mons. Canova his brother, by him they were sold to Sig.r Francesco Pesaro and by him to me. E. C. Venice 1842" (The Savile Gallery, *Catalogue of Drawings*, London, 1928).

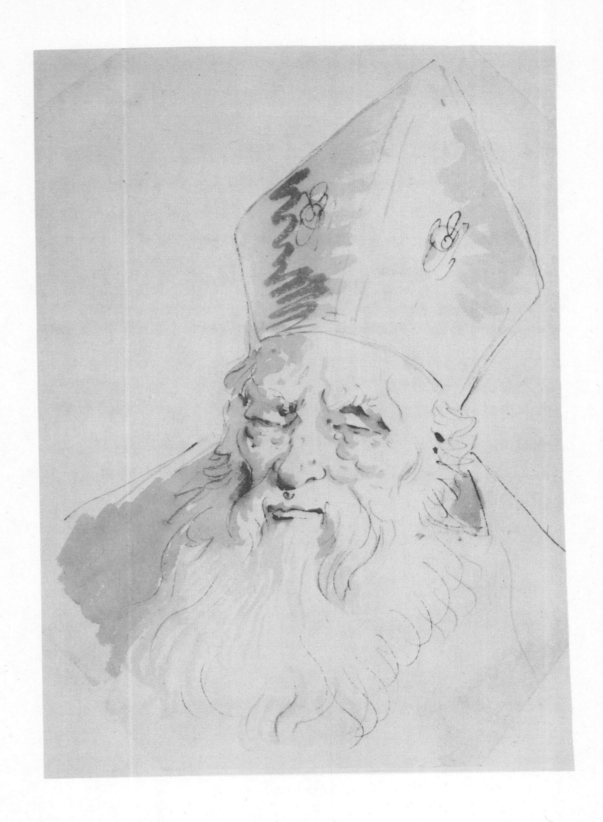

GIAMBATTISTA TIEPOLO, Venice, Madrid, 1696–1770

79. *Head of a Bearded Bishop with Miter*

Pen and ink with sepia wash over preliminary pencil drawing on paper, 21.1 x 14.5 cm.

BIBLIOGRAPHY: Morassi, no. 59.

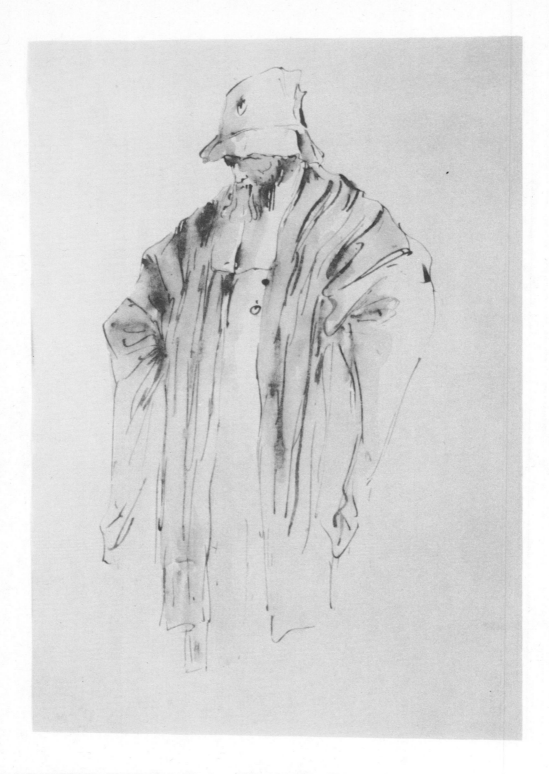

GIAMBATTISTA TIEPOLO, Venice, Madrid, 1696–1770

80. *Standing Man*

Pen and ink with gray wash on paper, 20.3 x 13.7 cm.

BIBLIOGRAPHY: Szabo, *Venetian Drawings*, no. 25.

This and other similar studies of single figures (the one at the Princeton University Art Gallery, for example) may have been part of an album like the one containing drawings by Giambattista labeled *Sole Figure Vestite* and now in the Victoria and Albert Museum. (See G. Knox, "Drawings by Giambattista and Domenico Tiepolo at Princeton," *Record of the Art Museum, Princeton University* 23 [1964], p. 10.)

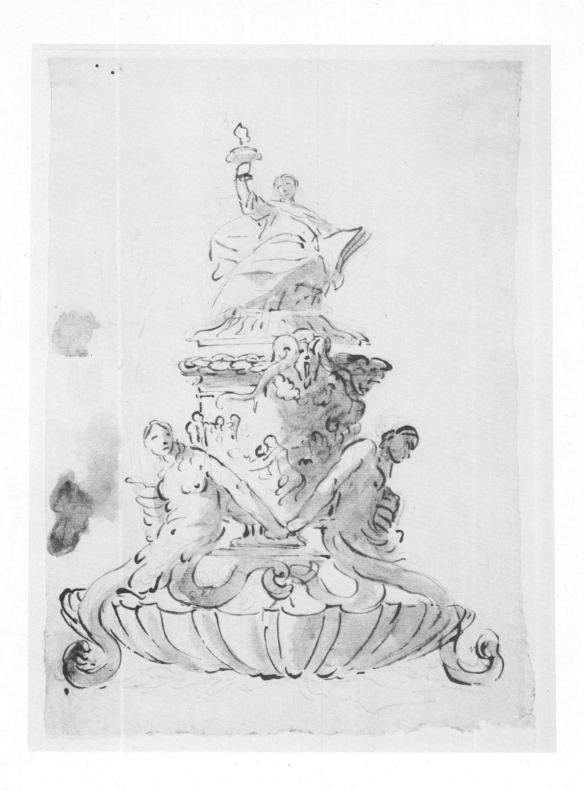

GIAMBATTISTA TIEPOLO, Venice, Madrid, 1696–1770

81. *Study of an Inkwell*

Pen and ink with gray wash over preliminary pencil drawing on paper, 45 x 29.5 cm.

BIBLIOGRAPHY: Morassi, no. 89; *The Tiepolos*, no. 31.

Morassi describes the subject of this drawing as a fountain. However, in a lecture in 1976, Janos Scholz identified it as an inkwell and described the drawing as a design for a cast-bronze object. It is generally accepted that the figure at the top symbolizes the art of painting.

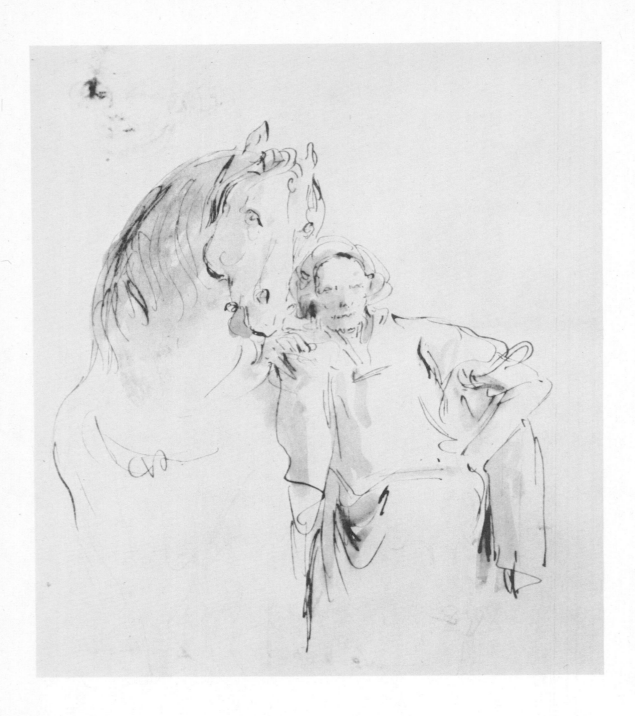

GIAMBATTISTA TIEPOLO, Venice, Madrid, 1696–1770

82a. *Man Leaning on a Horse*

Pen and ink with gray wash over preliminary pencil drawing on paper, 19.5 x 16.5 cm. On the verso: No. 82b.

BIBLIOGRAPHY: L. Fröhlich-Bum, "Four Unpublished Drawings by G. B. Tiepolo," *Apollo* 66 (1957), no. 391, pp. 56–57; Morassi, no. 62; Pignatti, no. 76; Szabo, *Venetian Drawings*, no. 24.

This is probably the first study for a fresco in the Villa Valmarana in Vicenza (see A. Morassi, *La Villa Valmarana*, Milan, 1944, pl. 9). Since the painting of this villa was begun by the two Tiepolos in 1757, the drawing may be dated to the same year or shortly before. The figure is in the scene called "Angelica Helps Medoro" in the so-called Gerusalemme Liberata Room of the villa, which received its name from Torquato Tasso's famous work (R. Pallucchini, *Gli Affreschi di G. B. e D. Tiepolo alla Villa Valmarana di Vicenza*, Bergamo, 1945, pl. 30).

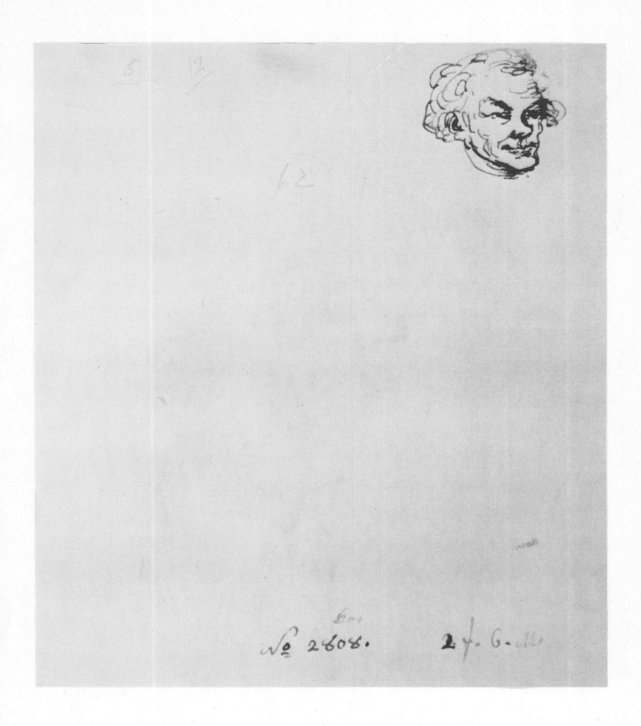

GIAMBATTISTA TIEPOLO, Venice, Madrid, 1696–1770

82b. *Head of a Man*

Pen and ink on paper, 19.5 x 16.5 cm. Inscribed at lower center: *No 2808 2 f G. M.* Verso of No. 82a.

BIBLIOGRAPHY: Morassi, no. 62; Pignatti, no. 76; Szabo, *Venetian Drawings*, no. 24.

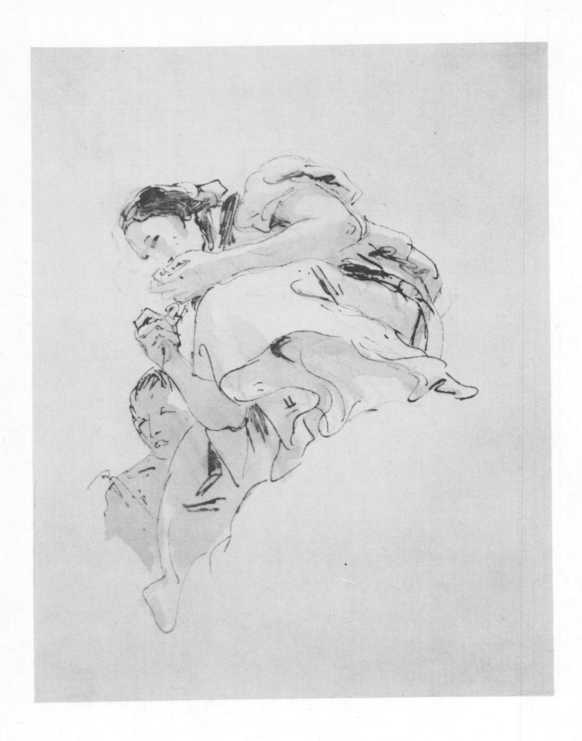

GIAMBATTISTA TIEPOLO, Venice, Madrid, 1696–1770

83. *Figure of a Crouching Woman with a Boy on Her Right*

Pen and ink with sepia wash over pencil on paper, 19.5 x 14.8 cm.

BIBLIOGRAPHY: Morassi, no. 63.

The two figures are represented as seen from below, therefore this and other related studies (Nos. 84–87) must have been made in preparation for frescoes or wall decorations painted on canvas. Morassi dates these nervous and quick drawings between 1755 and 1760.

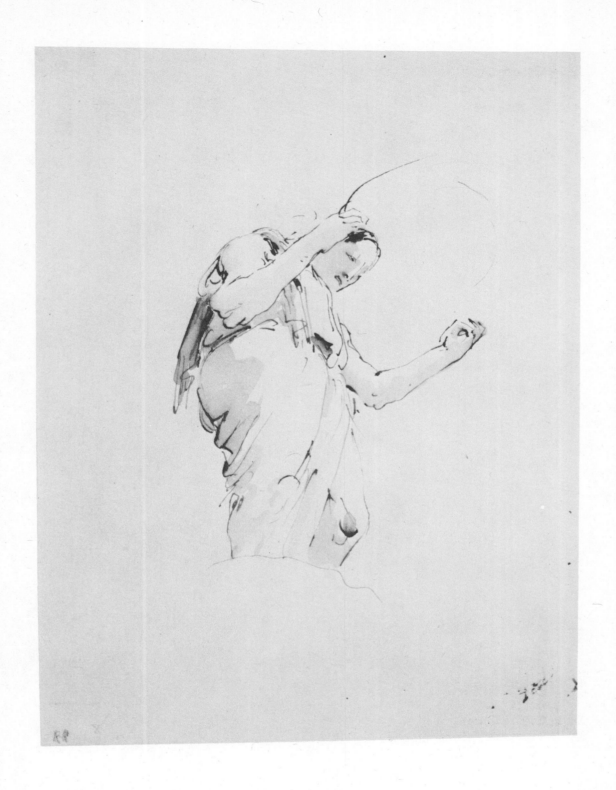

GIAMBATTISTA TIEPOLO, Venice, Madrid, 1696–1770

84. *Figure of a Standing Woman*

Pen and ink with sepia wash over pencil on paper, 21 x 15.6 cm.

BIBLIOGRAPHY: Morassi, no. 65.

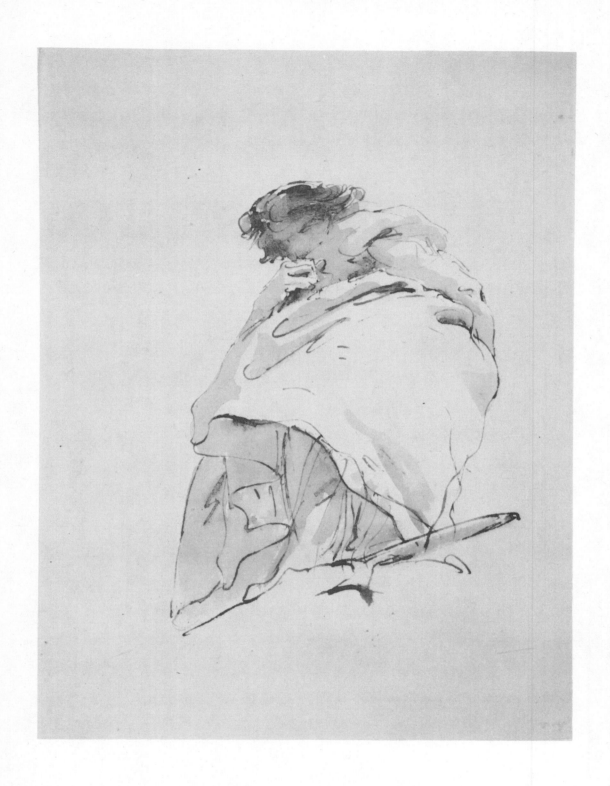

GIAMBATTISTA TIEPOLO, Venice, Madrid, 1696–1770

85. *Study of a Female Figure*

Pen and ink with sepia wash over pencil on paper, 24.7 x 20.1 cm.

BIBLIOGRAPHY: Morassi, no. 64.

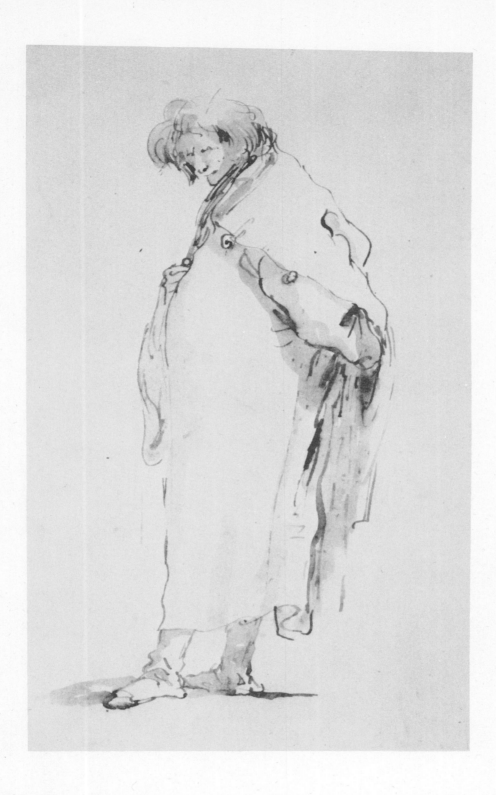

GIAMBATTISTA TIEPOLO, Venice, Madrid, 1696–1770

86. *Figure of a Man with Long Hair*

Pen and ink with gray wash over pencil on paper, 19.2 x 11.5 cm.

BIBLIOGRAPHY: Morassi, no. 67.

This quick drawing is almost like a caricature. However, it is probably a preliminary study for a fresco or wall decoration.

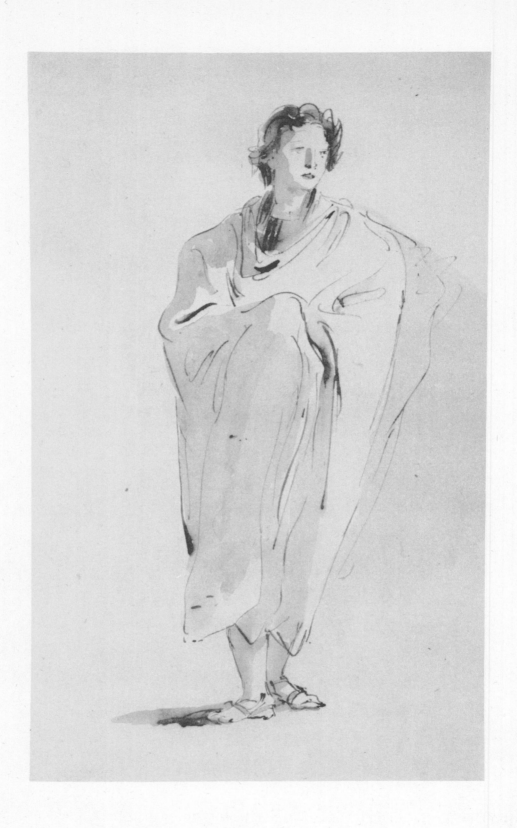

GIAMBATTISTA TIEPOLO, Venice, Madrid, 1696–1770

87. *Study of a Standing Young Man*

Pen and ink with sepia wash over pencil on paper, 20 x 12 cm.

BIBLIOGRAPHY: Morassi, no. 66.

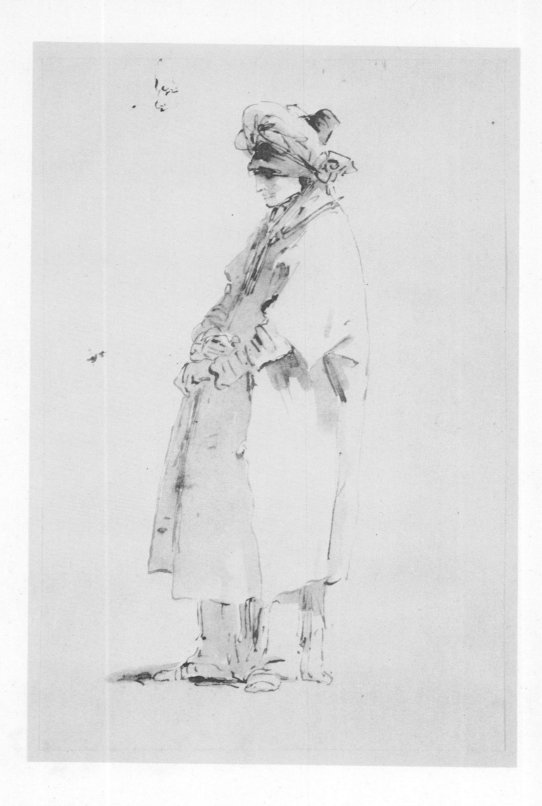

GIAMBATTISTA TIEPOLO, Venice, Madrid, 1696–1770

88. *Study of a Standing Oriental Figure*

Pen and ink with sepia wash over pencil on paper, 22.8 x 14.2 cm.

BIBLIOGRAPHY: Morassi, no. 68.

This drawing belongs to a large group of studies, mostly from nature, representing oriental figures in a style that resembles the drawings and prints of Rembrandt. It is another example of the Dutch master's influence in Venice.

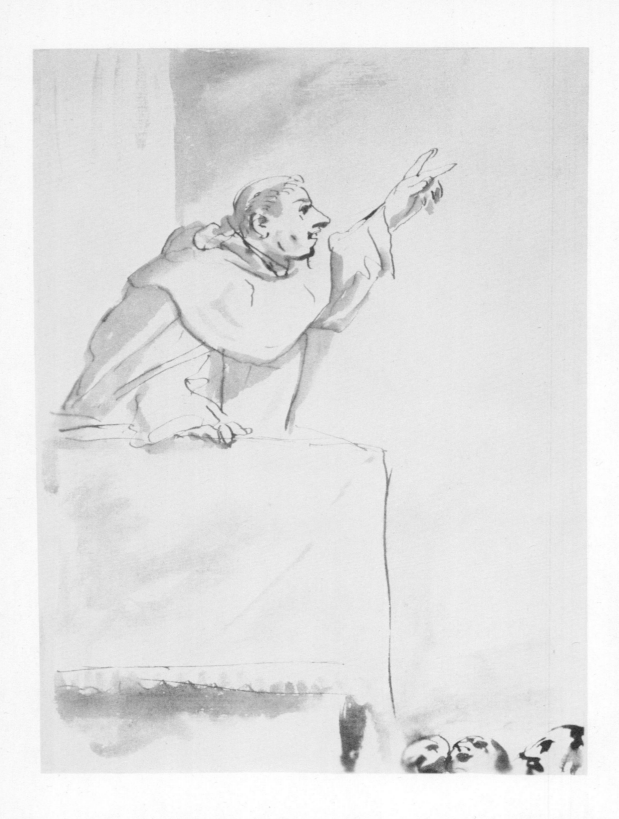

GIAMBATTISTA TIEPOLO, Venice, Madrid, 1696–1770

89. *Study of a Preaching Monk*

Pen and ink with brown wash on paper, 27.3 x 19.3 cm.

Unpublished.

This rapid study is probably from life and approaches the mood of the artist's famous carica-
tures (see Nos. 97–111).

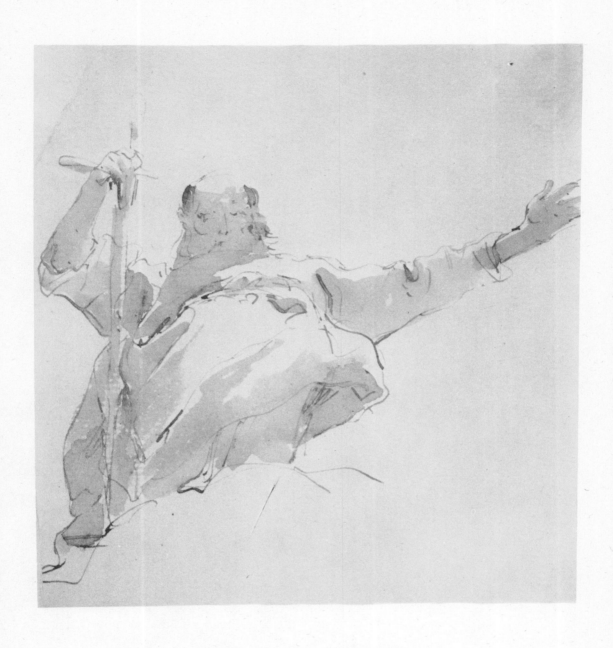

GIAMBATTISTA TIEPOLO, Venice, Madrid, 1696–1770

90. *Old Man with a Staff*

Pen and ink with sepia wash on paper, 17.8 x 16.2 cm.

Unpublished.

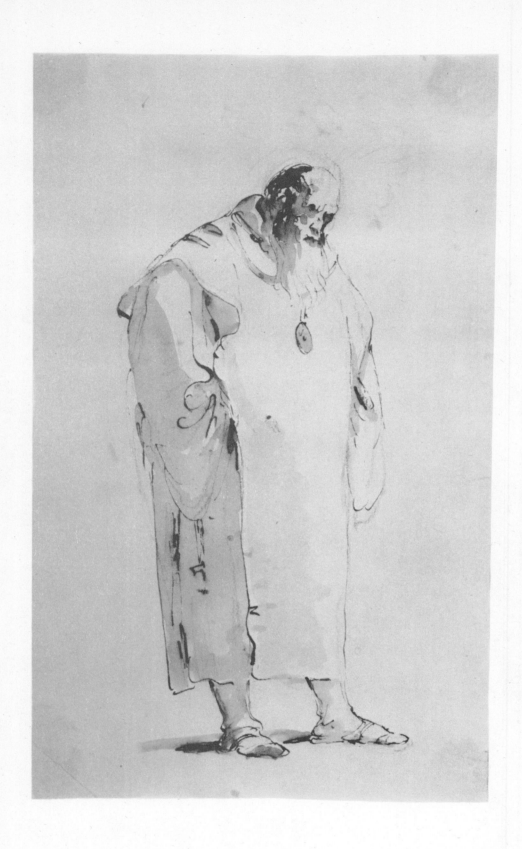

GIAMBATTISTA TIEPOLO, Venice, Madrid, 1696–1770
91. *Study of a Standing Monk*
Pen and brown ink with brown wash over pencil on paper, 22.2 x 14 cm.
Unpublished.

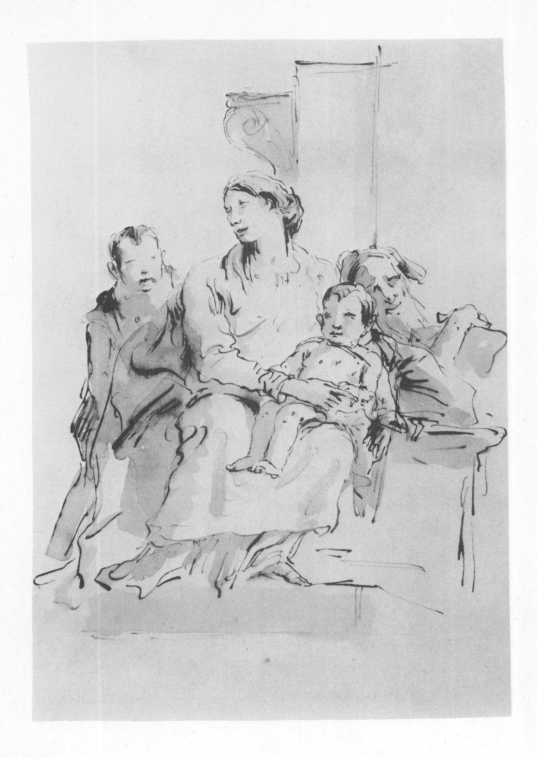

GIAMBATTISTA TIEPOLO, Venice, Madrid, 1696–1770

92. *The Holy Family with an Attendant Boy*

Pen and ink with brown wash on paper, 28.9 x 20 cm. Inscribed in black chalk on the verso:
Giov B. Tiepolo.

BIBLIOGRAPHY: Morassi, no. 70; Bean-Stampfle, no. 132.

Before his departure for Madrid in 1762, Tiepolo made many drawings representing the Holy Family with attendants. Some of these sheets were preserved in an album that was given by the artist to his son Giuseppe Maria, who was in the Somasco Convent in Venice. No. 93 is another version of the subject from the same album.

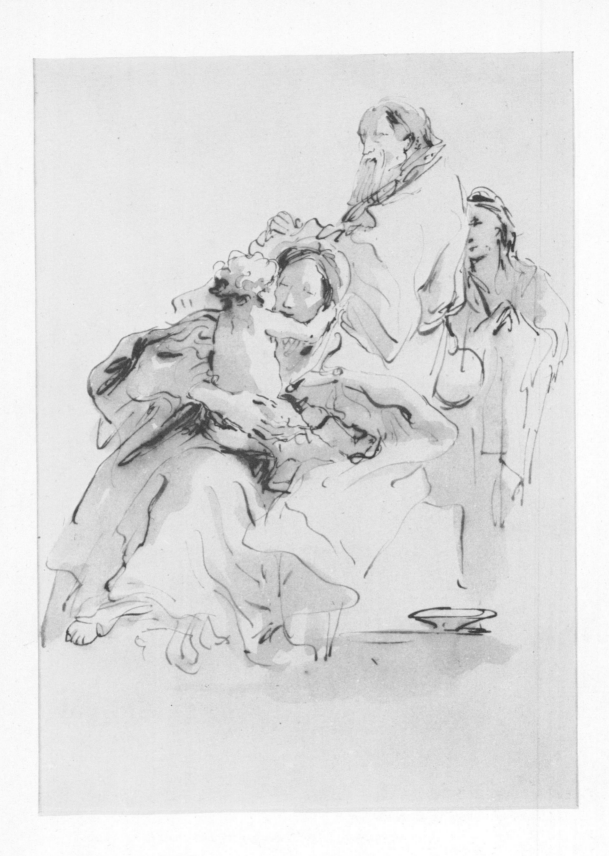

GIAMBATTISTA TIEPOLO, Venice, Madrid, 1696–1770

93. *The Holy Family with St. Joseph Standing and an Attendant*

Pen and ink with brown wash on paper, 29.1 x 20.2 cm.

BIBLIOGRAPHY: Morassi, no. 69; Bean-Stampfle, no. 133; *The Tiepolos*, no. 79.

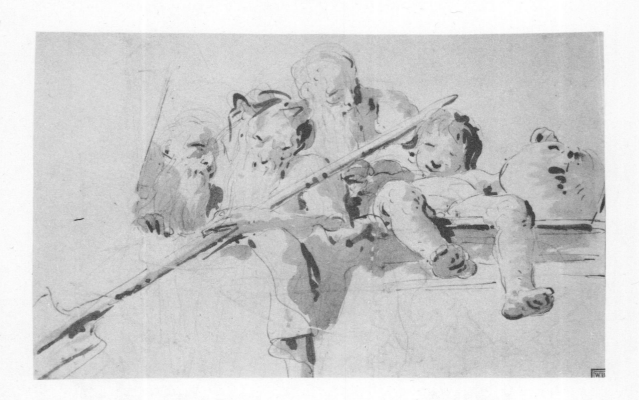

GIAMBATTISTA TIEPOLO, Venice, Madrid, 1696–1770

94. *Neptune, the Young Bacchus, and Two Old Men*

Pen and ink with brown wash over black chalk, 16.8 x 26.7 cm.

BIBLIOGRAPHY: Morassi, no. 57; Bean-Stampfle, no. 122.

This group looking over a balustrade, indicated mostly in black chalk, is probably an "idea" drawing for a fresco. Morassi connects it with those in the Palazzo Clerici in Milan (Morassi, p. 45). Bean and Stampfle suggest an association with the ceiling decorations for the Villa Contarini at Mira, now in the Musée Jacquemart-André in Paris.

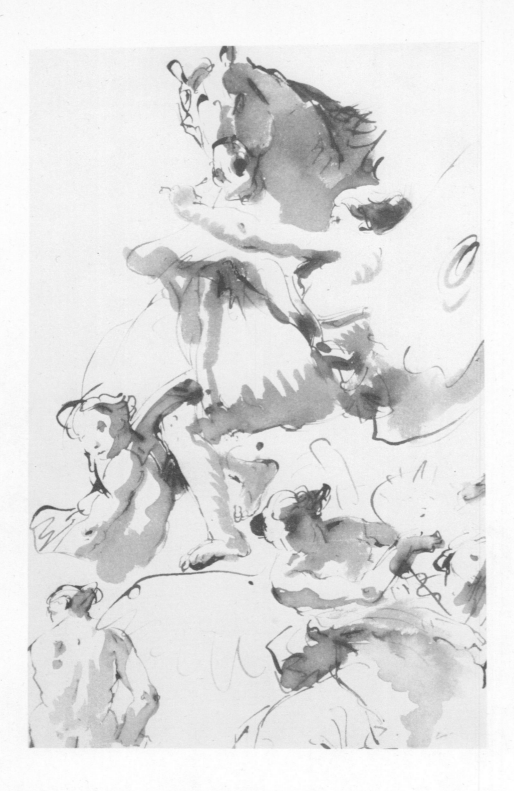

GIAMBATTISTA TIEPOLO, Venice, Madrid, 1696–1770

95. *Zephyr and a Horse*

Pen and ink with gray wash over pencil, 31.5 x 20.1 cm.

BIBLIOGRAPHY: Morassi, no. 88; Pignatti, no. 77.

Pignatti praises this "brilliant sketch" and associates it with the frescoes of the Palazzo Clerici and the Palazzo Labia. He then continues: "Its overwhelming power derives from the contrast between the spaces left blank and dark areas of wash. Its expressiveness is reminiscent of Rembrandt" (Pignatti, p. 40).

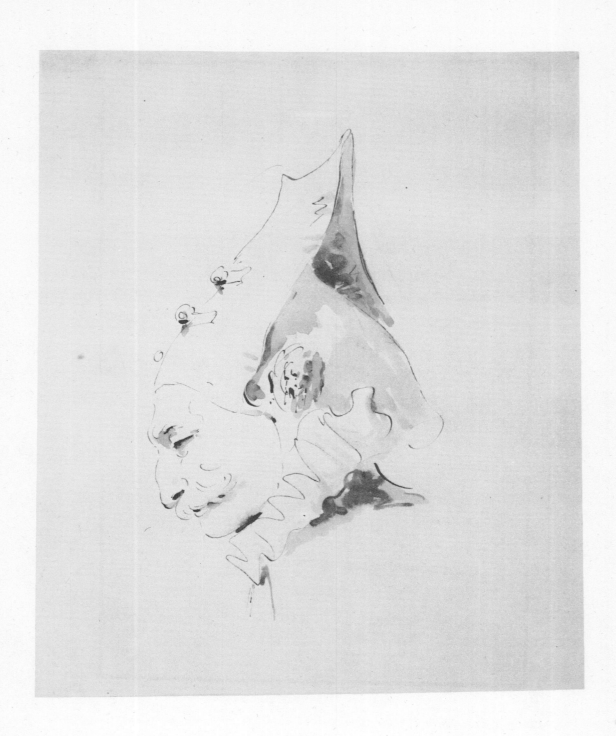

GIAMBATTISTA TIEPOLO, Venice, Madrid, 1696–1770
96. *Head of an Oriental in Profile*
Pen and ink with sepia wash over pencil on paper, 25 x 20 cm.
BIBLIOGRAPHY: Morassi, no. 60.

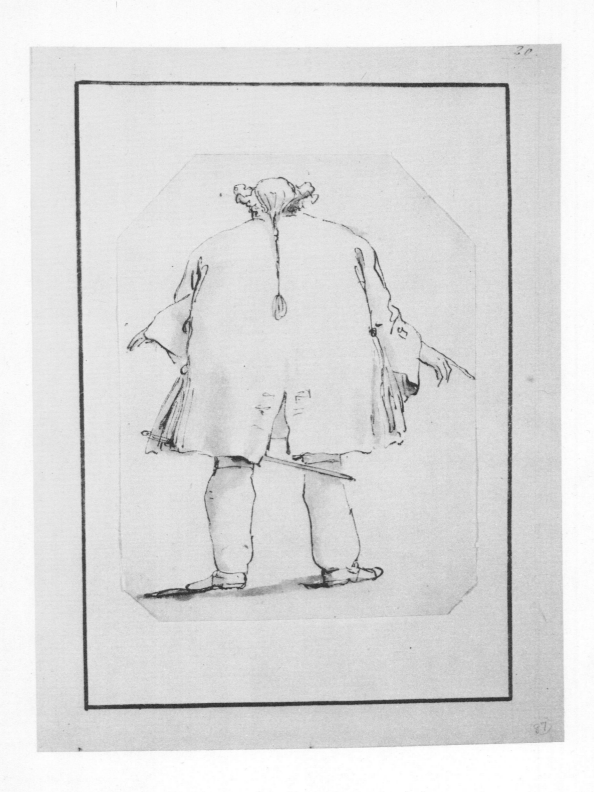

GIAMBATTISTA TIEPOLO, Venice, Madrid, 1696–1770

97. *Caricature of a Fat Nobleman*

Pen and ink with wash on paper, 16.5 x 12 cm.

BIBLIOGRAPHY: Morassi, no. 87; Szabo, *Venetian Drawings*, no. 26.

Morassi remarks that Giambattista Tiepolo produced many caricatures. He lists several large groups in the museums of Trieste and Milan and in various private collections. Morassi assumes that there are at least three albums of these animated drawings (Morassi, pp. 58–59).

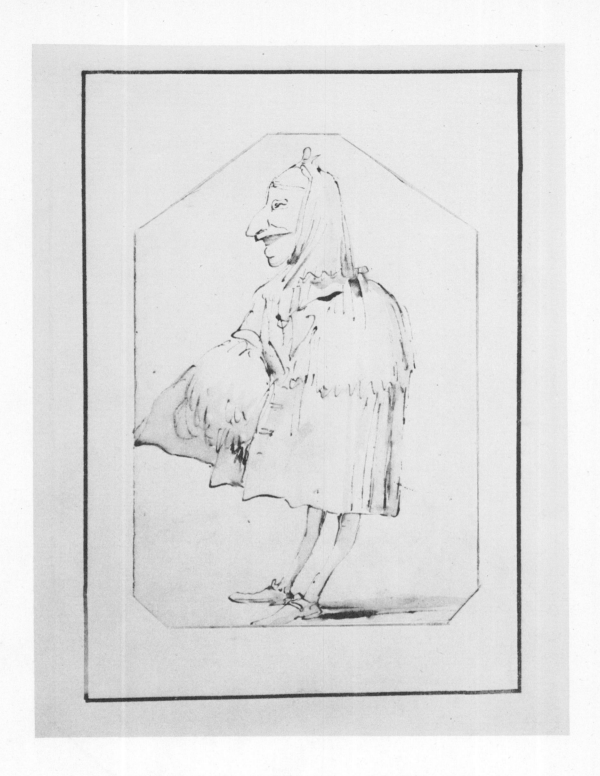

GIAMBATTISTA TIEPOLO, Venice, Madrid, 1696–1770

98. *Caricature of a Small Man with Mask and Mantle*

Pen and ink with wash on paper, 17.5 x 11.5 cm.

BIBLIOGRAPHY: Morassi, no. 85; Szabo, *Venetian Drawings*, no. 28.

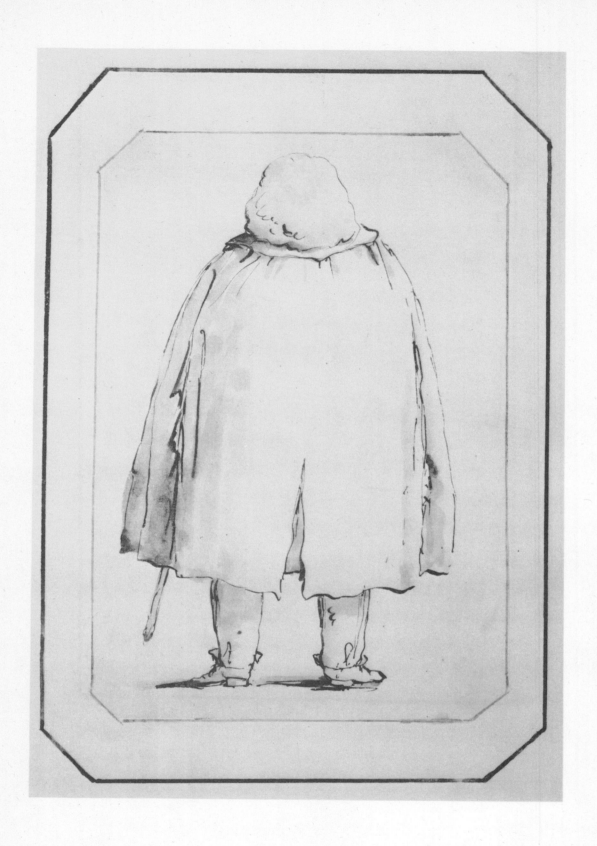

GIAMBATTISTA TIEPOLO, Venice, Madrid, 1696–1770

99. *Caricature of a Man with a Walking Stick*

Pen and ink with wash on paper, 18.5 x 12.3 cm.

BIBLIOGRAPHY: Morassi, no. 84.

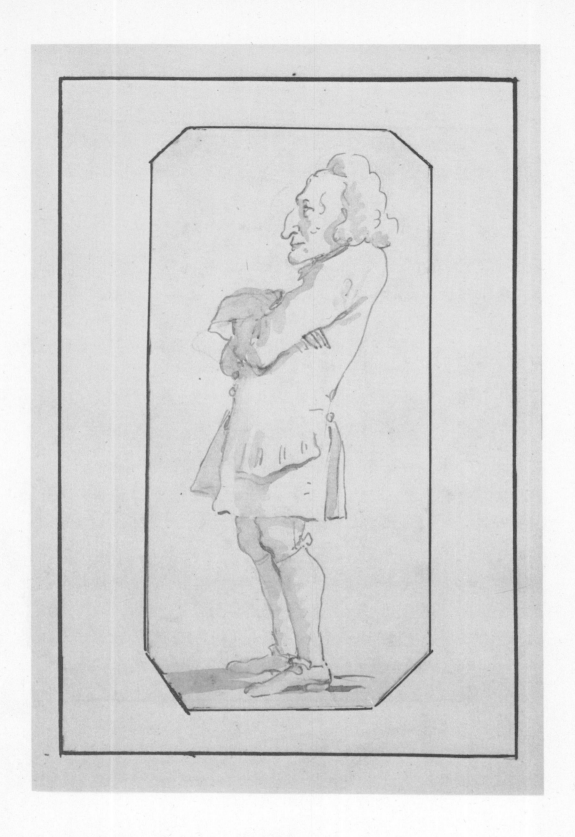

GIAMBATTISTA TIEPOLO, Venice, Madrid, 1696–1770

100. *Caricature of a Man in a Wig*

Pen and ink with sepia wash on paper, 17.9 x 8 cm.

BIBLIOGRAPHY: Morassi, no. 74.

According to Morassi, this is a portrait-like caricature, probably from around 1740–45.

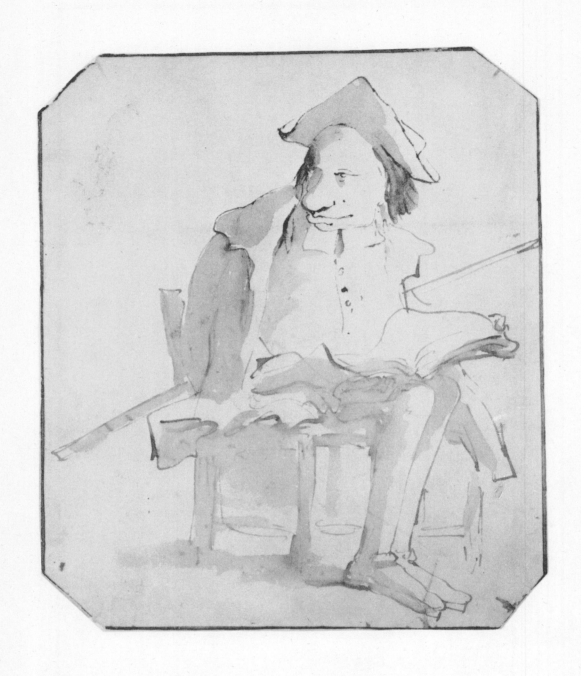

GIAMBATTISTA TIEPOLO, Venice, Madrid, 1696–1770

101. *Caricature of a Seated Small Man*

Pen and ink with sepia wash over pencil on paper, 16.5 x 13.7 cm.

BIBLIOGRAPHY: Morassi, no. 73.

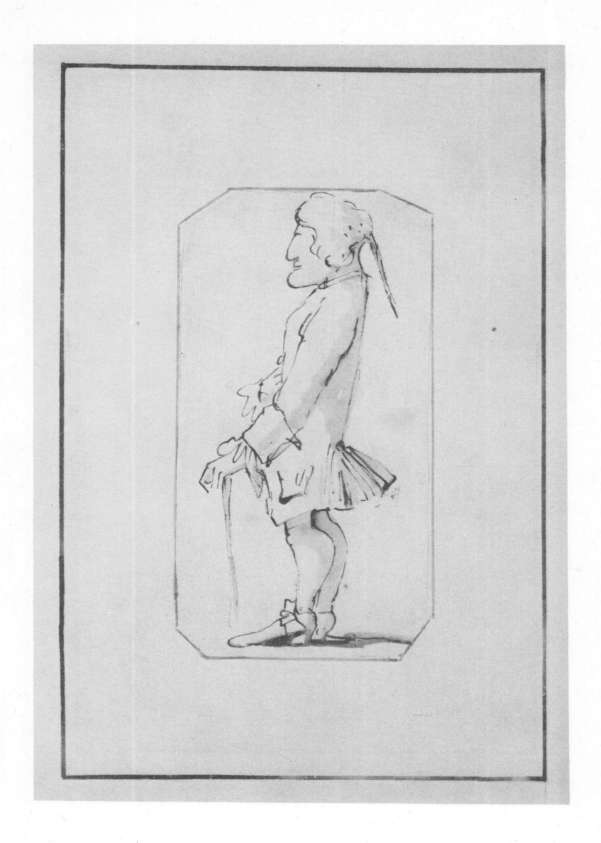

GIAMBATTISTA TIEPOLO, Venice, Madrid, 1696–1770
102. *Caricature of a Nobleman with a Walking Stick in Profile*
Pen and ink on paper, 14.6 x 7.5 cm.
BIBLIOGRAPHY: Morassi, no. 80.

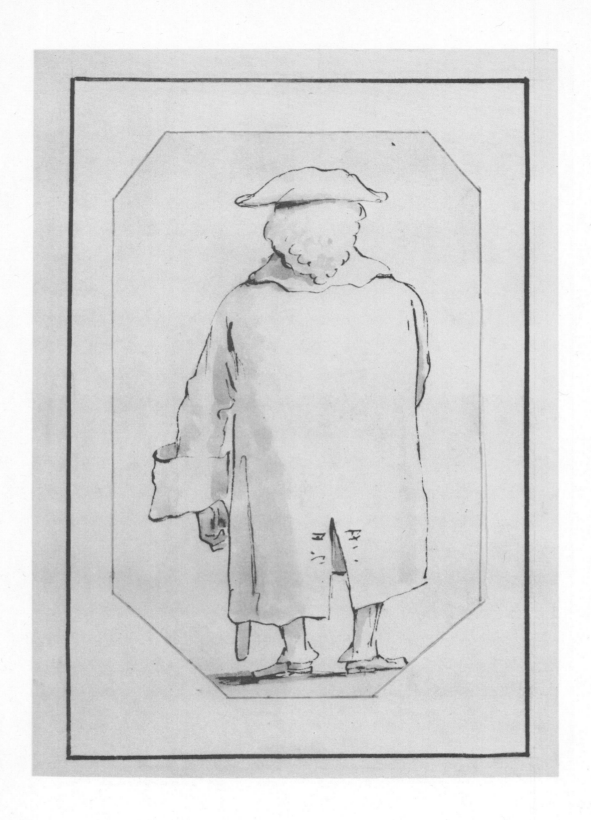

GIAMBATTISTA TIEPOLO, Venice, Madrid, 1696–1770

103. *Caricature of a Nobleman in a Wig with a Sword Under His Mantle*
Pen and ink on paper, 18.5 x 11.5 cm.
BIBLIOGRAPHY: Morassi, no. 79.

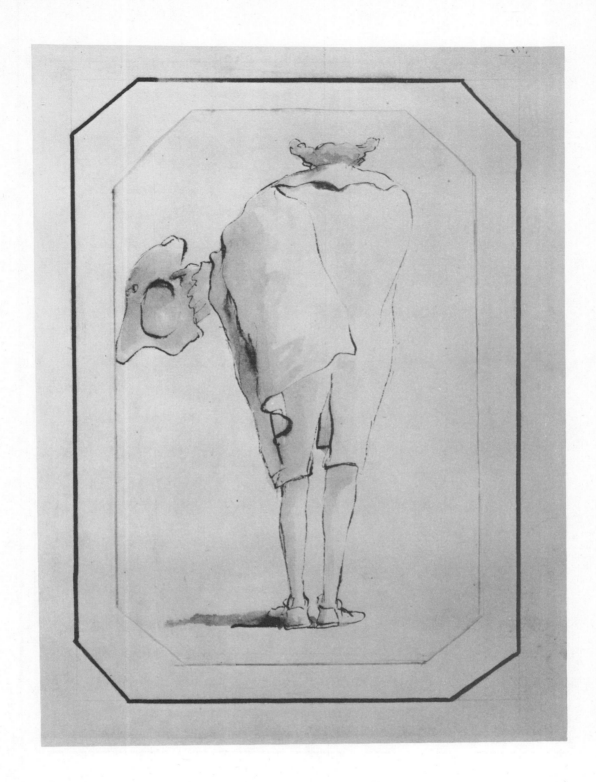

GIAMBATTISTA TIEPOLO, Venice, Madrid, 1696–1770

104. *Caricature of a Man with a Hat in His Left Hand*

Pen and ink with sepia wash over pencil on paper, 19.7 x 12.2 cm.

BIBLIOGRAPHY: Morassi, no. 76; Szabo, *Venetian Drawings*, no. 30.

This and other caricatures by Tiepolo reflect his amusement at his fellow humans rather than any social criticism or satire. A lighthearted attitude seems to guide his pen and brush in these fleeting drawings.

GIAMBATTISTA TIEPOLO, Venice, Madrid, 1696–1770

105. *Caricature of a Fat Woman with Mantle and Tricorn*

Pen and ink with wash on paper, 17.3 x 12.3 cm.

BIBLIOGRAPHY: Morassi, no. 86; Szabo, *Venetian Drawings*, no. 27.

GIAMBATTISTA TIEPOLO, Venice, Madrid, 1696–1770

106. *Caricature of a Woman in a Mantle and Tricorn*

Pen and ink with wash on paper, 17.2 x 10.2 cm.

BIBLIOGRAPHY: Morassi, no. 82.

GIAMBATTISTA TIEPOLO, Venice, Madrid, 1696–1770

107. *Caricature of a Nobleman with Long Coat and Tricorn*
Pen and ink on paper, 18.3 x 10.5 cm.
BIBLIOGRAPHY: Morassi, no. 81.

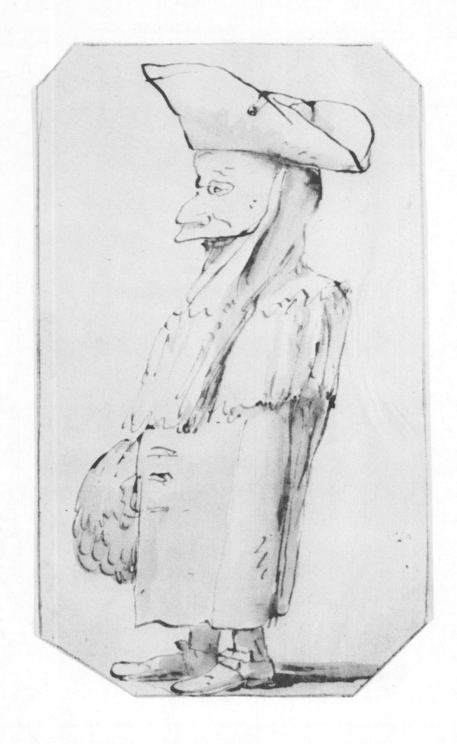

GIAMBATTISTA TIEPOLO, Venice, Madrid, 1696–1770

108. *Caricature of a Man in a Mask and Tricorn*

Pen and ink with wash on paper, 18.5 x 10.2 cm.

BIBLIOGRAPHY: Morassi, no. 77; Pignatti, no. 83; Szabo, *Venetian Drawings*, no. 29.

Pignatti remarks that this and other caricatures in the Robert Lehman Collection "are among the most spirited ones that Tiepolo ever drew" (Pignatti, p. 41). He dates them around 1760. The mask is probably the white ghostly type called *bautta*, which was worn by the patricians of Venice during the carnival season.

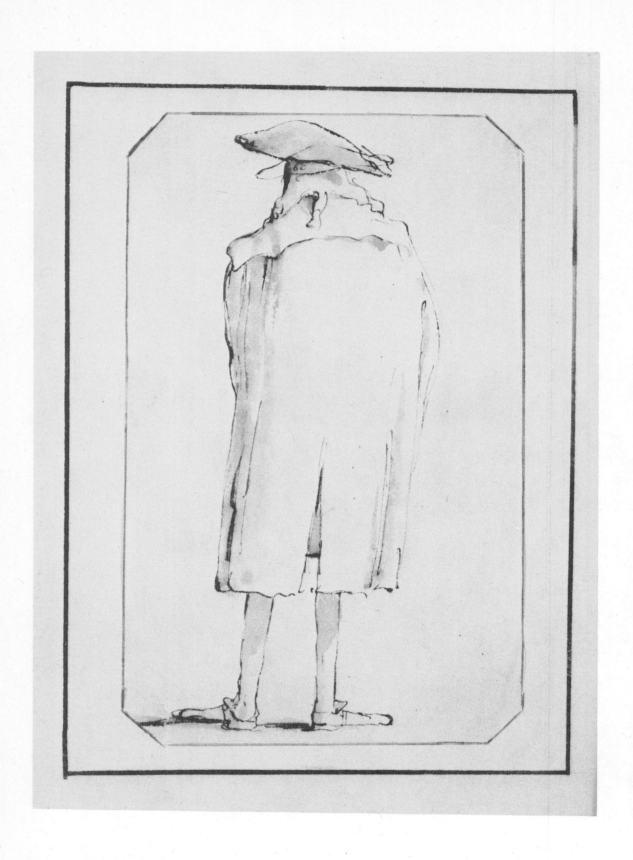

GIAMBATTISTA TIEPOLO, Venice, Madrid, 1696–1770

109. *Caricature of a Tall Nobleman with Tricorn*

Pen and ink with wash on paper, 19.7 x 12.2 cm.

BIBLIOGRAPHY: Morassi, no. 78.

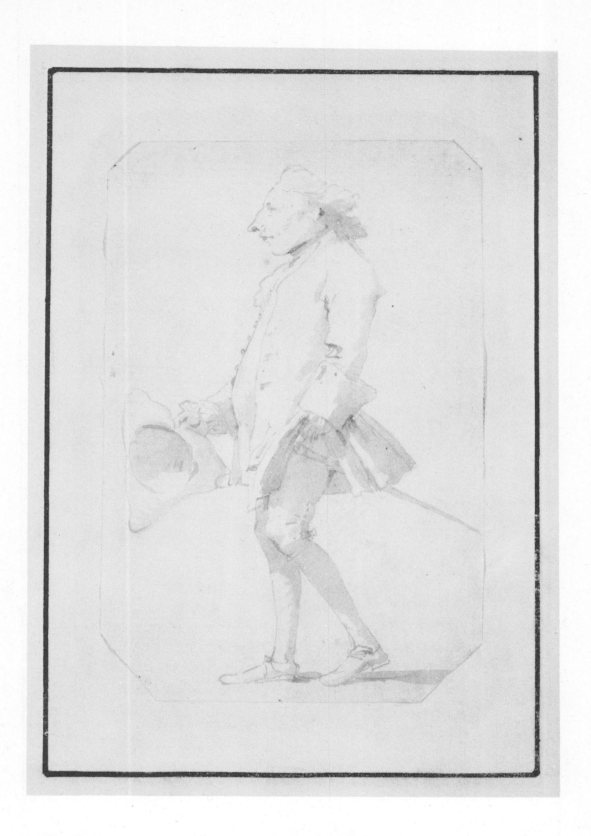

GIAMBATTISTA TIEPOLO, Venice, Madrid, 1696–1770

110. *Caricature of a Nobleman with Tricorn and Sword*

Pen and ink with gray wash on paper, 17.3 x 11.1 cm.

BIBLIOGRAPHY: Morassi, no. 75; *The Tiepolos*, no. 48.

Morassi dates this portrait-like caricature between 1740 and 1745.

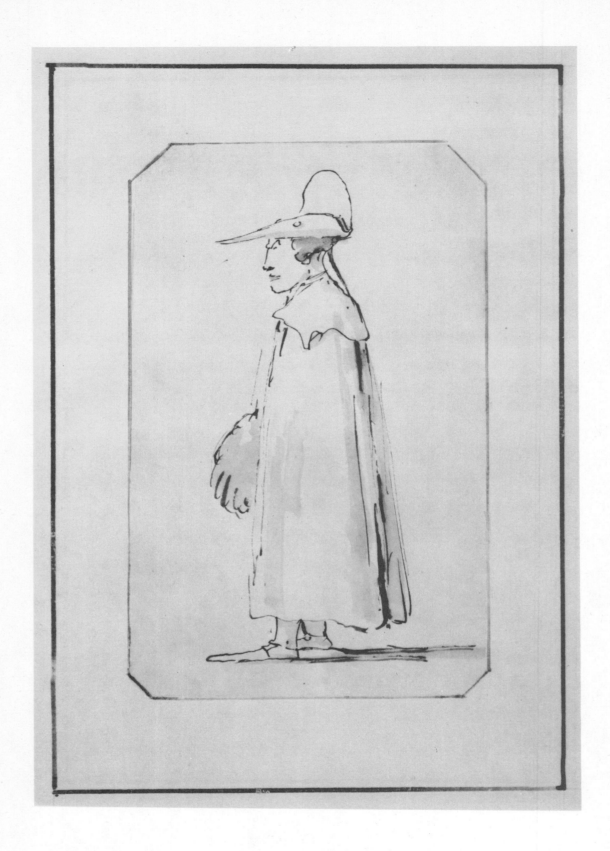

GIAMBATTISTA TIEPOLO, Venice, Madrid, 1696–1770

111. *Caricature of a Nobleman with Tricorn*

Pen and ink on paper, 16.5 x 10 cm.

BIBLIOGRAPHY: Morassi, no. 83.

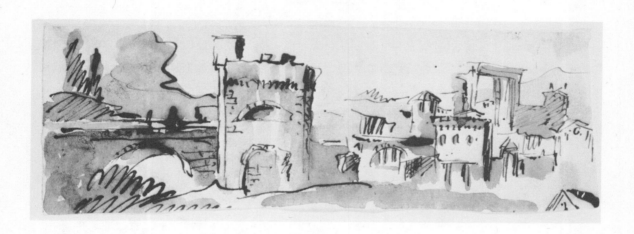

GIAMBATTISTA TIEPOLO, Venice, Madrid, 1696–1770

112. *Landscape with Castle*

Pen and ink with brown wash on paper, 5.5 x 17.4 cm.

BIBLIOGRAPHY: Szabo, *Venetian Drawings*, no. 31.

This drawing may be one of the views from nature that the artist did in his later years before moving to Spain. Pignatti lists several similar drawings in the British Museum, the Berlin Kupferstichkabinett, and the Rotterdam Museum. He assumes that they were part of an album (Pignatti, p. 41). The narrowness of this drawing might be an indication that it was cut down from a larger sheet.

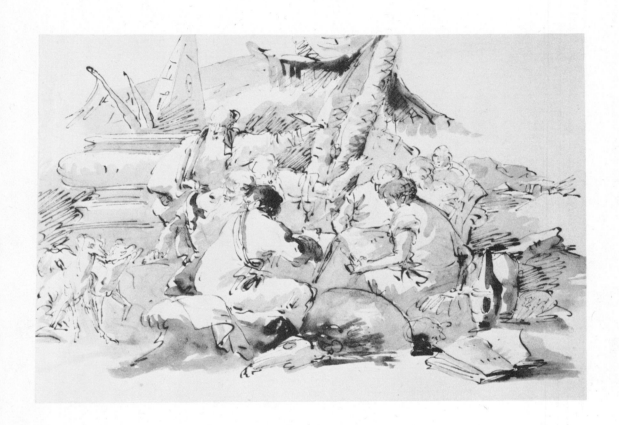

GIANDOMENICO TIEPOLO, Venice, 1727–1804

113. *Study of a Group Sitting at a Monument*

Pen and ink with wash over black chalk on paper, 20.5 x 30.3 cm.

BIBLIOGRAPHY: Morassi, no. 92.

Since the drawing is not signed, there is still no agreement about whether it is a late work by Giambattista or a masterpiece by the young Giandomenico.

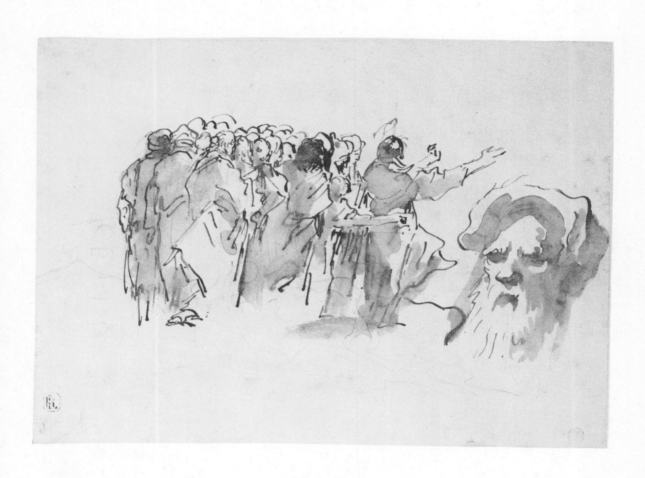

GIANDOMENICO TIEPOLO, Venice, 1727–1804

114. *Study of a Group Listening to a Preacher and a Head of an Old Man*

Pen and ink with gray wash over black chalk on paper, 19 x 26 cm.

BIBLIOGRAPHY: Morassi, no. 93.

According to Morassi, this is an early work by Giandomenico and probably represents St. John preaching.

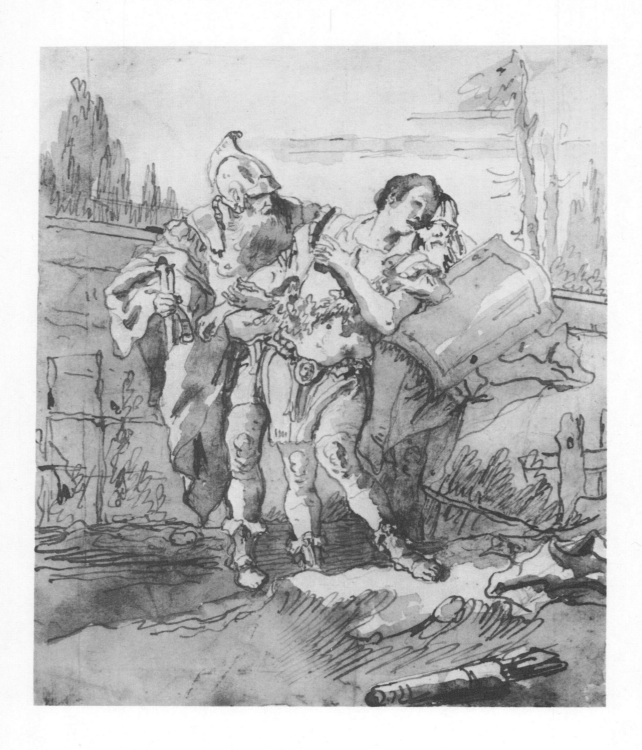

GIANDOMENICO TIEPOLO, Venice, 1727–1804

115. *Renaldo Abandons Armida*

Pen and ink with wash on paper, 22 x 18 cm.

Unpublished.

This drawing is probably after Giambattista's frescoes painted in 1757 in the Palazzo Trento
Valmarana.

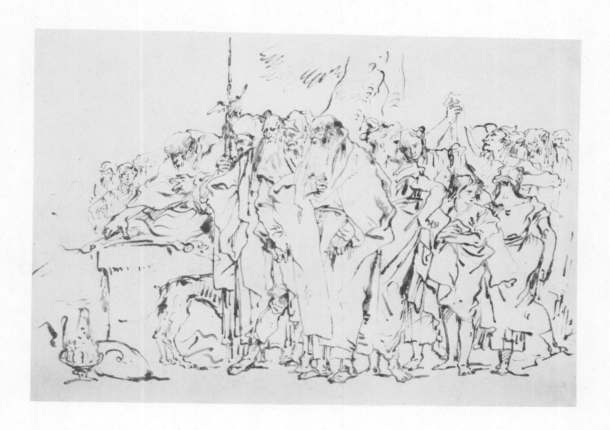

GIANDOMENICO TIEPOLO, Venice, 1727–1804

116. *Study for a Sacrifice Scene with a Crowd*

Pen and ink on paper, 19.5 x 28.5 cm.

BIBLIOGRAPHY: Morassi, no. 90.

This and similar pen and ink drawings without wash are considered early works of Giando-menico. According to Morassi, they are not studies for large compositions, but rather *capricci* that show off the prodigious talent of the young artist around 1740–50.

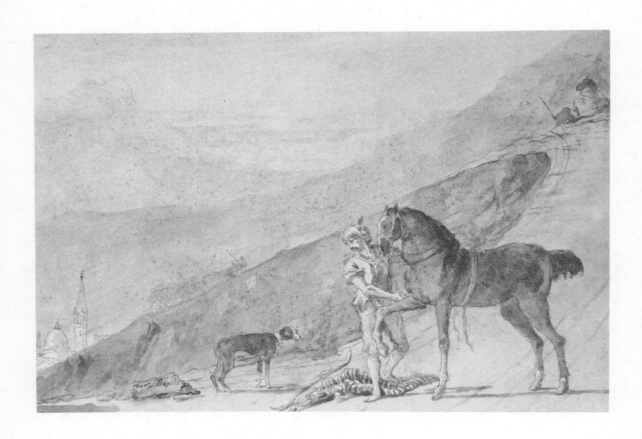

GIANDOMENICO TIEPOLO, Venice, 1727–1804

117. *Landscape with a Horse Held by a Page*

Pen and ink with wash over black chalk preliminary drawing on paper, 29 x 42 cm. Signed on a rock at lower left: *Dom. Tiepolo*.

BIBLIOGRAPHY: Morassi, no. 112; Szabo, *Venetian Drawings*, no. 34.

This composition is a mixture of fantasy and observation. The page's costume is of an imaginary oriental style, but the mountainous landscape and the buildings in the background are reminiscent of Spain. It is possible that the drawing contains some memories of Giandomenico's travels in Spain.

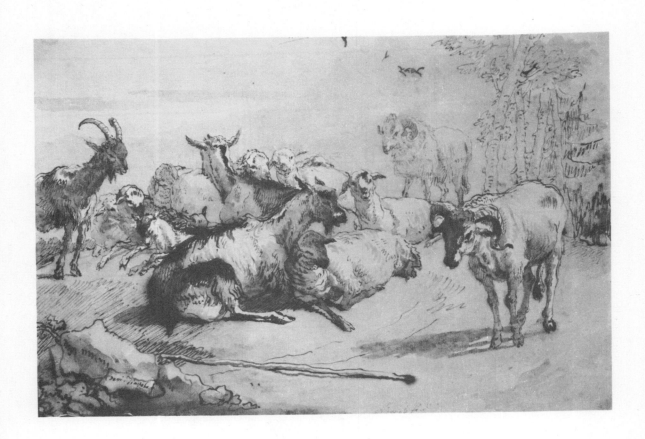

GIANDOMENICO TIEPOLO, Venice, 1727–1804

118. *Sheep and Goats*

Pen and ink with wash on paper, 19.3 x 29.2 cm. Signed on the rock in lower left corner: *Dom.º Tiepolo f.* Inscribed by a later hand at lower center: *Tiepolo fecit.*

Unpublished.

This drawing is probably a study from life, possibly from the artist's years in Spain.

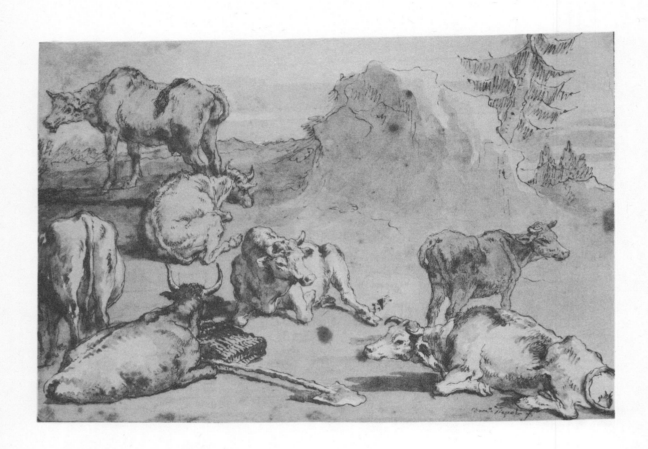

GIANDOMENICO TIEPOLO, Venice, 1727–1804

119. *A Herd of Oxen*

Pen and ink with wash on paper, 18.7 x 28 cm. Signed at lower right: *Dom? Tiepolo f.*
Unpublished.

Like the previous drawing, this is most likely from life and possibly from the Spanish years.

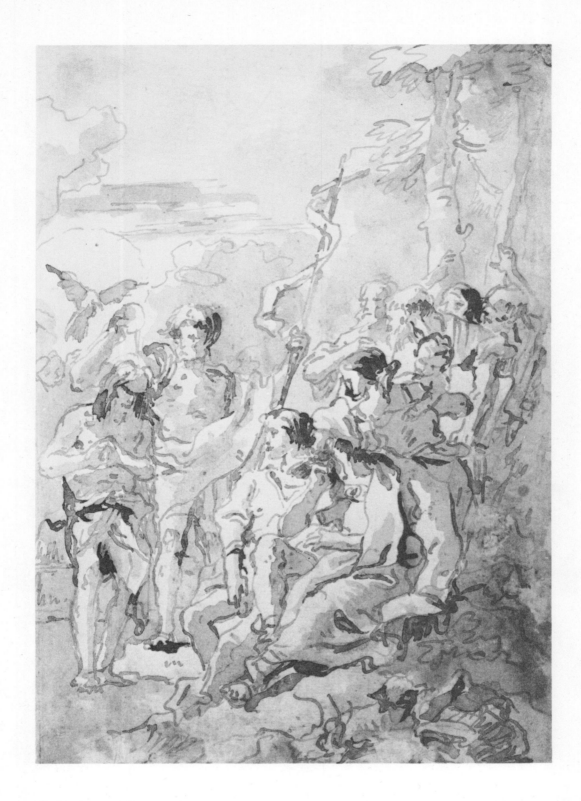

GIANDOMENICO TIEPOLO, Venice, 1727–1804

120. *The Baptism of Christ*

Pen and ink with brown wash on paper, 26.3 x 17 cm.

BIBLIOGRAPHY: Byam Shaw, *Domenico Tiepolo*, p. 34, n. 1.

This drawing was part of a series of variations on the theme of the Baptism of Christ that might have contained more than eighty-four drawings (Byam Shaw, *Domenico Tiepolo*, p. 34, n. 1). Some of the following baptism scenes possibly belonged to the same album.

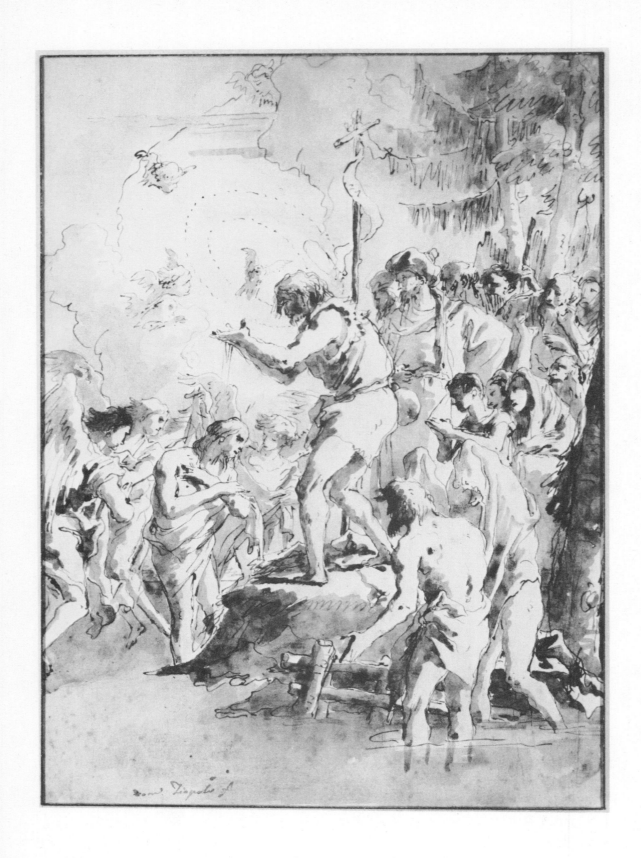

GIANDOMENICO TIEPOLO, Venice, 1727–1804

121. *The Baptism of Christ*

Pen and ink with wash on paper, 28.3 x 19.4 cm. Signed at lower left: *Dom. Tiepolo f.*

BIBLIOGRAPHY: Byam Shaw, *Domenico Tiepolo*, p. 34, n. 1.

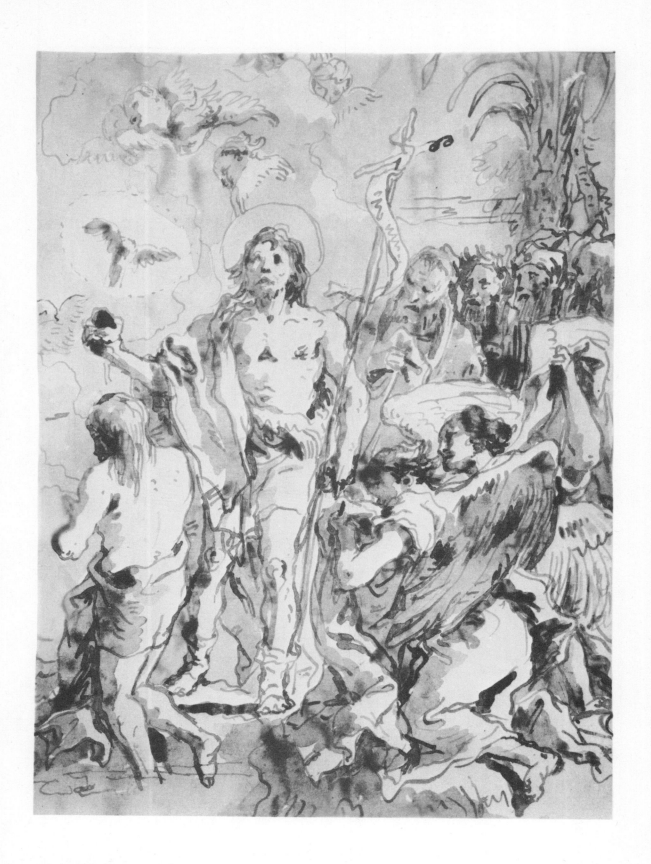

GIANDOMENICO TIEPOLO, Venice, 1727–1804

122. *The Baptism of Christ*

Pen and ink with wash on paper, 25.4 x 18.1 cm.

BIBLIOGRAPHY: Grassi Sale Cat., no. 122 (?).

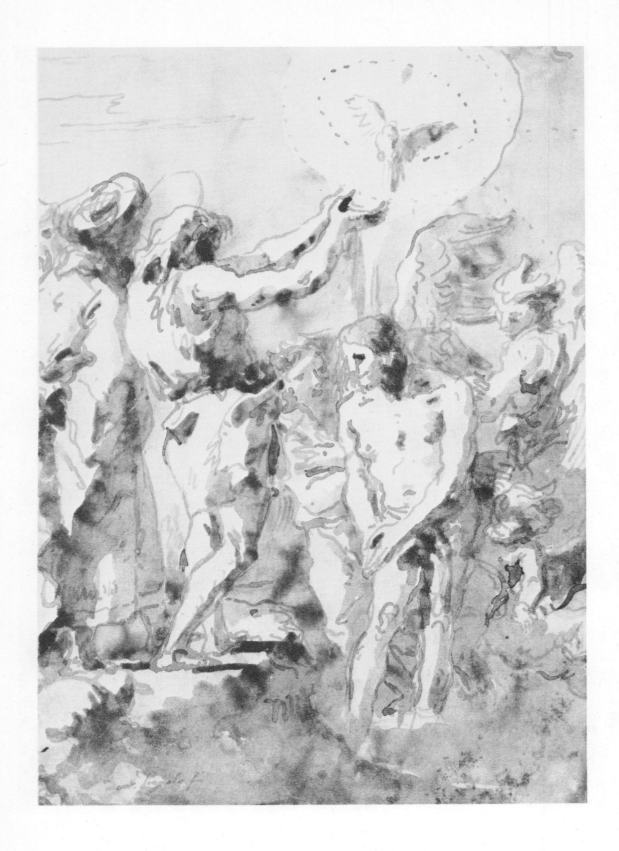

GIANDOMENICO TIEPOLO, Venice, 1727–1804

123. *The Baptism of Christ*

Pen and ink with wash on paper, 21.9 x 14.6 cm. Signed in lower left corner: *Domº Tiepolo f.*

BIBLIOGRAPHY: Byam Shaw, *Domenico Tiepolo*, p. 34, n. 1.

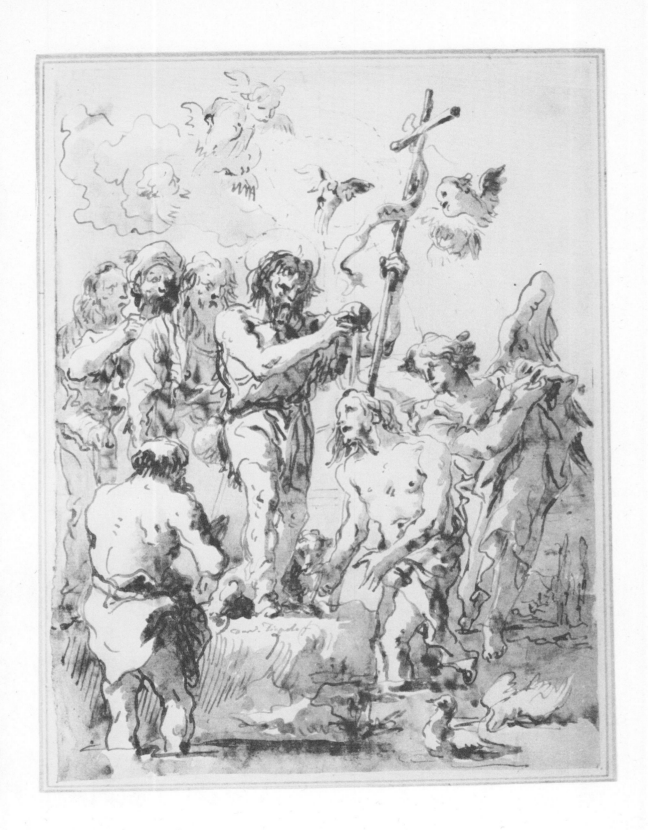

GIANDOMENICO TIEPOLO, Venice, 1727–1804

124. *The Baptism of Christ*

Pen and ink with wash on paper, 27 x 19.4 cm.

BIBLIOGRAPHY: Byam Shaw, *Domenico Tiepolo*, p. 34, n. 1

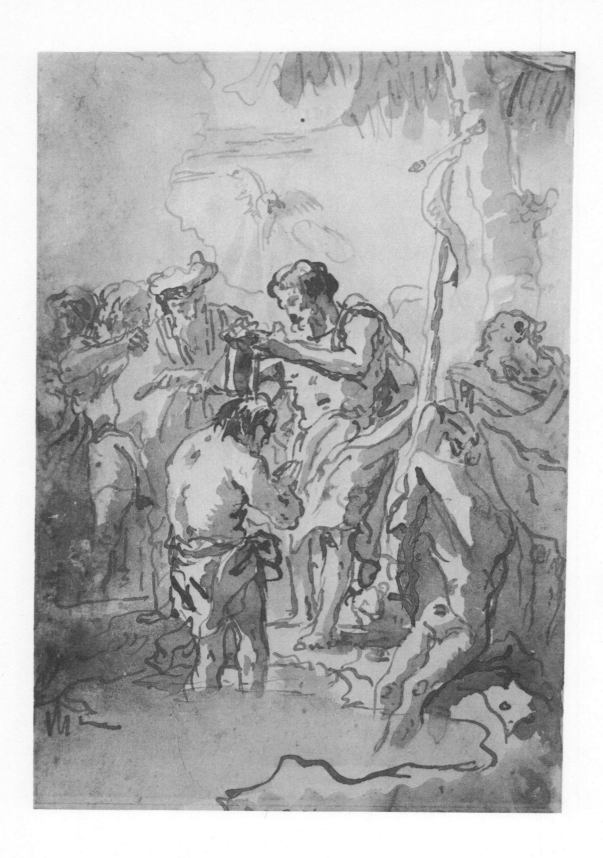

GIANDOMENICO TIEPOLO, Venice, 1727–1804

125. *The Baptism of Christ*

Pen and ink with wash on paper, 25.4 x 17.1 cm.

BIBLIOGRAPHY: Byam Shaw, *Domenico Tiepolo*, p. 34, n. 1

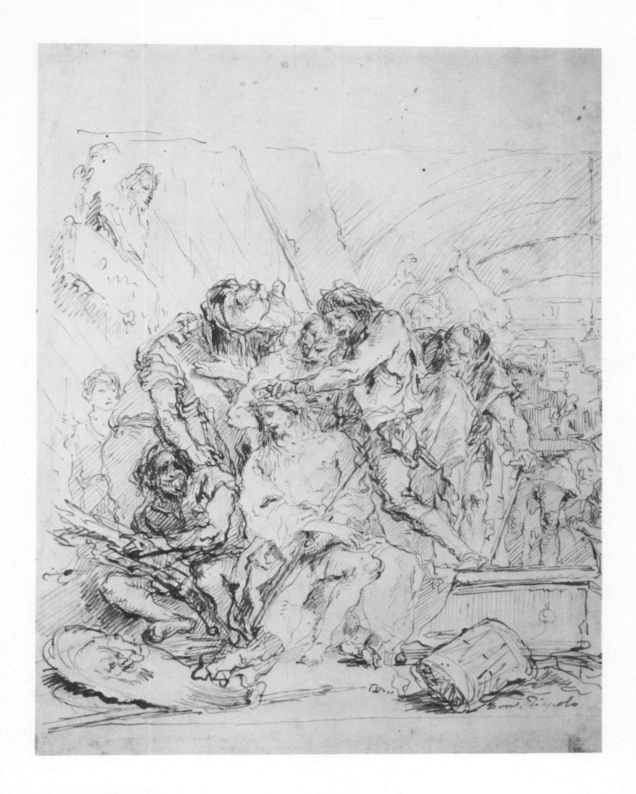

GIANDOMENICO TIEPOLO, Venice, 1727–1804

126. *Christ Crowned with Thorns*

Pen and ink on paper, 26.8 x 21.9 cm. Signed in lower right corner: *Dom. Tiepolo*.

BIBLIOGRAPHY: Byam Shaw, *Domenico Tiepolo*, p. 76.

Byam Shaw characterizes this drawing as "an excellent example…on a rather large sheet of paper, but with the final dimensions indicated by a rough margin-line above" (Byam Shaw, *Domenico Tiepolo*, p. 76). It belongs to a series of Passion scenes that are characterized by the absence of wash.

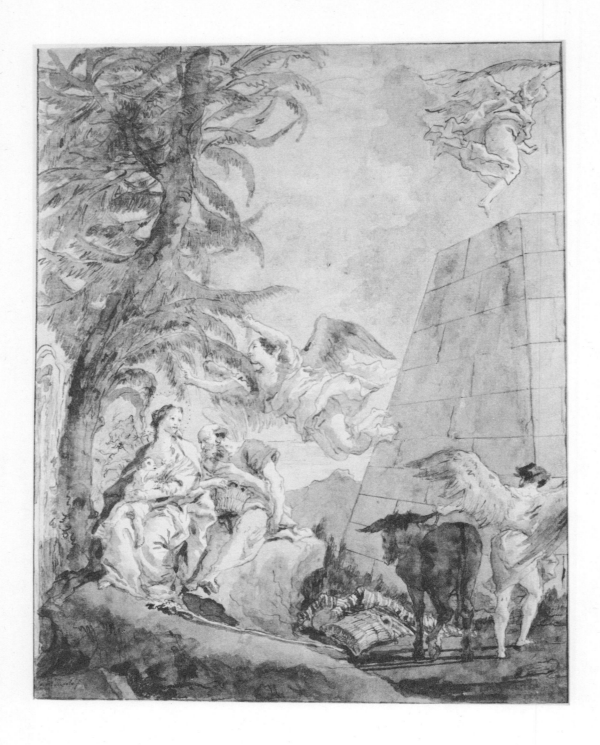

GIANDOMENICO TIEPOLO, Venice, 1727–1804

127. *Rest on the Flight into Egypt*

Pen and brown ink with wash over black chalk on paper, 47 x 37.9 cm. Signed in lower left corner: *Dom? Tiepolo f.*

BIBLIOGRAPHY: Bean-Stampfle, no. 257; *The Tiepolos*, no. 129.

According to a story, Giandomenico Tiepolo once etched twenty-four variations on the theme of the Flight into Egypt to demonstrate his ability to a patron (Bean-Stampfle, p. 103). A considerable number of drawings of the Flight still exist. This fresh and exceedingly fine sheet is another demonstration of the artist's virtuoso draftsmanship and is generally dated between 1750 and 1753.

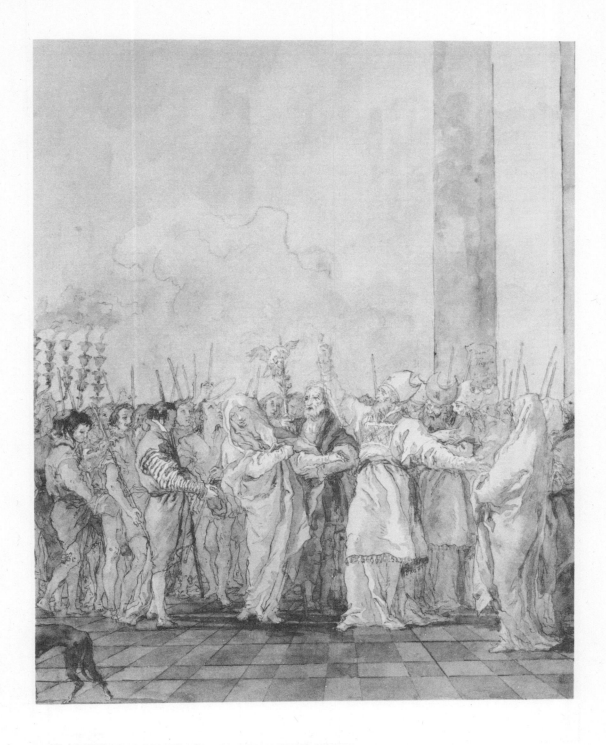

GIANDOMENICO TIEPOLO, Venice, 1727–1804

128. *The Betrothal of the Virgin*

Pen and ink with brown wash over black chalk on paper 48.3 x 38.6 cm. Signed in pen and ink on column at right: *Dom? Tiepolo f.*

BIBLIOGRAPHY: H. Guerlin, *Au temps du Christ, Giovanni Domenico Tiepolo,* Tours, 1921, p. 94; Bean-Stampfle, no. 253; M. Santifaller, "Giandomenico Tiepolos 'Hl. Joseph mit dem Jesuskind' in der Staatsgalerie Stuttgart und seine Stelle in der Ikonographie der Barock," *Jahrbuch der Staatlichen Kunstsammlungen in Baden-Württemberg* 13 (1976), p. 79, fig. 17; *The Tiepolos,* no. 131.

After his return from Spain in 1770, Giandomenico Tiepolo produced several series of drawings with biblical scenes and scenes from the lives of the Virgin and Christ. This large drawing belongs to these "album drawings," however, no closer dating can be assigned to it.

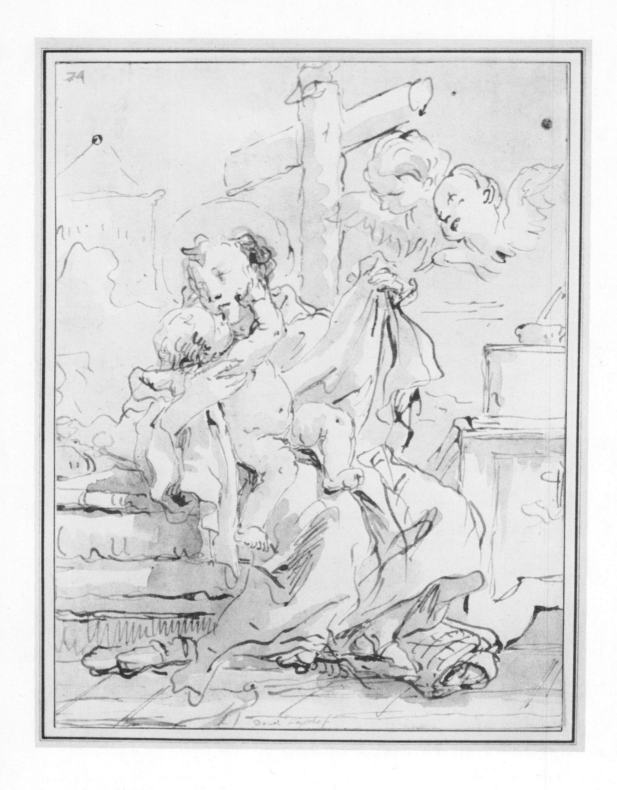

GIANDOMENICO TIEPOLO, Venice, 1727–1804

129. *St. Anthony and the Christ Child*

Pen and ink with wash on paper, 24.4 x 17.7 cm. Signed lower center: *Dom⁰ Tiepolo f.* Numbered in upper left corner in a nearly contemporary hand *74*(?).

BIBLIOGRAPHY: Colnaghi and Co., *Exhibition of Old Master Drawings*, London, 1960, no. 14; W. Schulz, "Tiepolo Probleme. Ein Antonius Album von Giandomenico Tiepolo," *Wallraf-Richartz Jahrbuch* 40 (1978), pp. 69, 72.

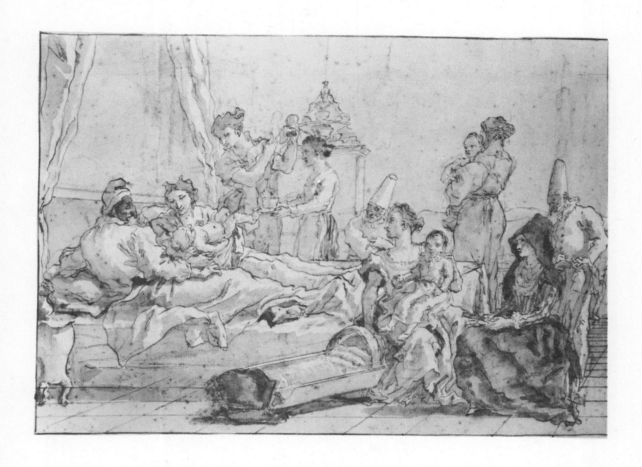

GIANDOMENICO TIEPOLO, Venice, 1727–1804

130. *The Family Life of Punchinello's Parents*

Pen and brown ink with wash over black chalk on paper, 35.1 x 46.7 cm.

BIBLIOGRAPHY: Byam Shaw, *Domenico Tiepolo*, pp. 55–56; Bean-Stampfle, no. 271; *Punchinello Drawings*, no. S 2; Szabo, *Venetian Drawings*, no. 41.

This is one of the first in Giandomenico's series of 103 drawings titled *Divertimento per li regazzi* ("Entertainment for Children"). Despite the title, the series was intended for adults—the people of Venice, affectionately called *regazzi* by the aging artist. Through Punchinello, the leading character of the *commedia dell'arte*, Tiepolo satirized and poked fun at Venetian life and society. The full range of the *commedia umana* evolves in the 103 episodes—some mildly satirical, others cruel. The subject was not new to the artist. His father, Giambattista, had made sketches of groups of Punchinelli (see No. 75). In 1793, Giandomenico himself had painted frescoes of Punchinelli for the Camera dei Pagliacci of the family villa in Zianigo. Like this scene, the other drawings in this series are full of warmth, humor, and shrewd observation. They are drawn in a light yet assured style with a superior use of washes. The album was dispersed through auction, but, fortunately, nine of the drawings are now gathered in the Robert Lehman Collection. (For the history of the album and its contents, see *Punchinello Drawings*, pp. 11–36.)

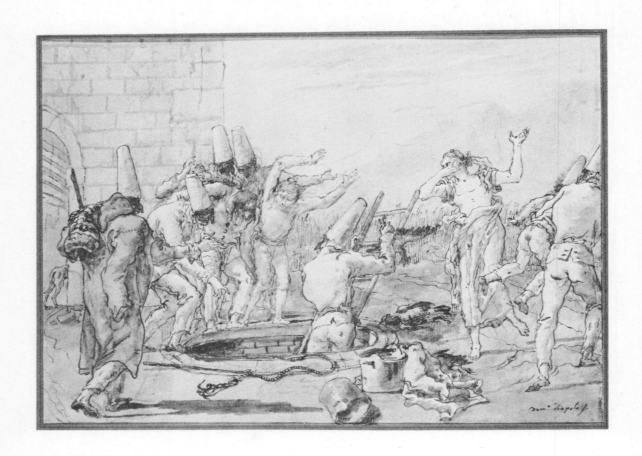

GIANDOMENICO TIEPOLO, Venice, 1727–1804

131. *Punchinello Retrieves Dead Fowl from a Well*

Pen and brown ink with brown wash over black chalk on paper, 35 x 46.5 cm. Signed in lower right corner: *Dom? Tiepolo f.*

BIBLIOGRAPHY: A. Morassi, "Domenico Tiepolo," *Emporium* 93 (1941), pp. 277, 280; Chicago, *Tiepolo Exhibition*, no. 112; Cincinnati, no. 233; Bean-Stampfle, no. 280; *Punchinello Drawings*, no. S 8.

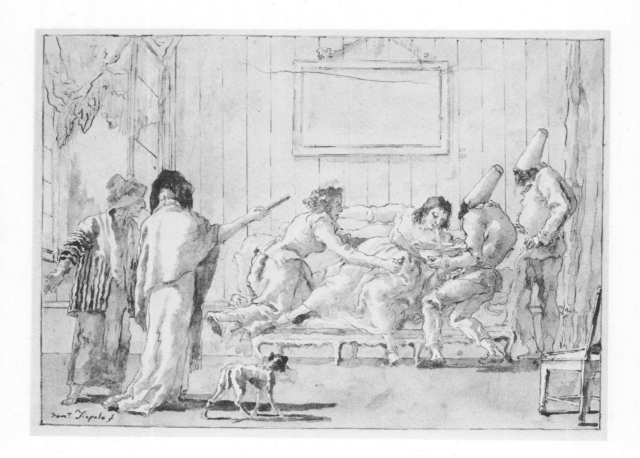

GIANDOMENICO TIEPOLO, Venice, 1727–1804

132. *Punchinello's Indisposed Mistress*

Pen and brown ink with brown wash over black chalk on paper, 32.5 x 46.7 cm. Signed in lower left corner: *Dom? Tiepolo f.* Numbered in upper left corner of margin: *15*.

BIBLIOGRAPHY: Chicago, *Tiepolo Exhibition*, no.104; A. Morassi, "Domenico Tiepolo," *Emporium* 93 (1941), p. 279; Byam Shaw, *Domenico Tiepolo*, p. 56; Bean-Stampfle, no. 270; *Punchinello Drawings*, no. S 16.

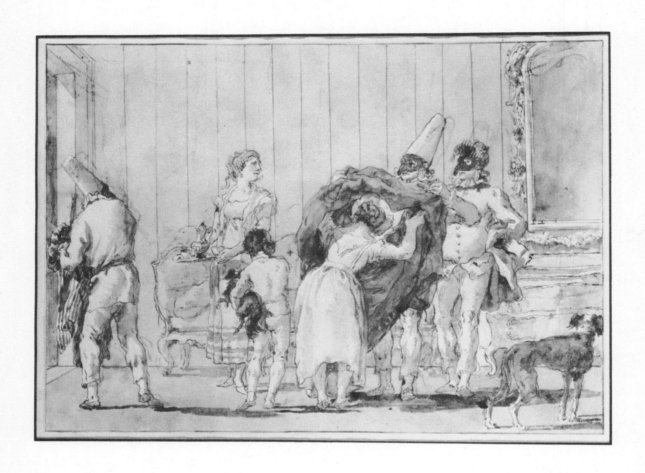

GIANDOMENICO TIEPOLO, Venice, 1727–1804

133. *The Visit of the Dressmaker*

Pen and brown ink with brown wash over black chalk on paper, 35.2 x 46.8 cm. Numbered in upper left corner of margin: *12*.

BIBLIOGRAPHY: Byam Shaw, *Domenico Tiepolo*, p. 56; Bean-Stampfle, no. 278; *The Tiepolos*, no. 121; *Punchinello Drawings*, no. S 17.

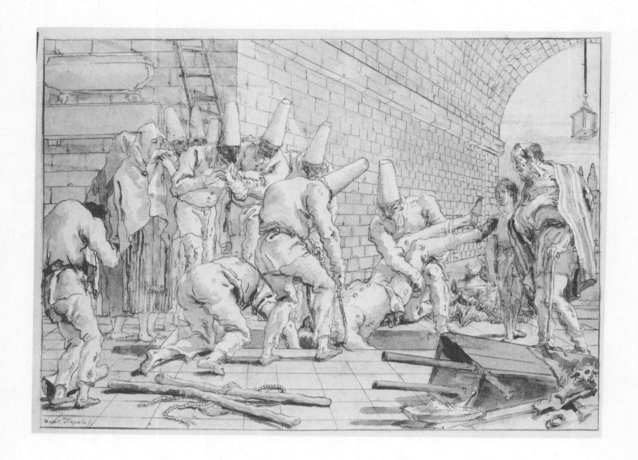

GIANDOMENICO TIEPOLO, Venice, 1727–1804

134. *The Burial of Punchinello*

Pen and brown ink with brown wash over black chalk on paper, 35.3 x 47.3 cm. Signed in lower left corner; *Dom? Tiepolo f*. Numbered in upper left corner of margin: *103*.

BIBLIOGRAPHY: Bean-Stampfle, no. 283; *Punchinello Drawings*, no. S 25.

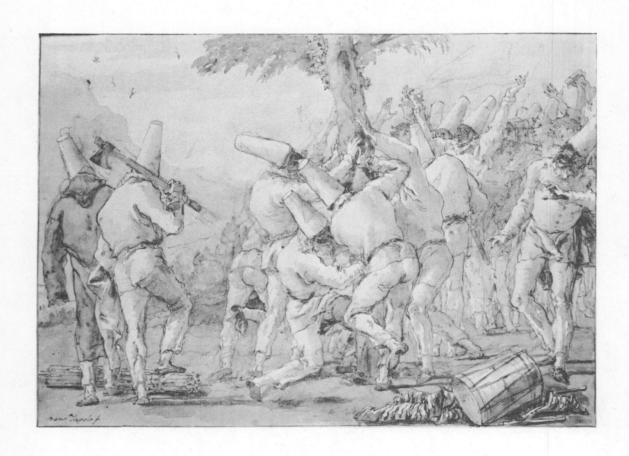

GIANDOMENICO TIEPOLO, Venice, 1727–1804

135. *Punchinelli Felling (?) a Tree*

Pen and brown ink with wash over black chalk on paper, 35.3 x 47.3 cm. Signed in lower left corner: *Dom? Tiepolo f.* Numbered in upper left corner of margin: *40*.

BIBLIOGRAPHY: Bean-Stampfle, no. 274; *Punchinello Drawings*, no. S 28.

It was suggested recently that the Punchinelli "may be cutting or raising a tree to serve as an *albero della cuccagna*, or maypole. Domenico also might be mocking the planting of the 'Tree of Liberty,' that symbol of French 'liberation' which in the late 1790's had been raised in the piazze of conquered Veneto cities." The latter interpretation is strengthened by the presence of a cast-off military drum; the faggot might be the *fasces*, a Roman symbol adopted during the French Revolution.

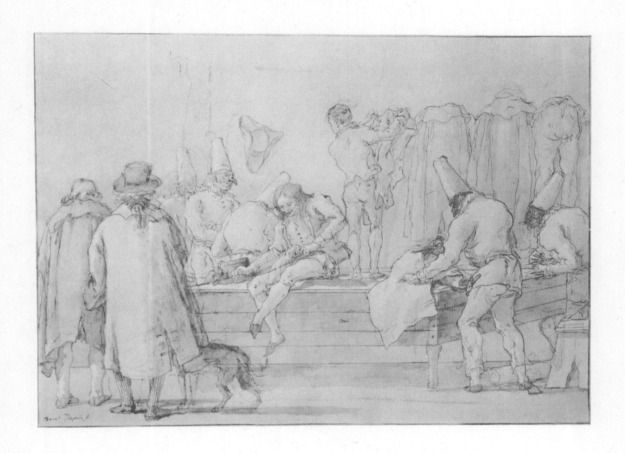

GIANDOMENICO TIEPOLO, Venice, 1727–1804

136. *Punchinello as a Tailor's Assistant*

Pen and golden-brown ink with wash over black chalk on paper, 35.3 x 47 cm. Signed in lower left corner: *Domᵒ Tiepolo f.* Numbered in upper left corner of margin: *55.*

BIBLIOGRAPHY: Byam Shaw, *Domenico Tiepolo*, p. 92, pl. 88; Bean-Stampfle, no. 277; *Punchinello Drawings*, no. S 50; Szabo, *Venetian Drawings*, no. 42.

This and the following drawing belong to a group that Byam Shaw calls "Punchinello's Various Trades and Occupations." Other similarly spirited drawings in the album represent him as a peddler, barber, carpenter, and tavern-keeper.

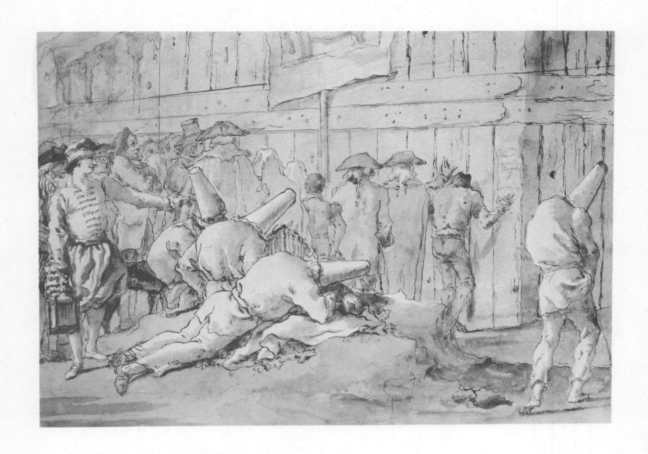

GIANDOMENICO TIEPOLO, Venice, 1727–1804

137. *Punchinelli Resting Outside the Circus*

Pen and brown ink with wash over black chalk on paper, 35 x 46.5 cm. Signed on the fence: *Dom?
Tiepolo f.* Numbered in upper left corner of the margin: *50*.

BIBLIOGRAPHY: Byam Shaw, *Domenico Tiepolo*, p. 56; Bean-Stampfle, no. 275; *Punchinello Draw-
ings*, no. S 54.

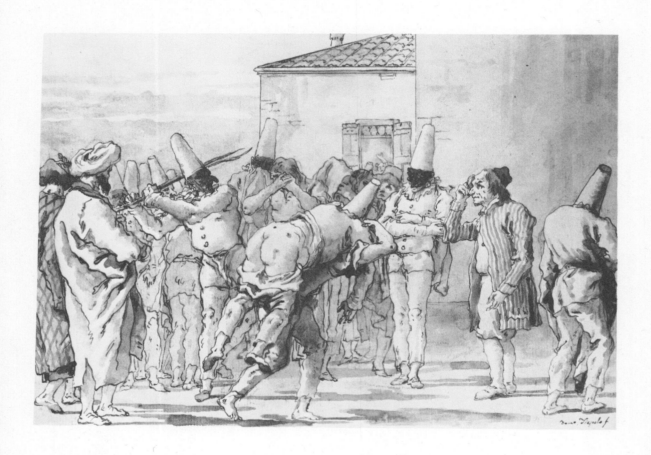

GIANDOMENICO, TIEPOLO, Venice, 1727–1804

138. *The Flogging of Punchinello*

Pen and brown ink with wash over black chalk on paper, 35.5 x 47.2 cm. Signed in lower right corner
Dom? Tiepolo f. Numbered in upper left corner of margin: *85.*

BIBLIOGRAPHY: Bean-Stampfle, no. 281; *Punchinello Drawings*, no. S 57.

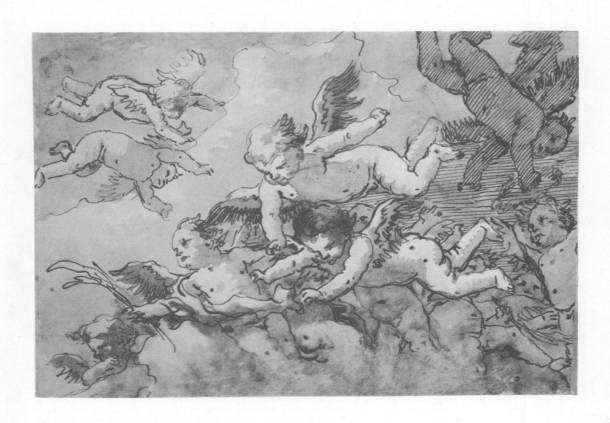

GIANDOMENICO TIEPOLO, Venice, 1727–1804

139. *Group of Flying Putti*

Pen and ink with gray wash on paper, 17 x 25 cm.

BIBLIOGRAPHY: Morassi, no. 109.

One of the putti is holding a palm leaf. This may be an indication that the drawing is a sketch for the upper part of a fresco or painting representing a martyred saint.

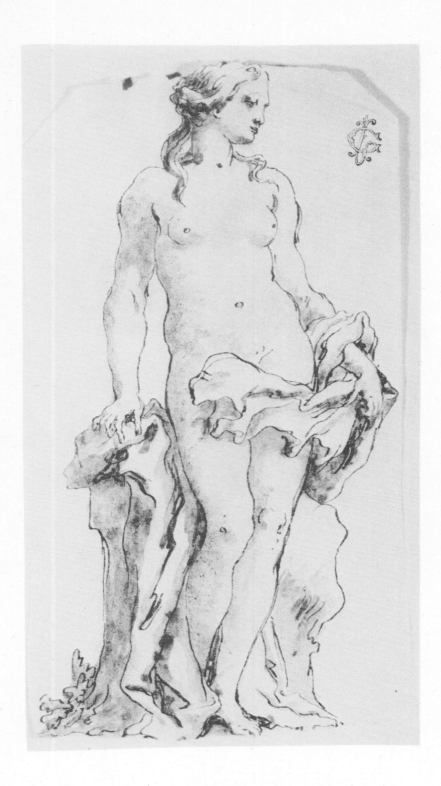

GIANDOMENICO TIEPOLO, Venice, 1727–1804

140. *Goddess*

Pen and ink with wash on paper, 24.2 x 12.8 cm.

BIBLIOGRAPHY: Grassi Sale Cat., no. 129; Chicago, *Tiepolo Exhibition*, no. 99.

It has been suggested that this drawing is also the representation of a garden statue like the one seen in a Punchinello drawing *(Punchinello Drawings,* no. 25).

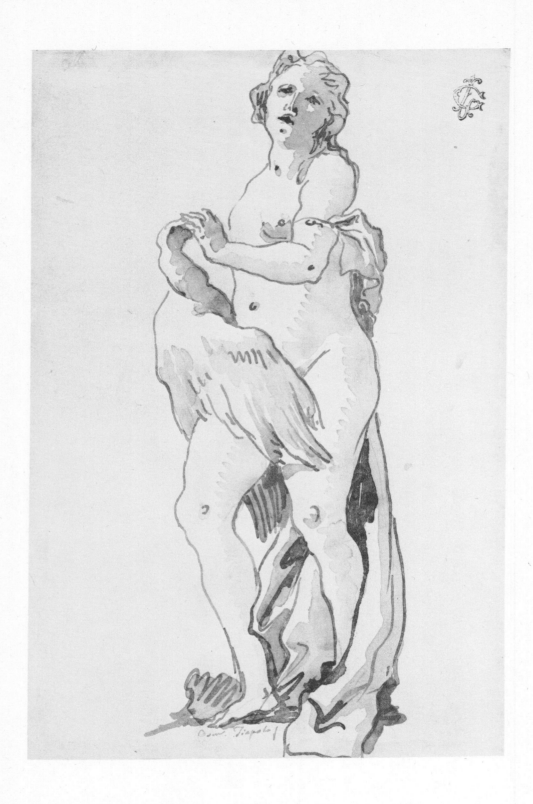

GIANDOMENICO TIEPOLO, Venice, 1727–1804

141. *Leda and the Swan*

Pen and ink with wash on paper, 25.4 x 13.8 cm. Signed lower center: *Dom Tiepolo f.*

BIBLIOGRAPHY: Grassi Sale Cat., no. 127; Chicago, *Tiepolo Exhibition*, no. 98; Byam Shaw, *Domenico Tiepolo*, p. 94.

Byam Shaw calls attention to a figure very similar to this one that appears as a garden statue in one of the Punchinello drawings (Byam Shaw, *Domenico Tiepolo*, p. 94).

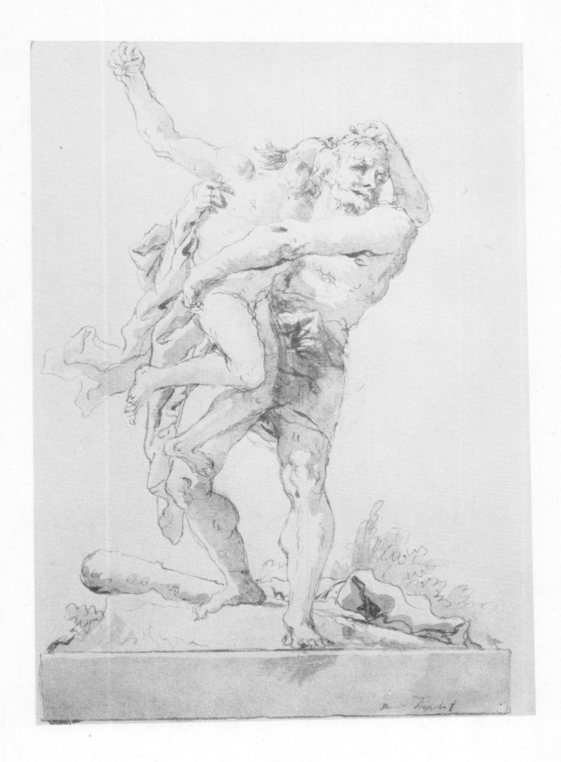

GIANDOMENICO TIEPOLO, Venice, 1727–1804

142. *Hercules and Antaeus*

Pen and ink with wash on paper, 21.6 x 15.2 cm. Signed lower right on the corner of the base: *Dom?
Tiepolo f.*

Unpublished.

At least three different series by Giandomenico Tiepolo with representations of Hercules and
Antaeus are known. This forceful drawing belongs to a group in which the figures were most
likely copied from small bronzes, as indicated by the presence of a base or plinth (Byam Shaw,
Domenico Tiepolo, p. 42).

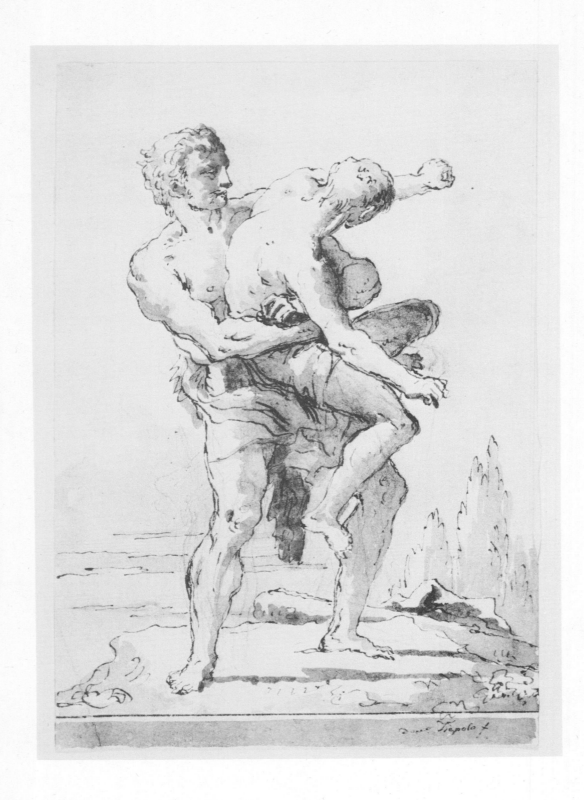

GIANDOMENICO TIEPOLO, Venice, 1727–1804

143. *Hercules and Antaeus*

Pen and ink with wash over pencil on paper, 20 x 14 cm. Signed in lower right corner: *Dom? Tiepolo f.*

BIBLIOGRAPHY: Morassi, no. 95

The suggestion of a continuous dado at the bottom of this drawing probably indicates that it is a study for a wall painting. Morassi dates it to the artist's late period.

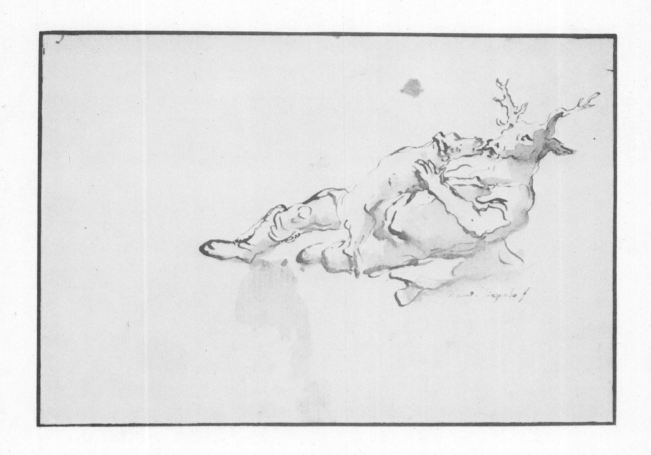

GIANDOMENICO TIEPOLO, Venice, 1727–1804

144. *Study of Actaeon*

Pen and ink with wash on paper, 14.2 x 26 cm. Signed below the figure at right: *Dom? Tiepolo f.*
BIBLIOGRAPHY: Byam Shaw, *Domenico Tiepolo*, p. 88.

Byam Shaw dates this drawing to around 1800, based on comparisons to two similar compositions.

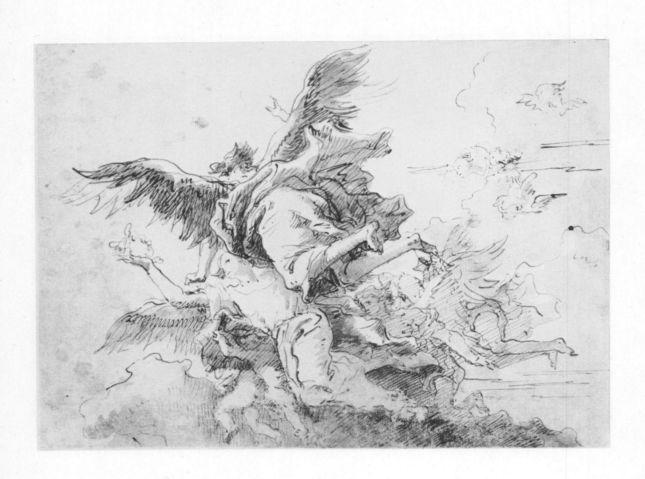

GIANDOMENICO TIEPOLO, Venice, 1727–1804

145. *Angels and Cherubim*

Pen and ink with wash on paper, 16.5 x 23 cm.

BIBLIOGRAPHY: Byam Shaw, *Domenico Tiepolo*, p. 34, n. 1.

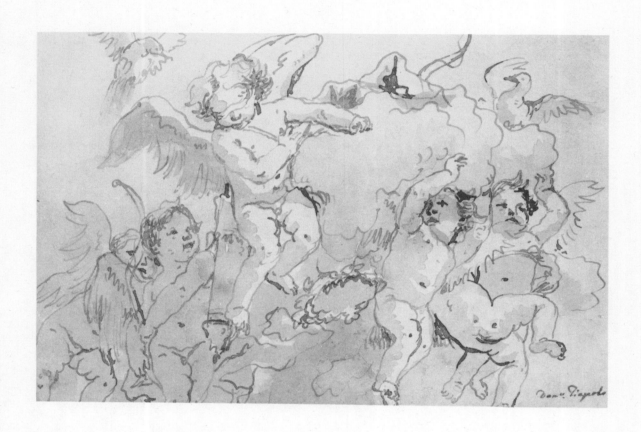

GIANDOMENICO TIEPOLO, Venice, 1727–1804

146. *Blindfolded Cupid with Putti*

Pen and ink with wash on paper, 16.4 x 24.2 cm. Signed in lower right corner: *Domº Tiepolo*.
Unpublished.

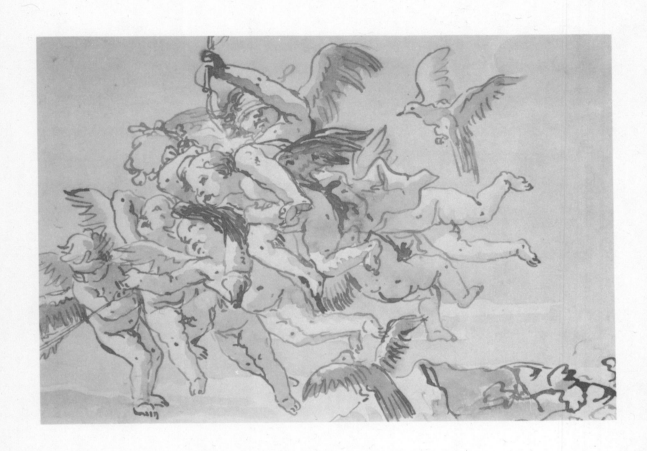

GIANDOMENICO TIEPOLO, Venice, 1727–1804

147. *Cupid with Putti*

Pen and ink with wash on paper, 17.2 x 24.3 cm. Traces of signature in lower left corner.
Unpublished.

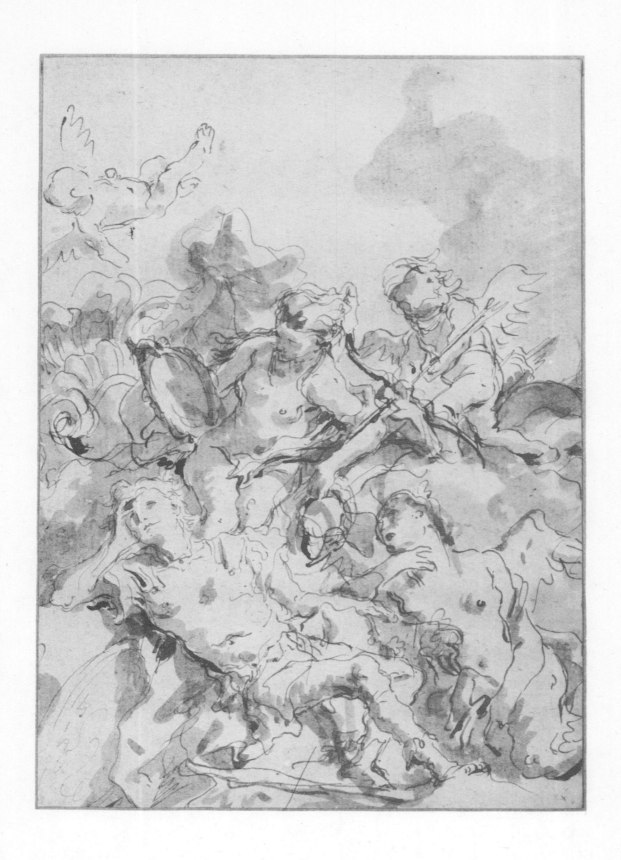

GIANDOMENICO TIEPOLO, Venice, 1727–1804

148. *Venus and Mars with Cupid*

Pen and ink with wash on paper, 23.8 x 16.5 cm.
Unpublished.

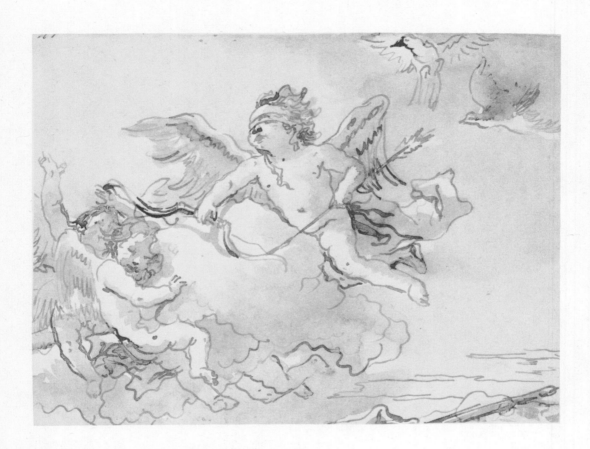

GIANDOMENICO TIEPOLO, Venice, 1727–1804

149. *Flying Cupid with Putti and Pigeons*

Pen and ink with gray wash on paper, 18.5 x 24.5 cm.

BIBLIOGRAPHY: Morassi, no. 110.

This drawing belongs to a group of quick and amusing sketches, all probably made in connection with frescoes like the *Triumph of Venus*. They are all from the richly creative period between 1780 and 1790.

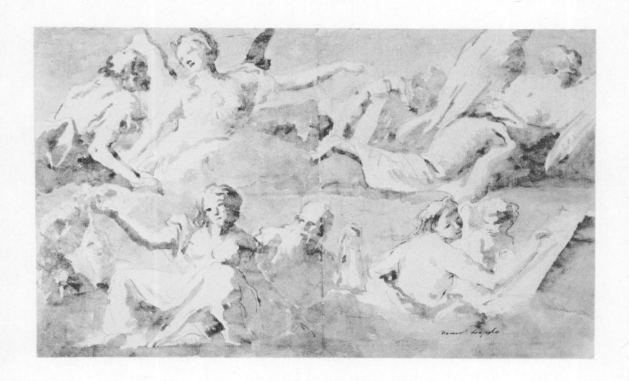

GIANDOMENICO TIEPOLO, Venice, 1727–1804

150. *Study for a Frieze with the Allegorical Figures of Veritas and Time*

Pen and ink with gray wash over black chalk on paper, 22 x 36.5 cm. Signed at lower right: *Dom.co Tiepolo f.*

BIBLIOGRAPHY: Morassi, no. 108.

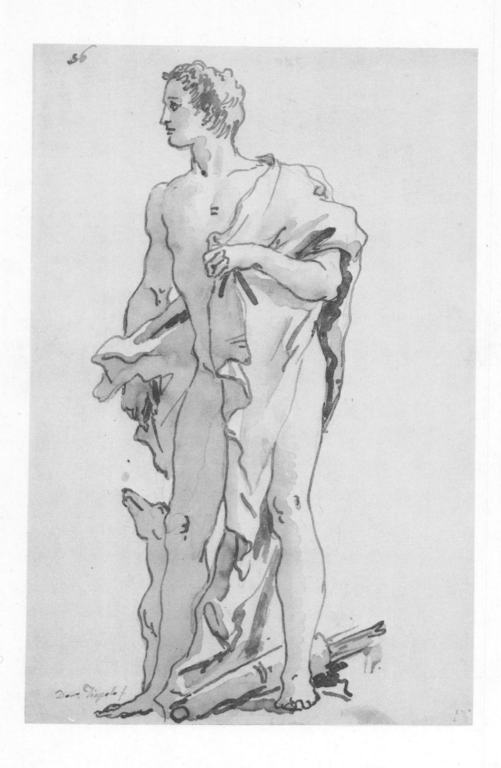

GIANDOMENICO TIEPOLO, Venice, 1727–1804

151. *Endymion*

Pen and ink with wash on paper, 27.6 x 17.2 cm. Signed in lower left corner: *Dom.co Tiepolo f.* Numbered in upper left corner: *36*.

BIBLIOGRAPHY: Morassi, no. 98.

Classical figures like this one and the next drawing appear several times in niches in Tiepolo's frescoes and paintings.

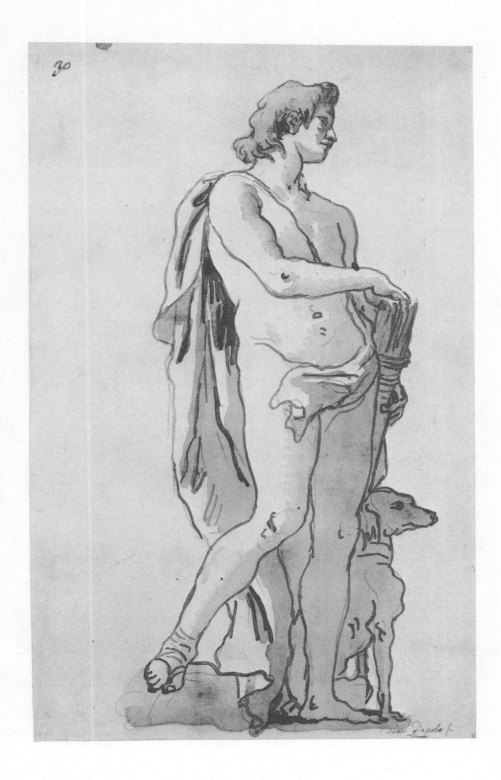

GIANDOMENICO TIEPOLO, 1727–1804

152. *Endymion*

Pen and ink with wash on paper, 27.6 x 17.2 cm. Signed in lower right corner: *Dom.co Tiepolo f.* Numbered in upper left corner: *30*.

BIBLIOGRAPHY: Morassi, no. 97.

The numbering of this and the preceding drawing may be an indication that a series of such works were gathered in an album.

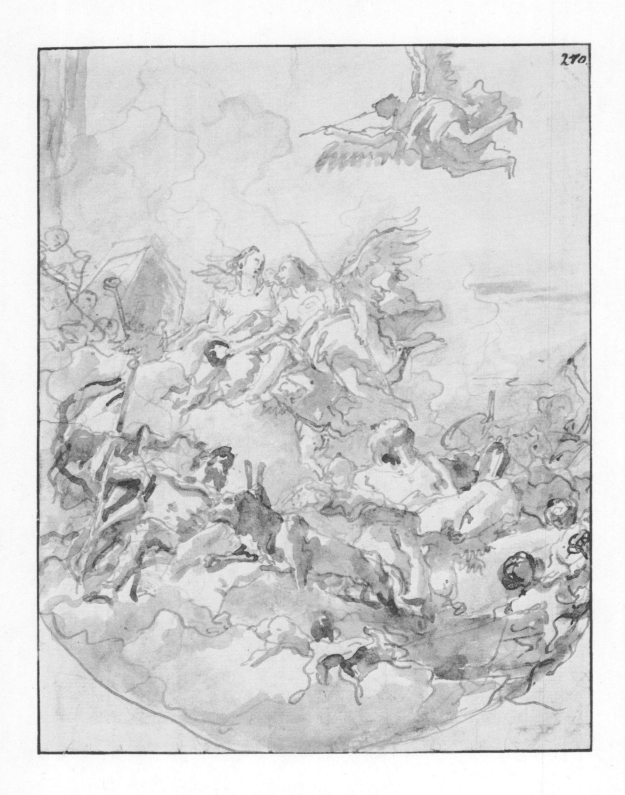

GIANDOMENICO TIEPOLO, Venice, 1727–1804

153. *Sketch for a Ceiling Fresco*

Pen and ink with wash on paper, 27.3 x 20.6 cm. Numbered in upper right corner: *270*.
Unpublished.

Three angels, one with a trumpet, hover over a group of seated saints or apostle figures. This
drawing is probably connected with one of the frescoes the Tiepolos painted during their stay
in Madrid in the late 1760s.

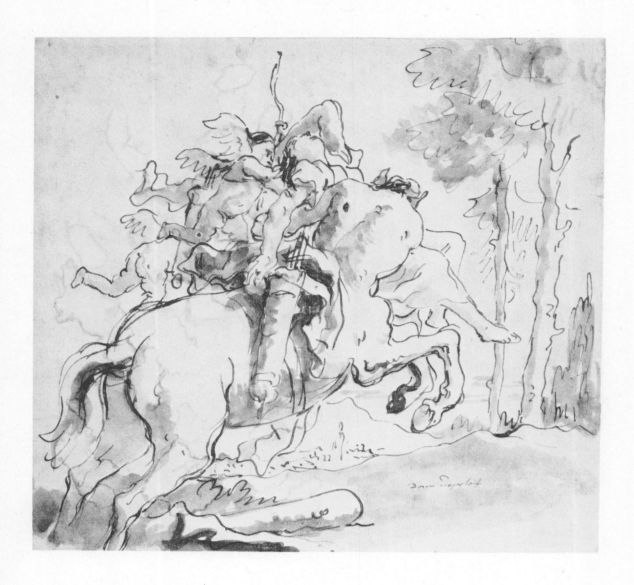

GIANDOMENICO TIEPOLO, Venice, 1727–1804

154. *The Rape of Dejanira*

Pen and ink with wash on paper, 27.3 x 29.9 cm. Signed in lower right corner: *Dom.o Tiepolo f.*

BIBLIOGRAPHY: Cailleux, "Centaurs, Fauns...," no. 23.

This drawing and the following are from a group of more than one hundred sheets representing centaurs, fauns, and satyrs in various compositions and techniques. Byam Shaw calls them "the most delightful and original of all Domenico's allegorical and mythological subjects."

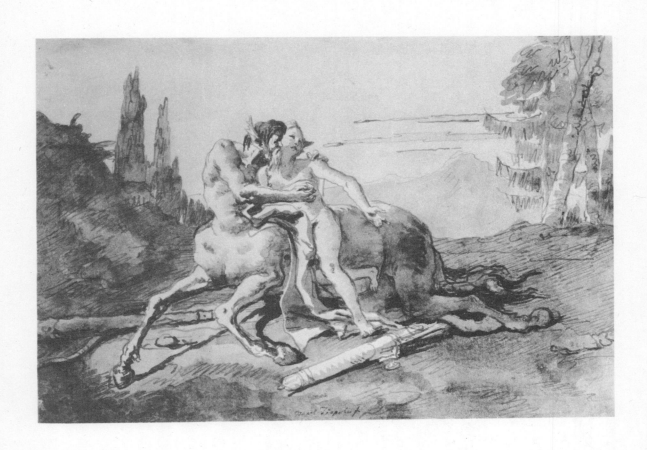

GIANDOMENICO TIEPOLO, Venice, 1727–1804

155. *Nessus Prepares to Rape Dejanira*

Pen and ink with wash on paper, 18.8 x 27.2 cm. Signed at lower center: *Dom? Tiepolo f.*
BIBLIOGRAPHY: Cailleux, "Centaurs, Fauns...," no. 11.

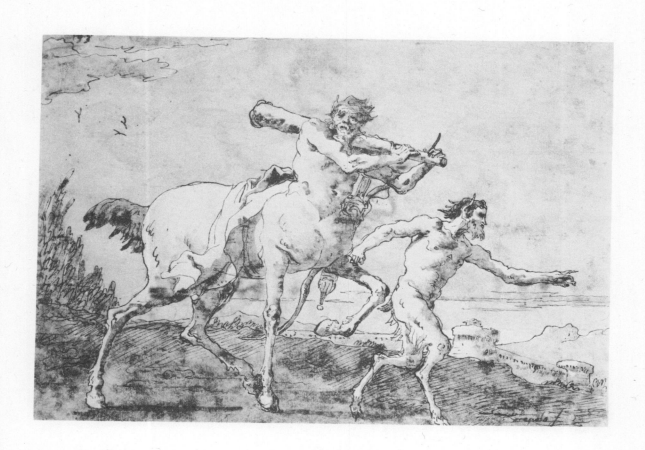

GIANDOMENICO TIEPOLO, Venice, 1727–1804

156. *A Centaur Guided by a Satyr*

Pen and ink with wash on paper, 19 x 28 cm. Signed on the wall of the fortification at right: *Dom. Tiepolo f.* Also signed in an early-nineteenth-century hand in lower right corner: *Tiepolo f.*

BIBLIOGRAPHY: Cailleux, "Centaurs, Fauns...," no. 72.

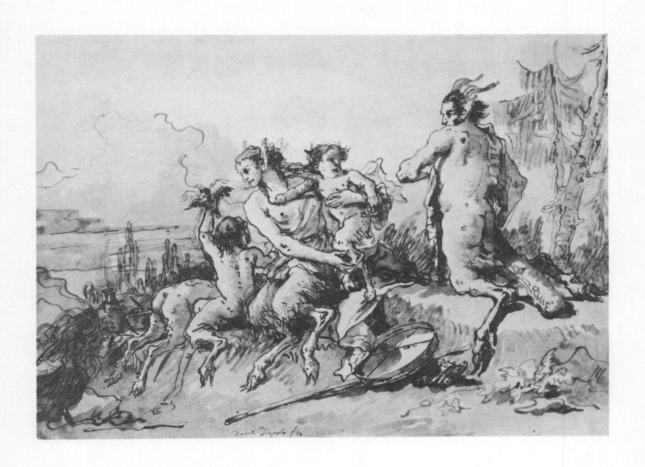

GIANDOMENICO TIEPOLO, Venice, 1727–1804

157. *Family of Satyrs*

Pen and ink with wash on paper, 19 x 26.5 cm. Signed at lower center: *Dom⁰ Tiepolo f.*

BIBLIOGRAPHY: Cailleux, "Centaurs, Fauns...," no. 87.

Byam Shaw dates the drawings with centaurs and satyrs between 1759 and 1791, but Cailleux dates at least some of them between 1753 and 1762, the year of the Tiepolos' departure for Madrid (Byam Shaw, *Domenico Tiepolo*, p. 42).

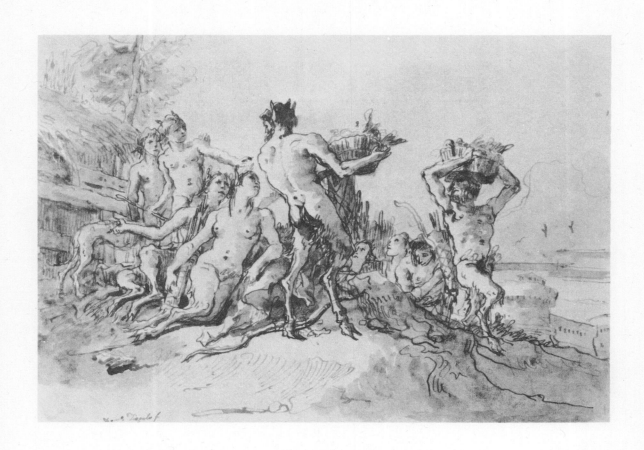

GIANDOMENICO TIEPOLO, Venice, 1727–1804

158. *Satyr Families with Harvest Baskets*

Pen and ink with wash over black chalk on paper, 19.4 x 27.6 cm. Signed in lower left corner: *Dom?*
Tiepolo f.

BIBLIOGRAPHY: Bean-Stampfle, no. 245; Cailleux, "Centaurs, Fauns…," no. 93; *The Tiepolos*,
no. 130.

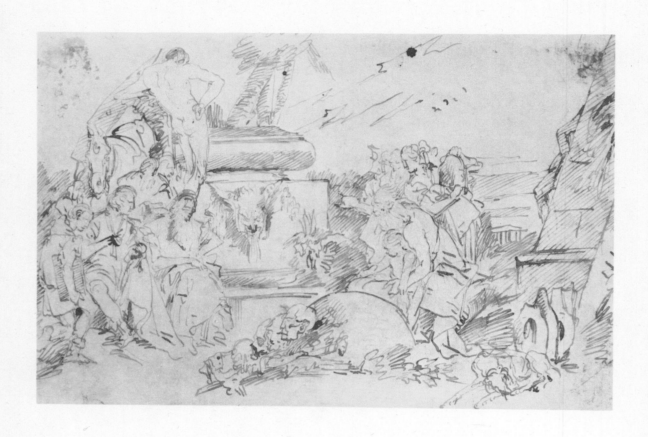

GIANDOMENICO TIEPOLO, Venice, 1727–1804

159. *Group of Figures Around a Fountain*

Pen and ink on paper, 20.3 x 30.5 cm.

Unpublished.

According to a verbal communication by J. Byam Shaw, this unsigned drawing could be the
work of Lorenzo Tiepolo, the younger brother of Giandomenico and the third artist in the
Tiepolo family.

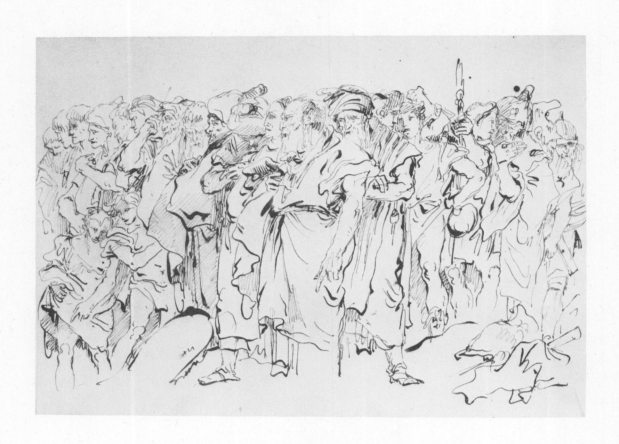

GIANDOMENICO TIEPOLO, Venice, 1727–1804

160. *Study for a Gathering of Orientals*
Pen and ink on paper, 19.5 x 28 cm.
BIBLIOGRAPHY: Morassi, no. 91; *The Tiepolos*, no. 100.

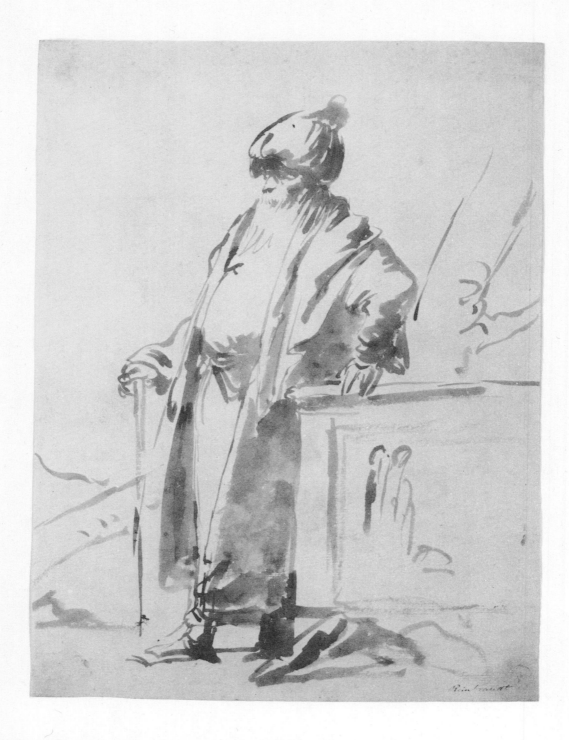

GIANDOMENICO TIEPOLO, Venice, 1727–1804

161. *Study of an Oriental*

Pen and ink on paper, 25 x 18 cm. Inscribed in lower right corner in a late-eighteenth-century hand: *Rimbrandt*.

BIBLIOGRAPHY: Morassi, no. 94; *The Tiepolos*, no. 128; Szabo, *Venetian Drawings*, no. 32.

From the inscription in the lower right corner, it is inferred that Tiepolo copied this turbaned figure beside an altar from a work of Rembrandt. Paintings and engravings by the seventeenth-century Dutch master were in several Venetian collections in Tiepolo's time and were thus easily available for copying (Morassi, p. 63). However, this drawing could also be a study from life. Oriental people have been a common sight in Venice throughout its history, especially in the eighteenth century.

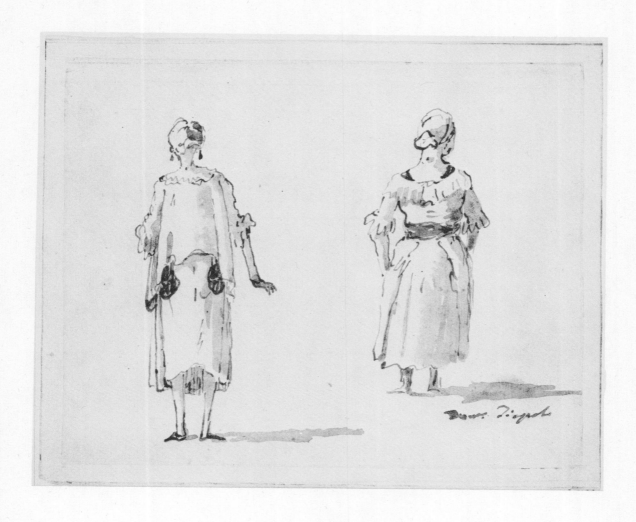

GIANDOMENICO TIEPOLO, Venice, 1727–1804

162. *Caricature of Two Young Women*

Pen and ink with wash on paper, 15.3 x 19.5 cm. Signed at lower right: *Dom? Tiepolo*.

BIBLIOGRAPHY: Morassi, no. 113; Szabo, *Venetian Drawings, no. 33*.

Similar figures are represented on Domenico's frescoes in the guesthouse of the Villa Valmarana in Vicenza, which were painted in 1775. Morassi thinks, however, that this particular sheet of caricature figures is from a later time.

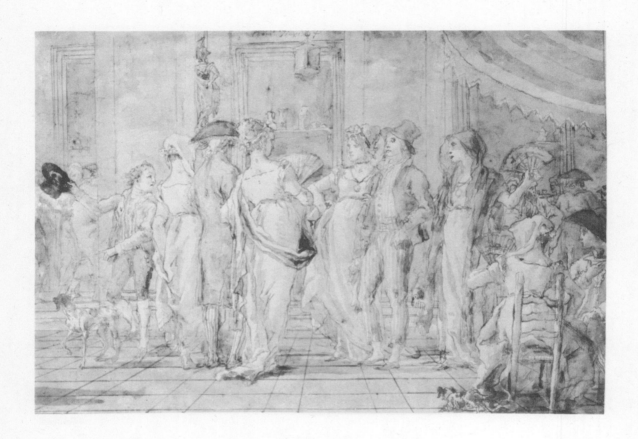

GIANDOMENICO TIEPOLO, Venice, 1727–1804

163. *Meeting at "Liston"*

Pen and ink with wash over black chalk preliminary drawing on paper, 29.8 x 41.9 cm. Signed at upper center: *Dom.o Tiepolo f.*

BIBLIOGRAPHY: G. Morazzoni, *La moda a Venezia nel sec. XVIII*, Milan, 1931, pl. 86; J. Byam Shaw, "Some Venetian Draughtsmen of the Eighteenth Century," *Old Master Drawings* 7 (1932–33), pp. 47–63; A. Morassi, "Domenico Tiepolo," *Emporium* 47 (1941), p. 281; W. R. Juynboll, "Een Caricatuur van Giovanni Domenico Tiepolo," *Bulletin Museum Boymans* 7 (1956), p. 79; Morassi, no. 114; Pignatti, no. 112; *The Tiepolos*, no. 26; Szabo, *Venetian Drawings*, no. 37.

This brilliant depiction of Venetian life and society at the end of the eighteenth century is also a testament to Giandomenico's surpassing talent. At the same time it is a shrewd observation of the process of history, for these two groups of people who have met while strolling on the piazza near the Café Florian stand for the old society confronting the new order. The former is represented on the left by a nobleman in old-fashioned costume with a wig and tricorn. The representative of the new order is the young gentleman in striped hose, a short jacket, and a hairstyle "à la mode Directoire." The golden tonality of the sheet and the indulgent attitude of the artist lend an unusual charm and warmth to this drawing.

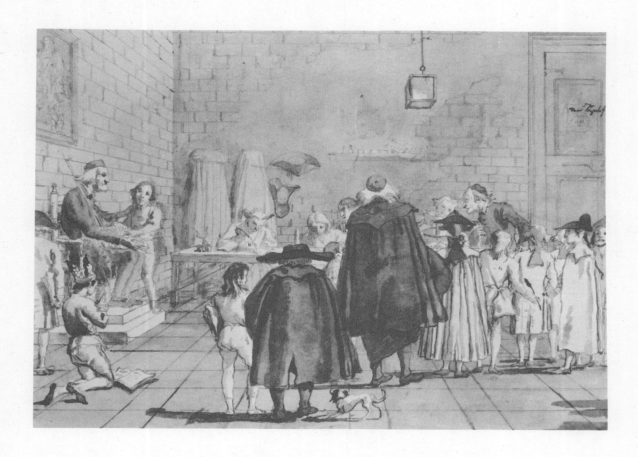

GIANDOMENICO TIEPOLO, Venice, 1727–1804

164. *The School*

Pen and brown ink with gray wash over black chalk drawing on paper, 36.8 x 50.2 cm. Signed and dated in pen and ink at upper right: *Tiepolo 1791*. Signed again in pen and darker ink at upper right: *Dom.o Tiepolo f.*

BIBLIOGRAPHY: K. T. Parker, "Giovanni Domenico Tiepolo," *Old Master Drawings* 6 (1931), p. 49; Byam Shaw, *Domenico Tiepolo*, pp. 48, 63–64; Bean-Stampfle, no. 262; Szabo, *Venetian Drawings*, no. 35.

A delightful scene of contemporary life is masterfully recorded in this virtuoso drawing. Each group in the lively composition is represented in a different manner. The aged reading master and the unfortunate student wearing a dunce's cap are lightly drawn, while the backs of the serious parents are emphasized by the heavy wash. The students waiting on the right are defined only by a few light strokes of wash on the white paper.

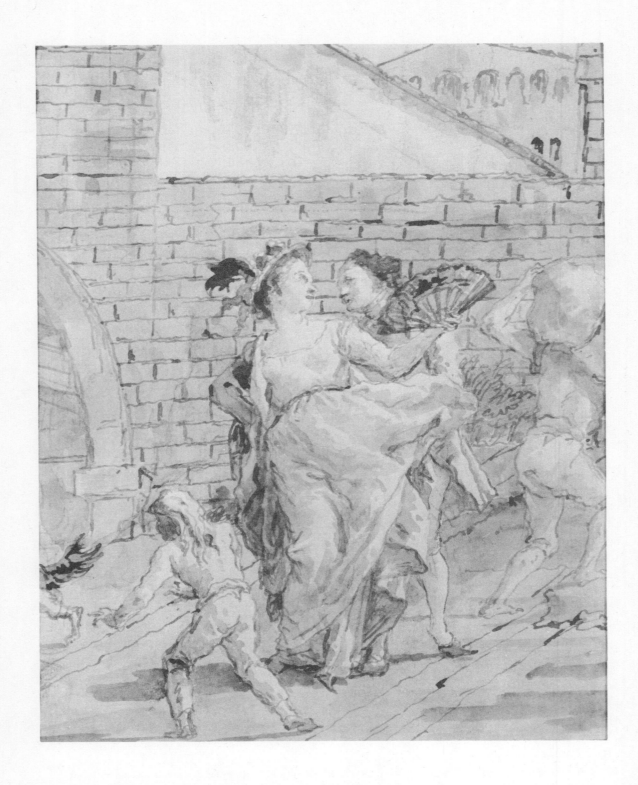

GIANDOMENICO TIEPOLO, Venice, 1727–1804

165. *A Venetian Rendezvous*

Pen and ink with wash on paper, 28.6 x 22.2 cm. The page has been cut on the left side.

BIBLIOGRAPHY: Wildenstein and Co., *Timeless Master Drawings*, exhibition catalogue, New York, 1959, no. 104; Szabo, *Venetian Drawings*, no. 36.

The abrupt ending on the left side of this drawing indicates that it was part of a larger composition that has been cut. The vibrant scene belongs to those works by Giandomenico representing subjects from contemporary life.

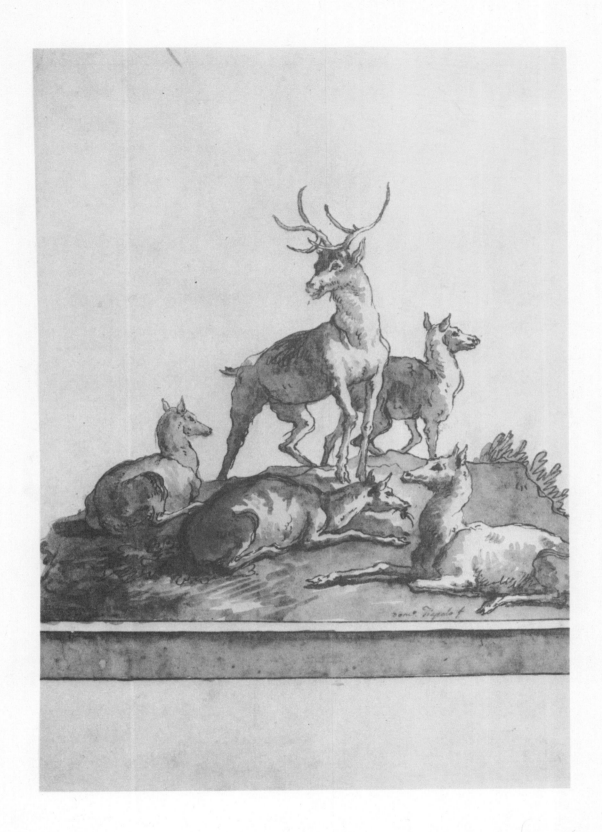

GIANDOMENICO TIEPOLO, Venice, 1727–1804

170. *A Deer Surrounded by Four Animals*

Pen and ink with wash on paper, 28.5 x 20 cm. Signed above the ledge at right: *Dom.co Tiepolo f.*

BIBLIOGRAPHY: Morassi, no. 102; J. Byam Shaw, "The Remaining Frescoes in the Villa Tiepolo at Zianigo," *Burlington Magazine* 101 (1959), fig. 39.

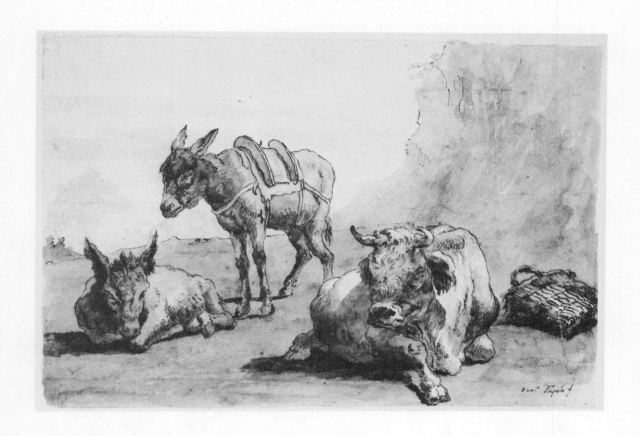

GIANDOMENICO TIEPOLO, Venice, 1727–1804

171. *A Bull with Two Donkeys*

Pen and ink with wash on paper, 18.7 x 28.3 cm. Inscribed in lower right corner: *Dom.o Tiepolo f.*

BIBLIOGRAPHY: Morassi, no. 105; Szabo, *Venetian Drawings*, no. 39.

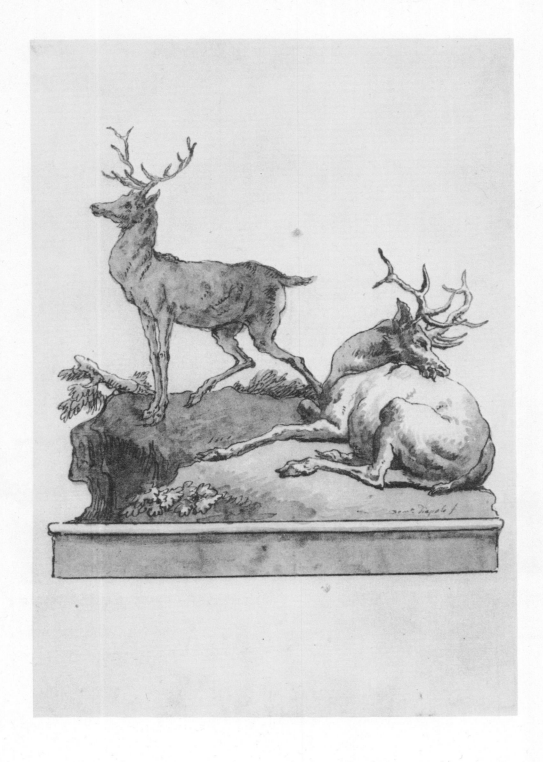

GIANDOMENICO TIEPOLO, Venice, 1727–1804

172. *Standing and Lying Deer*

Pen and ink with wash on paper, 28.5 x 20 cm. Signed on the ground under the lying deer: *Dom.co Tiepolo f.*

BIBLIOGRAPHY: Morassi, no. 103; J. Byam Shaw, "The Remaining Frescoes in the Villa Tiepolo at Zianigo," *Burlington Magazine* 101 (1959), fig. 36, pp. 392, 395; Byam Shaw, *Domenico Tiepolo*, pp. 42–43.

Byam Shaw has demonstrated that this lying deer is borrowed from an etching by the German artist Johann Elias Ridinger of Augsburg, whose work was a major source of Giandomenico's animal drawings.

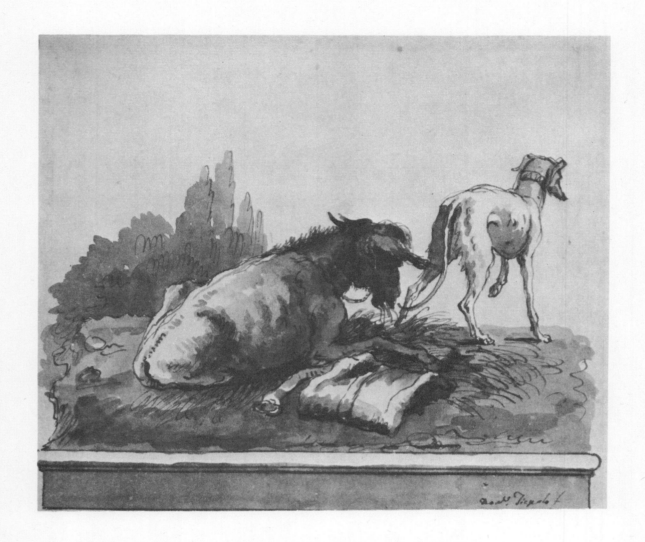

GIANDOMENICO TIEPOLO, Venice, 1727–1804

173. *Donkey with a Dog*

Pen and ink with wash on paper, 16.7 x 19.7 cm. Signed on ledge at lower right: *Dom? Tiepolo f.*
Unpublished.

It is possible that the drawings of animals that include a ledge were made by Giandomenico
with the decoration of the villa at Zianigo in mind (Byam Shaw, *Domenico Tiepolo*, pp. 42–43).

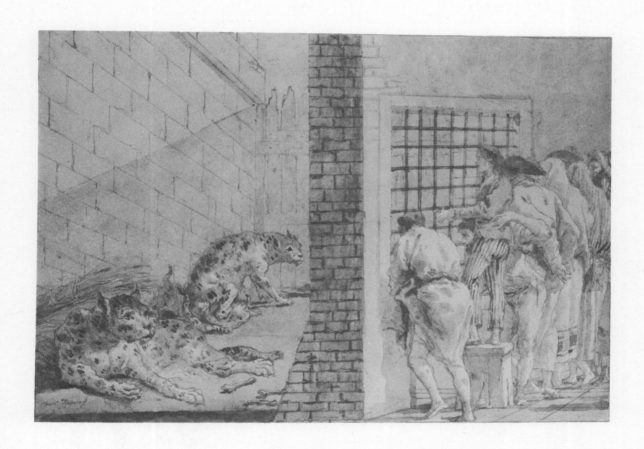

GIANDOMENICO TIEPOLO, Venice, 1727–1804

166. *A Visit to the Menagerie*

Pen and ink with wash over black chalk drawing on paper, 28.8 x 41.5 cm. Signed at lower left: *Dom.o Tiepolo f.*

BIBLIOGRAPHY: M. Knoedler and Co.,. *Exhibition of Old Master, Impressionist and Contemporary Drawings*, London, 1958, no. 8; Byam Shaw, *Domenico Tiepolo*, p. 48, no. 7; Szabo, *Venetian Drawings*, *no. 38*.

This drawing represents another scene of contemporary life. Judging from the costumes, it is from the last years of the eighteenth century.

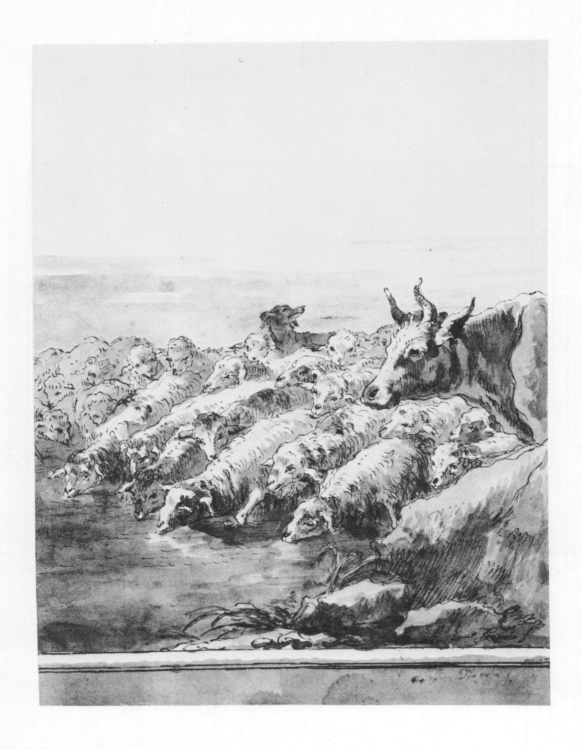

GIANDOMENICO TIEPOLO, Venice, 1727–1804

167. *A Flock of Sheep with an Ox and a Dog*

Pen and ink with wash on paper, 26.8 x 19.8 cm. Signed on ledge in lower right corner: *Dom. Tiepolo f.*
Inscribed in an early-nineteenth-century hand above the original signature: *Dom? Tiepolo f.*

BIBLIOGRAPHY: Morassi, no. 106; J. Byam Shaw, "The Remaining Frescoes in the Villa Tiepolo at
Zianigo," *Burlington Magazine* 101 (1959), p. 392.

This and the following five drawings have been found to correspond to animals represented in
frescoes at the villa at Zianigo (see Byam Shaw, *Domenico Tiepolo*, pp. 42–43 and the article
cited above).

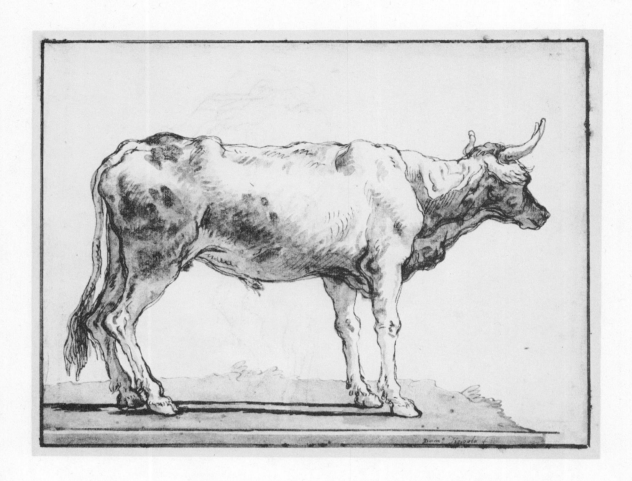

GIANDOMENICO TIEPOLO, Venice, 1727–1804

168. *Standing Bull*

Pen and ink with wash over black chalk, 18.5 x 24.6 cm. Signed on ledge at lower right: *Dom? Tiepolo f.*

BIBLIOGRAPHY: Morassi, no. 107; J. Byam Shaw, "The Remaining Frescoes in the Villa Tiepolo at Zianigo," *Burlington Magazine* 101 (1959), p. 392.

Behind the bull, the figure of a man drawn in black chalk is faintly visible.

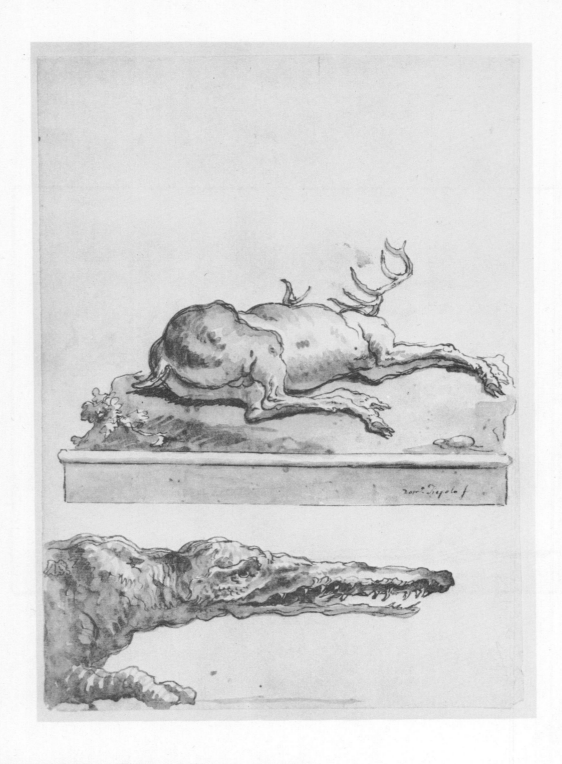

GIANDOMENICO TIEPOLO, Venice, 1727–1804

169. *A Deer Lying on a Ledge and the Head of a Crocodile*

Pen and ink with wash on paper, 28.5 x 20 cm. Signed on the ledge under the deer: *Dom? Tiepolo f.*

BIBLIOGRAPHY: Morassi, no. 104; J. Byam Shaw, "The Remaining Frescoes in the Villa Tiepolo at Zianigo," *Burlington Magazine* 101 (1959), fig. 38, p. 395.

Byam Shaw has remarked that this stag, which appears in a painting at Zianigo, is identical to one painted by Giambattista for the Grand Staircase at Würzburg, completed in 1753. Morassi points out that the crocodile may be connected to Giambattista's frescoes of the Palazzo Clerici in Milan (1740) or possibly to those in Würzburg (1751–53) and Madrid (1764). These are indications of the wide range of possible dates assigned to the animal drawings.

GIANDOMENICO TIEPOLO, Venice, 1727–1804

178. *Study of a Seahorse and a Dolphin*

Pen and ink with wash on paper, 6.5 x 15.3 cm. Signed in lower right corner: *Do? Tiepolo f.*

BIBLIOGRAPHY: Morassi, no. 101.

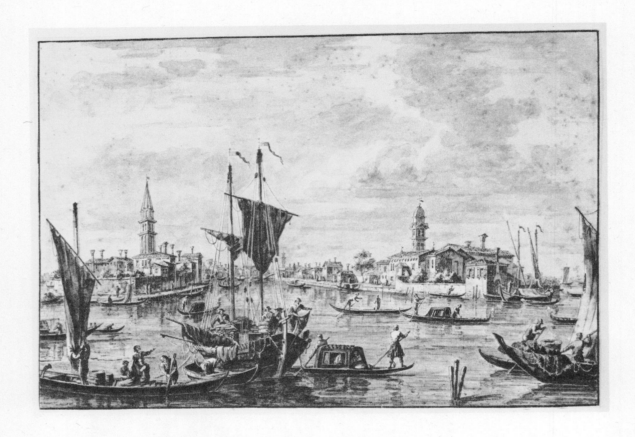

FRANCESCO TIRONI, Venice, d. ca. 1800

179. *View of Mazzorbo*

Pen and ink with gray wash on paper, 28 x 41.5 cm.

BIBLIOGRAPHY: Morassi, no. 115

This is a preparatory drawing for an engraving made and published by A. Sandi (1735–1817) as part of a series of six *vedute*. The engraving carries the inscription *F. Tironi pin*.

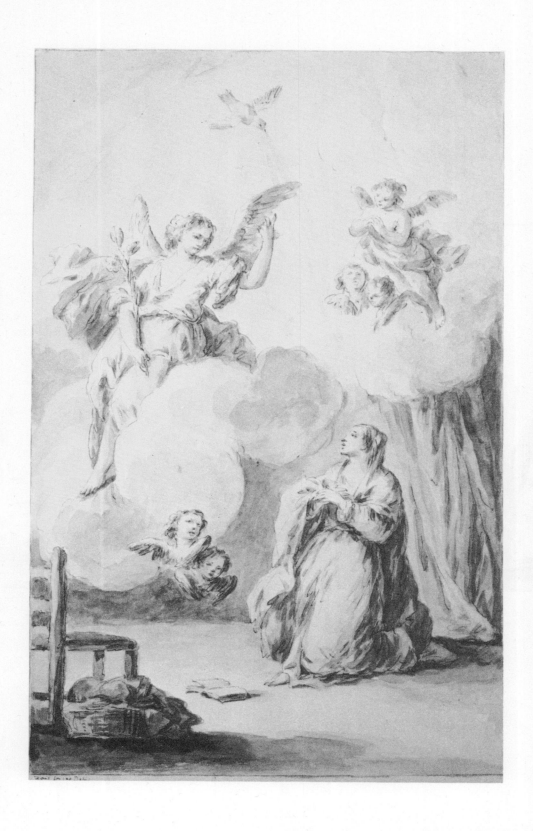

GIUSEPPE ZAIS, Venice, 1709–1784

180. *The Annunciation*

Pen and ink with gray wash on paper, 35 x 21.6 cm. Inscribed in the margin in lower left corner: *Zais in. et Del.*

Unpublished.

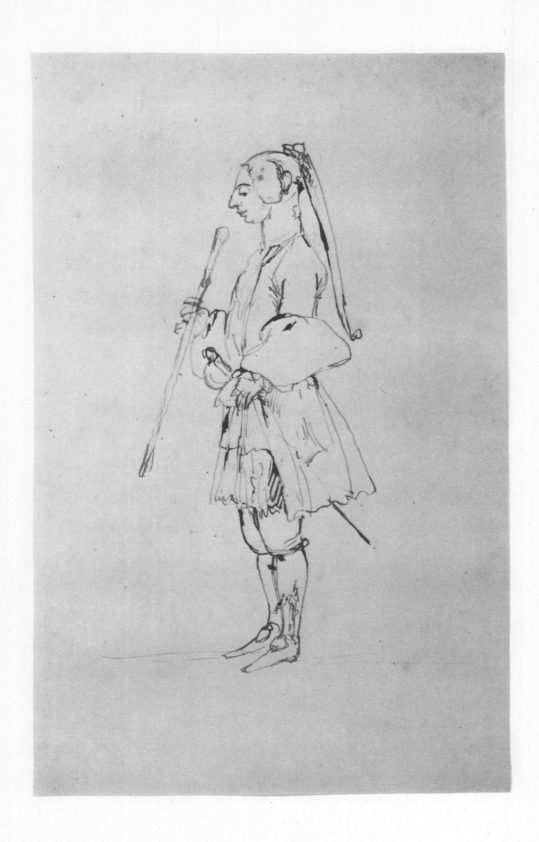

ANTONIO MARIA ZANETTI, Venice, 1680–1767
181. *Caricature of a Man with a Sword and Walking Stick*
Pen and ink on paper, 27.5 x 17.5 cm.
BIBLIOGRAPHY: Morassi, no. 117.

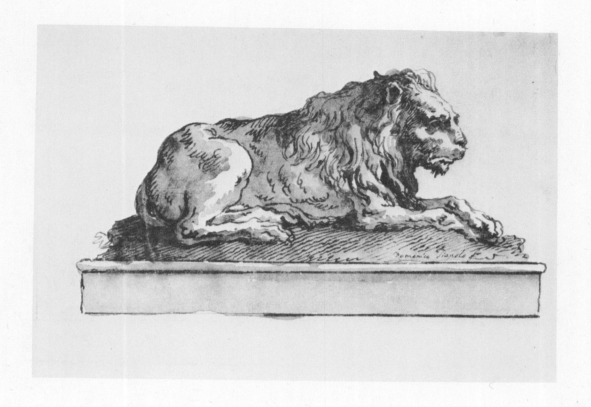

GIANDOMENICO TIEPOLO, Venice, 1727–1804

174. *Sitting Lion in Profile*

Pen and ink with wash on paper, 12 x 17.3 cm. Signed on the ground at right: *Domenico Tiepolo f.*

BIBLIOGRAPHY: Morassi, no. 100.

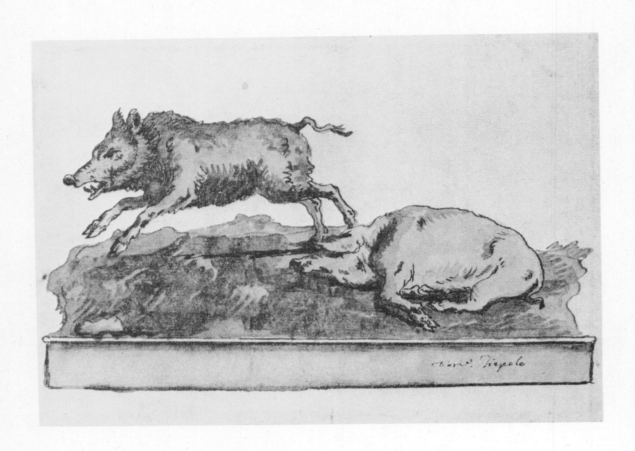

GIANDOMENICO TIEPOLO, Venice, 1727–1804

175. *Two Wild Boars*

Pen and ink with wash on paper, 12.1 x 17 cm. Signed in lower right corner of ledge: *Dom? Tiepolo*.
Unpublished.

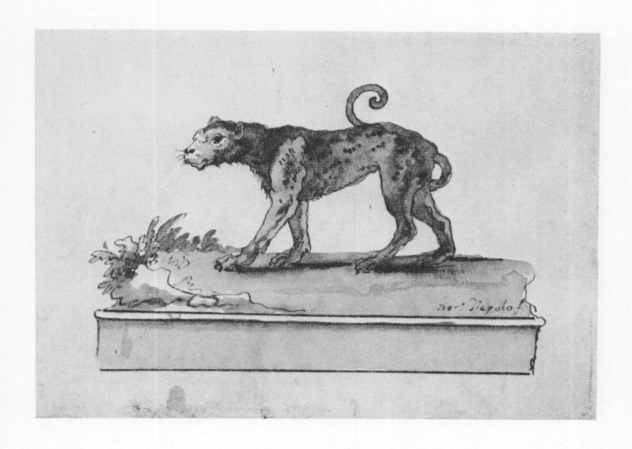

GIANDOMENICO TIEPOLO, Venice, 1727–1804

176. *Feline Wild Beast*

Pen and ink with wash on paper, 11.2 x 16.4 cm. Signed on pedestal at lower right: *Dom? Tiepolo f.*
Unpublished.

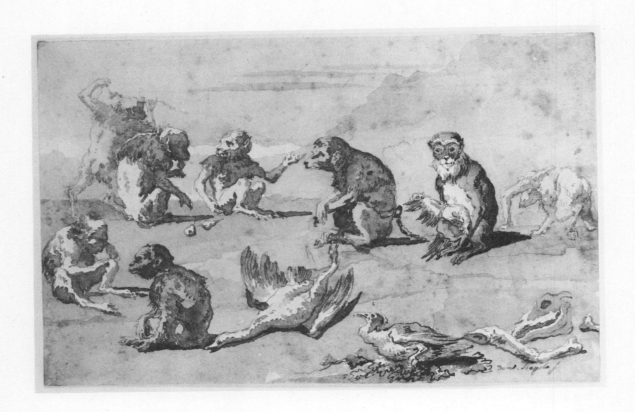

GIANDOMENICO TIEPOLO, Venice, 1727–1804

177. *A Group of Monkeys with a Dead Goose*

Pen and ink with wash on paper, 18.2 x 28.3 cm. Signed at lower right: *Dom? Tiepolo f.*

BIBLIOGRAPHY: Morassi, no. 126; Byam Shaw, *Domenico Tiepolo*, no. 48, pl. 48; Szabo, *Venetian Drawings*, no. 40.

Byam Shaw points out that this subject was not drawn from life. The figures of the monkeys were borrowed from the works of Stefano della Bella (Byam Shaw, *Domenico Tiepolo*, p. 82).

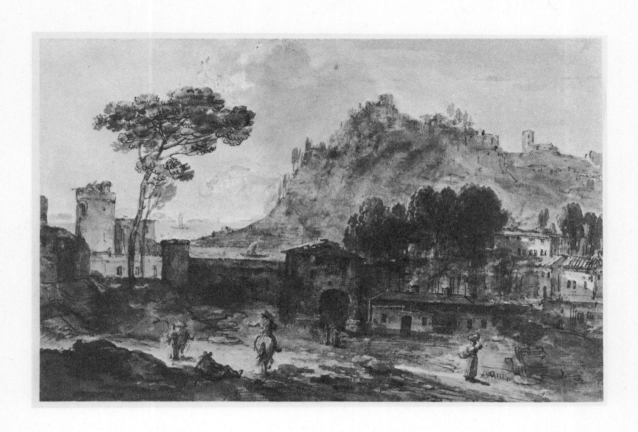

FRANCESCO ZUCCARELLI, Venice, 1702–1788

182. *Fantastic Landscape*

Pen and ink with wash and white highlights on paper, 30.5 x 46.8 cm.

BIBLIOGRAPHY: Morassi, no. 127.

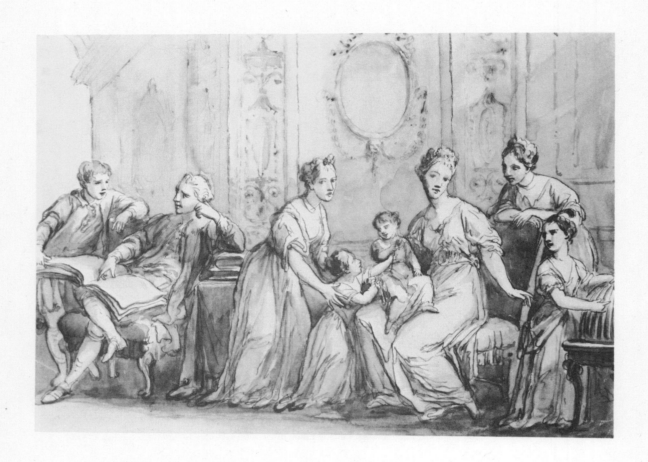

ANTONIO ZUCCHI, Venice, Rome, 1726–1795

183. *Study for a Family Portrait*

Pen and ink with wash on paper, 25.5 x 36 cm.

BIBLIOGRAPHY: Morassi, no. 119; Szabo, *Venetian Drawings*, no. 45.

This well-composed, pleasantly described group is represented in the manner of the eighteenth-century English conversation pieces. This is not surprising, since English paintings and engravings were common in Venice at this time. Furthermore, Zucchi was married to Angelica Kauffmann, well known for her success in this genre.

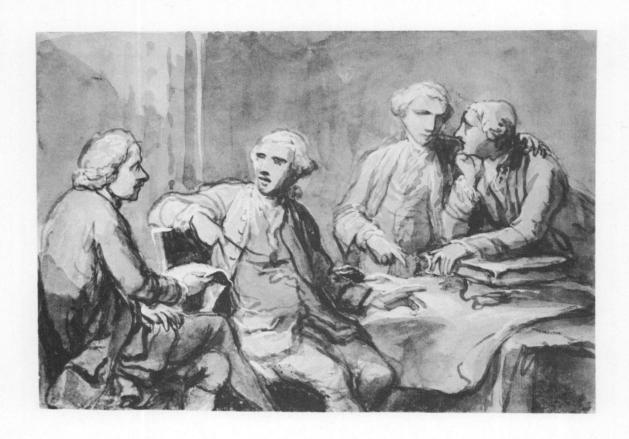

ANTONIO ZUCCHI, Venice, Rome, 1726–1795

184. *Study of a Group of Men*

Pen and ink with wash and white highlights on paper, 18.5 x 27 cm.

BIBLIOGRAPHY: Morassi, no. 118; Szabo, *Venetian Drawings*, no. 44.

Like the previous drawing, this is also in the manner of a conversation piece.

WORKS ABBREVIATED

Bean-Stampfle
Bean, Jacob, and Stampfle, Felice. *Drawings from New York Collections, III: The Eighteenth Century in Italy*. New York, 1971.

Cailleux, "Centaurs, Fauns..."
Cailleux, Jean. "Centaurs, Fauns, Female Fauns, and Satyrs Among the Drawings of Domenico Tiepolo," *Burlington Mazazine* 116 (June, 1974), Advertisement Supplement, pp. i–xxviii.

Chicago, *Tiepolo Exhibition*
Art Institute of Chicago. *Paintings, Drawings, and Prints by the Two Tiepolos: Giambattista and Giandomenico*, exhibition catalogue. Chicago, 1938.

Cincinnati
Cincinnati Art Museum. *The Lehman Collection, New York*, exhibition catalogue. Cincinnati, 1959.

Grassi Sale Cat.
Sotheby & Co. *Catalogue of Important Drawings by Old Masters mainly of the Italian School from the G. L. Collection ...sold 13 May 1924*. London, 1924.

Morassi
Morassi, Antonio. *Venezianische Handzeichnungen des Achtzehnten Jahrhunderts aus der Sammlung Paul Wallraf*. Venice, 1959.

Paris
Musée de l'Orangerie. *Exposition de la collection Lehman de New York*, exhibition catalogue. Paris, 1957.

Pignatti
Pignatti, Terisio. *Venetian Drawings from American Collections, a Loan Exhibition*. Washington, D.C., National Gallery of Art, 1974.

Punchinello Drawings
Indiana University, Bloomington Art Museum. *Domenico Tiepolo's Punchinello Drawings*, exhibition catalogue. Bloomington, 1979.

Byam Shaw
Shaw, J. Byam. *The Drawings of Domenico Tiepolo*. London, 1962.

Szabo, *Venetian Drawings*
Szabo, George. *From the Pens of the Masters: Eighteenth Century Venetian Drawings from the Robert Lehman Collection of The Metropolitan Museum of Art*, exhibition catalogue. Huntington, New York, Heckscher Museum, 1980.

The Tiepolos
Birmingham, Alabama, Museum of Art. *The Tiepolos: Painters to Princes and Prelates*, exhibition catalogue. Birmingham, 1978.